D1531536

MODERN ART
THE GROUNDBREAKING MOMENTS

MODERN ART
THE GROUNDBREAKING MOMENTS

BRAD FINGER

PRESTEL
Munich · London · New York

Manet

Monet

Cézanne

Van Gogh

Rodin

Matisse

Picasso

Malevich

Kandinsky

Duchamp

Ernst

Kirchner

Rivera

Calder

Pollock

Riley

Hamilton

Klein

Dubuffet

Paik

Close

Smithson

CONTENTS

INTRODUCTION

The nineteenth century ushered in an unprecedented era of change. The spread of modern industry, the rapid growth of cities, and the dramatic advances in transportation and mass media inspired radically new artworks. *Modern Art: The Groundbreaking Moments* discusses the key pioneering efforts of this art, starting with Édouard Manet's *Le déjeuner sur l'herbe* (The Luncheon on the Grass). Manet's provocative work was shown at the 1863 Salon des Refusés in Paris, the first great exhibition of avant-garde painting. From such beginnings, modern artists developed an abundance of movements and styles. Further chapters examine Claude Monet's *Impression, Sunrise*, one of the first Impressionst paintings; Wassily Kandinsky's *Composition VII*, an early work of abstract art; and Richard Hamilton's *Just what is it that makes today's homes so different, so appealing?*, a founding image of Pop Art. Each one discusses why the artists produced their works—touching upon their chief sources of inspiration and their innovative art-making techniques. The chapter on the video art of Nam June Paik assesses the ways in which the artist was responsive to advances in technology. Other chapters explain the effect of political upheaval on artists, including the revolutionary muralist Diego Rivera, or show how others were merely seeking to create their own personal niche in the art world, such as the Op artist Bridget Riley and the Photorealist Chuck Close.

Modern Art: The Groundbreaking Moments will also discuss how its featured artworks inspired later generations and movements. Vincent van Gogh's passionate *Wheatfield with Crows* from 1890 profoundly influenced the work of German Expressionism in the 1910s and 1920s. Paul Cézanne's *Mont Sainte-Victoire* stimulated the geometrical explosiveness of Cubism. And Marcel Duchamp's readymades, including his *Fountain*, inspired a remarkable variety of postmodern conceptual art and performance art as well as outraging many critics at the time. As this book will show, the history of modern art has always been a process of dynamic cultural exchange; a process that since World War II has become increasingly diverse and multicultural. The stirrings of modernism that began in Paris have now spread to China, Latin America, and around the world. The twenty-two chapters of *Modern Art: The Groundbreaking Moments,* present a small but influential sampling of that diversity.

left——**ERNST LUDWIG KIRCHNER, FEMALE ARTIST (MARCELLA)**
1910 | oil on canvas | 100 × 76 cm | Brücke-Museum | Berlin.

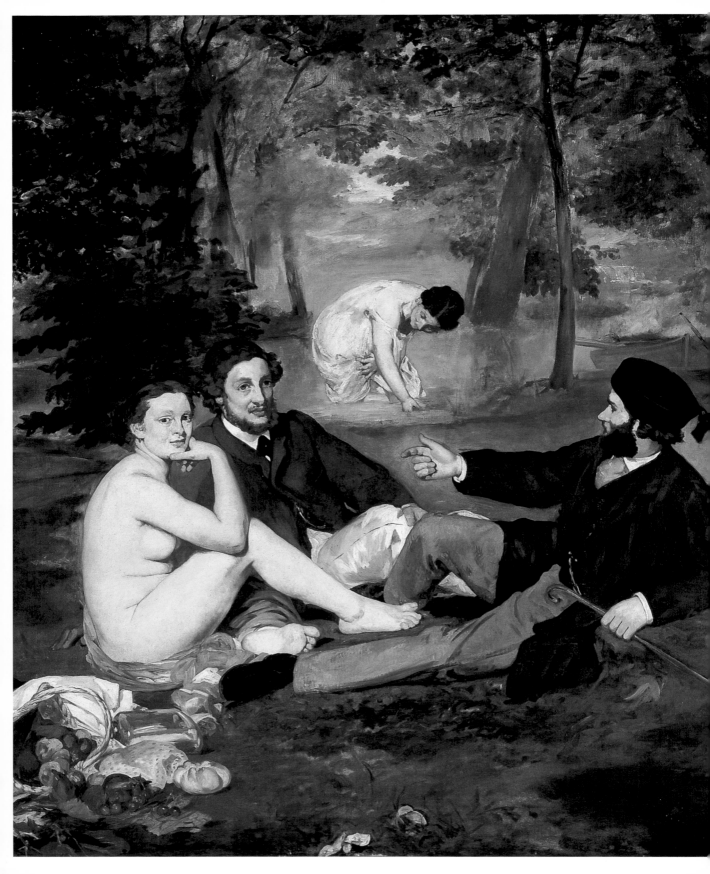

1815: Congress of Vienna ·········· 1819: Carlsbad Decrees ··········
1817: Wartburg Festival ··········
1826: First photographs ··········

8/9

1819 – 1877: Gustave Courbet 1830 – 1903: Camille Pissarro 1832 – 1883: Édouard Manet

ÉDOUARD MANET: *LE DÉJEUNER SUR L'HERBE*

The nineteenth century was an age of radical transformation. Technological progress was becoming a central feature of Western culture, changing the way people lived, worked, and interacted with one another. New industrial marvels were being developed with startling regularity: the steam engine, the telegraph, the mechanical reaper, and the photograph. All of them had dramatic consequences for the lives of ordinary people, leading many to move from small towns to cities, from farm life to industrial careers. Paris was one of many Western cities whose population had boomed. By the 1850s, Parisian city planners were conducting the world's most audacious program of urban renewal. Under the direction of Baron Georges-Eugène Haussmann, overcrowded medieval districts were torn down and replaced by wide boulevards and grand apartments. Royal hunting grounds, including the Bois de Boulogne, were turned into landscaped city parks; and huge train stations, such as the Gare de Lyon and the Gare du Nord, were built or reconstructed. One of the most

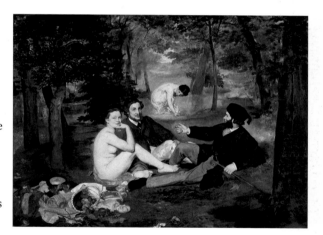

spectacular of these urban projects was centered around the Louvre museum, which had only been open to the public for a few decades. The monumental Rue de Rivoli provided a grand thoroughfare connecting the Tuileries Garden and the museum, enhancing the Louvre's new role as a "modern" tourist attraction.

Édouard Manet (1832–83) was a key figure in Paris's cultural revolution. Born into a wealthy family of diplomats and judges, he rebelled against the legal career his father had desired for him. In 1850, Manet

left——ÉDOUARD MANET, LE DÉJEUNER SUR L'HERBE | detail.
right——ÉDOUARD MANET, LE DÉJEUNER SUR L'HERBE | 1862/63
oil on canvas | 208 × 265.5 cm | Musée d'Orsay | Paris.

10/11 MANET **1848:** Revolutions in Europe **1853-1856:** Crimean War

1849: Death of Chopin

1857-1859: First world economic crisis

1840 – 1926: Claude Monet

1841 – 1919: Auguste Renoir

1853 – 1890: Vincent van Gogh

> »*Like* Le déjeuner, *Courbet's* L'atelier du peintre *places a vaguely classical nude within a contemporary scene; Courbet's work, however, has an overtly allegorical function.*«

began his artistic studies under Thomas Couture (1815–79), one of the more inventive painters and teachers of the day. Couture's own works are often characterized by bold brushstrokes and a precise understanding of light and shade. In his writings, Couture promoted the use of modern subjects in art, saying:

"I did not make you study the old masters so that you would always follow trodden paths. Those lessons were indispensable to give you fluency in the language. Now that you possess it, speak; but speak in order to relate to your own times. Why this antipathy for our land, our customs, our modern inventions? … You say, 'But the ancients never did anything like that?' For the very good reason that such things did not exist."

Manet's own paintings would absorb Couture's interest in modern themes. They would also benefit from the rich diversity of mid-nineteenth-century Parisian art, from the passionate color and brushwork of Eugène Delacroix (1798–1863) to the stark, aggressive realism of Gustave Courbet (1819–77). And like nearly all Parisian art students, the young Manet would spend hours in the Louvre, analyzing and copying its vast assemblage of old master paintings—works by Raphael, Diego Velazquez, the Le Nain brothers, Peter Paul Rubens, Antoine Watteau, Francisco de Goya, and Jean-Baptiste-Siméon Chardin. These studies were supplemented by extensive travel throughout Europe, where he viewed collections in Germany, Austria-Hungary, the Netherlands, and Italy. Manet soon acquired an encyclopedic knowledge of Western art history. When he left Couture's studio in 1856, he began to develop a style that boldly

combined pictorial elements of old and modern masters with the "vernacular" imagery of his rapidly changing city.

In 1863, Manet produced several paintings for the Paris Salon. This "official" exhibition of new works was organized by the city's leading art school, the Académie des Beaux-Arts. But Manet had never studied at the school, and the paintings he submitted were rejected by the straight-laced jury of Académie members. Many other artists suffered the same fate that year, as the jury rejected more than half of the submitted paintings, a decision that drew the ire of artists and art critics alike. Press coverage of the 1863 Salon was often scathing, and it prompted the French government to sponsor their own event to "let the public judge the legitimacy of these complaints" and to view the "rejected works of art" for themselves. The new exhibition was called the Salon des Refusés ("Exhibition of Rejects"), and it received an unprecedented amount of publicity. Manet's own art garnered much of the critical attention. For many skeptical viewers, his works seemed unpolished and needlessly provocative. The one painting that caused the most stir among critics and the public was *Le déjeuner sur l'herbe* (The Luncheon on the Grass) (fig. pp. 8/9).

In *Le déjeuner*, Manet placed a nude female figure in the middle of a bizarre picnic scene. The woman sits next to two fully clothed, middle-class Parisian

right——**Gustave Courbet, L'Atelier du peintre** | 1855 oil on canvas | 361 × 598 cm | Musée d'Orsay | Paris.

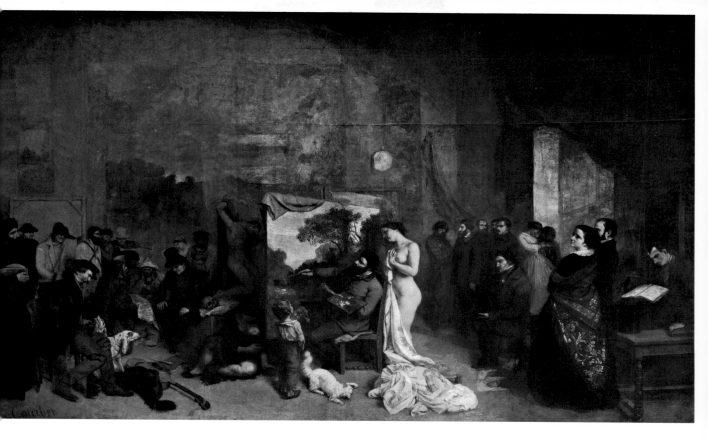

gentlemen; her garishly lit body stands out against the men's dark clothing and the surrounding forest. The female nude had long been a favorite subject for artists, and Manet's woman adopts a pose based on Renaissance-era depictions of Venus. But the placement of such a figure in the "modern world," alongside clothed men, offended many viewers. And though the woman's reclining posture resembled that of a Renaissance goddess, her skin and face were painted with a sharp naturalism; her nonchalant gaze focused directly at the viewer. Other aspects of Manet's technique also provoked critical comment. The spatial relationship between the figures in the foreground and the reclining woman behind was unnatural, giving the landscape a disorienting, flat appearance—like a warped stage set. This unnatural look was heightened by the artist's loose, free brushwork.

One can compare *Le déjeuner* with a slightly older work by Gustave Courbet. As the leading artist of France's Realist movement, Courbet had sought to highlight the gritty, sometimes prurient aspects of modern life. Like *Le déjeuner*, Courbet's *L'atelier du peintre* (The Painter's Studio) (1855) (fig. above) places a vaguely classical nude within a contemporary scene; Courbet's work, however, has an overtly allegorical function, as its subtitle indicates: "*A Real Allegory of a Seven Year Phase in my Artistic and Moral Life.*" The female nude is clearly defined as an artist's model, and her nakedness is partially veiled by the robe she holds in her hands and by a demure facial expression that is turned away from the viewer and toward the painter at work. For Courbet, the model is merely one figure amidst a group of characters—beggars, wealthy businessmen, and exotic foreigners—that represent the ideas and social themes that he was exploring as an artist. The Realist master also incorporates traditional techniques, including rich, three-dimensional modeling; somber, earthy colors; and fine detail. For nineteenth-century Parisians, the style and content of *L'atelier du peintre* was relatively familiar. By comparison, Manet's later picture seemed to provoke the viewer in disturbing, enigmatic ways.

Though the publicity surrounding *Le déjeuner* was initially critical, Manet's painting would soon become an iconic image for many younger artists. Claude Monet (1840–1926), Pierre-Auguste Renoir

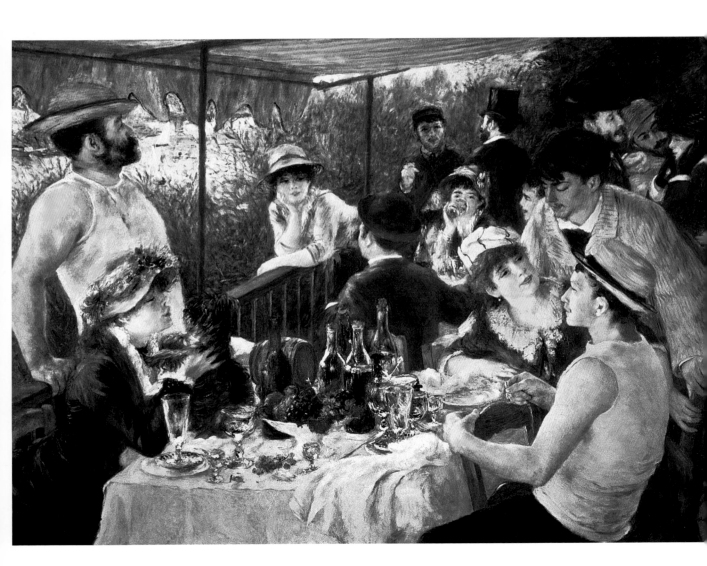

»*The soft hues of the* Boating Party *seem to flood the picture with shimmering light, giving it a sense of lively impermanence.*«

1886: Completion of the Statue of Liberty 1895: Discovery of X-rays MANET 12/13

1889: Completion of the Eiffel Tower

1906: San Francisco earthquake

1886 – 1957: Diego Rivera 1895 – 1965: Dorothea Lange 1904 – 1989: Salvador Dalí

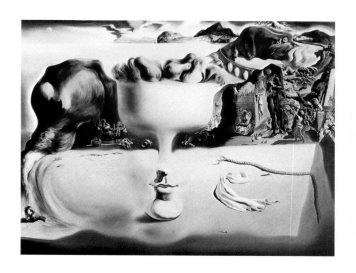

(1841–1919), and Camille Pissarro (1830–1903) would all attend the Salon des Refusés, and their nascent Impressionist movement would find inspiration in Manet—especially in his flattened compositions and in the witty way he incorporated images of Paris's insouciant lifestyle. In *Le déjeuner des canotiers* (Luncheon of the Boating Party) (1880–81), Renoir created his own image of the Parisian leisure class (fig. left) . His characters' informal attitudes and flatly modeled bodies owe much to Manet's earlier work—as does the humorous mixture of formal and casual attire. But Renoir has taken even more liberties with color and brushwork than did his mentor. The soft hues of the *Boating Party* seem to flood the picture with shimmering light, giving it a sense of lively impermanence.

Other aspects of *Le déjeuner* were absorbed by twentieth-century modernists. Manet's bold incongruities, his defiance of easy interpretation, would become hallmarks of Surrealism. One of Salvador Dalí's (1904–89) works, *Apparition of Face and Fruit Dish on a Beach* (1938), incorporates many of *Le déjeuner*'s details—including the fruit and the enigmatic female gaze (fig. above) . And like Manet, the Spanish Surrealist combines classical and contemporary figures within a spatially skewed framework. Dalí's nightmarish distortions touch upon a myriad of twentieth-century themes, from the Spanish Civil War to Freudian psychological torment. But the work's determined ambiguity harkens back to Manet's leafy Parisian luncheon.

left——PIERRE-AUGUSTE RENOIR, LUNCHEON OF THE BOATING PARTY
1880/81 | oil on canvas | 129.9 × 172.7 cm | The Phillips Collection Washington, DC.
above——SALVADOR DALÍ, APPARITION OF FACE AND FRUIT DISH ON A BEACH | 1938 | oil on canvas | 114.8 × 143.8 cm | Wadsworth Atheneum Hartford, Connecticut.

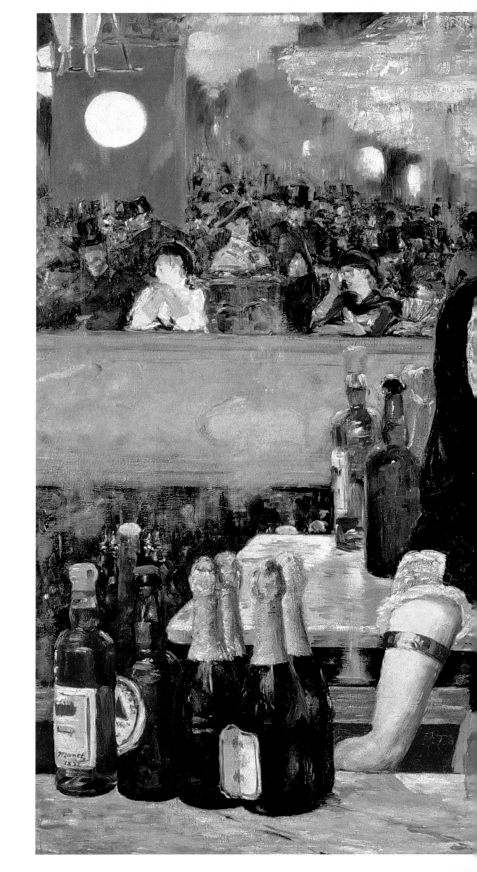

right——ÉDOUARD MANET, BAR IN THE
FOLIES-BERGÈRE | 1882 | oil on canvas
96 × 130 cm | Courtauld Institute | London.

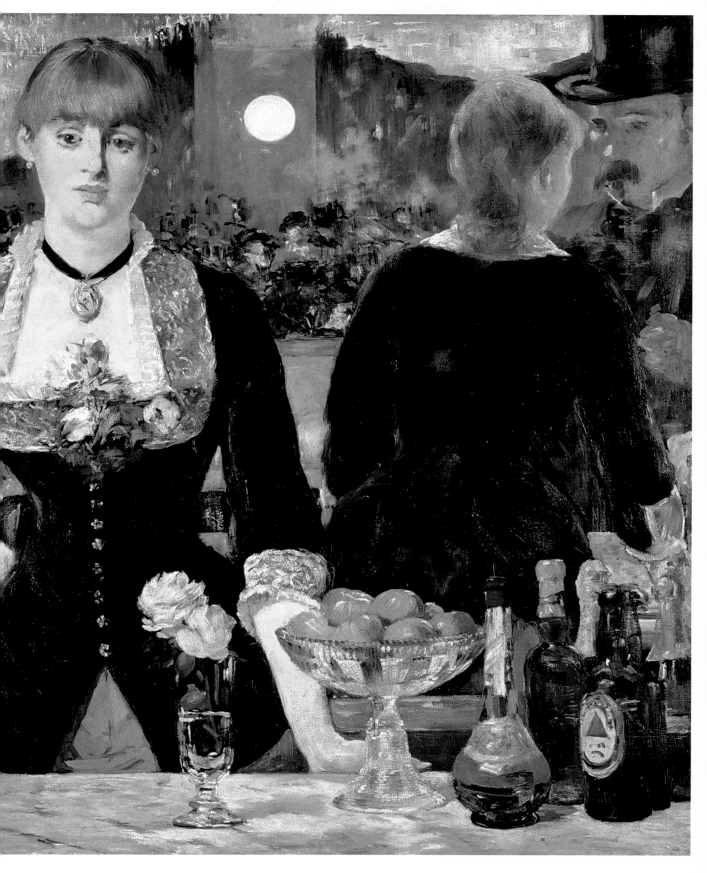

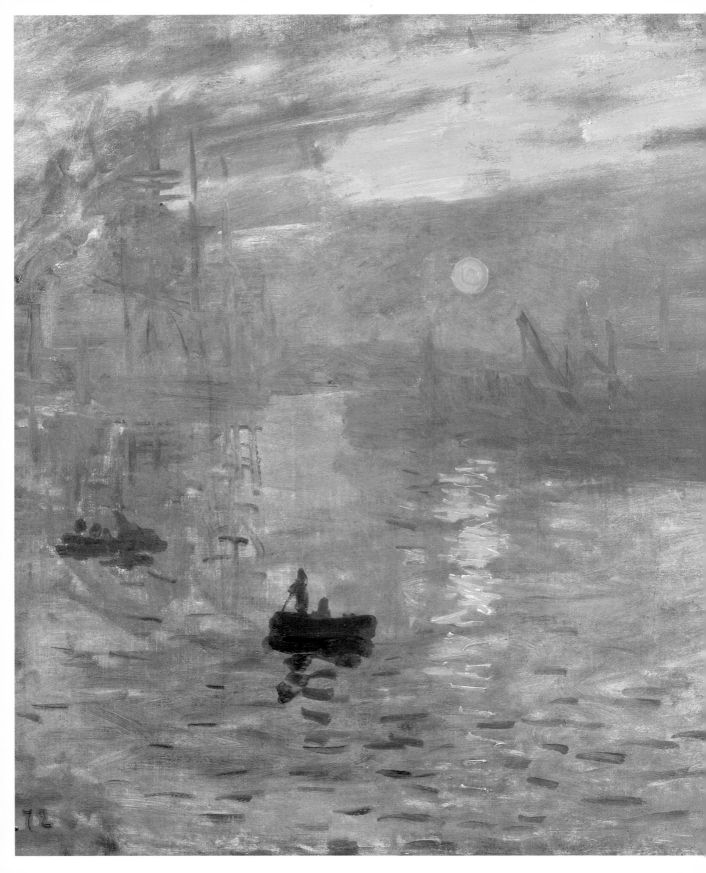

1830 – 1903: Camille Pissarro 1832 – 1883: Édouard Manet 1840 – 1926: Claude Monet

CLAUDE MONET: THE BIRTH OF IMPRESSIONISM

Claude Monet (1840–1926) was only twenty two when he first saw the revolutionary works of Édouard Manet (1832–1883), probably at the Salon de Refusés of 1863. The young painter from Normandy had settled in Paris only a year earlier, but he had quickly become part of an innovative group of art students that also included Pierre-Auguste Renoir (1841–1919), Alfred Sisley (1839–99), and Frédéric Bazille (1841–70). Monet would later describe the profound impression that Manet's works had on him and his friends, calling them a "road to Damascus" —an inspiration toward the development of a new art. Manet's status as a leading cultural rebel of Paris, and his willingness to question the value of traditional academic standards, certainly inspired Monet. But the artistic journeys of the two men would differ considerably. Manet became famous for work that aggressively engaged the viewer, mixing Renaissance and Baroque imagery, modern Parisian life, and distorted compositions. Monet created a quieter, more meditative art that drew upon themes of earlier Romantic and Realist painters. Such artists

probably included the British painter John Constable (1776–1837), who sought to convey feelings and emotions evoked by nature through direct observation. Constable had developed an unusual method of applying paint with sketchy brushstrokes and a rich array of hues. This technique enabled him to capture the play of light on grass, trees, and other natural forms. The result of these efforts was a remarkable series of landscapes that pulsated with energy. Like Constable, Monet would spend a lifetime exploring the subtleties of color and light in nature.

In the ten years following the 1863 Salon des Refusés, the turbulent art world of Paris became progressively diversified and fragmented. Avant-garde artists were gaining prominence, and the conservative Académie des Beaux-Arts was seen as increasingly irrelevant. In 1873, Monet and several of his like-minded contemporaries, including Camille Pissarro (1830–1903), would not even submit artwork to the Académie's official Salon. Instead, at the end of that year, they decided to create an organization called the *Société Anonyme Coopérative des Artistes Peintres, Sculpteurs, Graveurs* (The Cooperative and Anonymous Association of Painters, Sculptors, and Engravers). This new group produced its own exhibitions in its own way, eschewing the Salon's formal juries and prizes. On April 15th, 1874, the *Société Anonyme*'s first exhibition opened to the public; and like the

left——**CLAUDE MONET, IMPRESSION, SOLEIL LEVANT** | detail | 1872
oil on canvas | 48 × 63 cm | Musée Marmottan Monet | Paris.

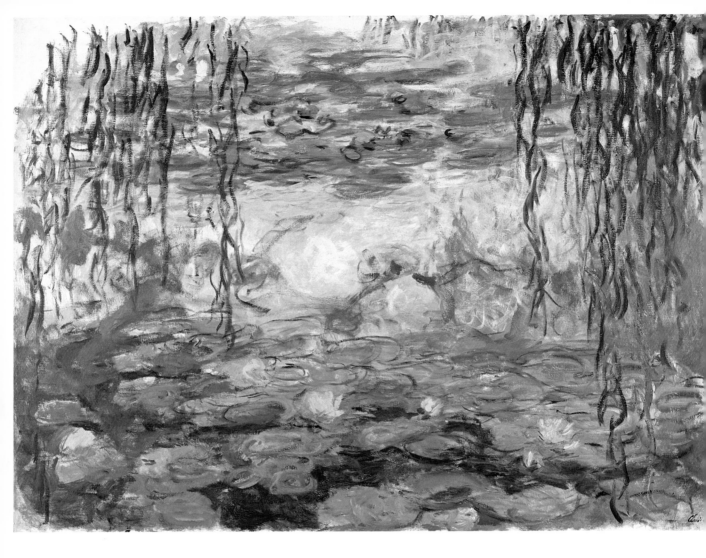

Salon des Refusés, it proved to be surprisingly successful, attracting more than 3,000 visitors and the attention of the city's top art critics.

Among all the works at the exhibition, Monet's *Impression, soleil levant* (Impression, Sunrise) (fig. p. 16, 20/21) made the longest-lasting impact. The painting featured a harbor scene in Le Havre, the small city in Normandy where Monet had been raised. Here the artist revealed the radical techniques that he had been developing since the 1860s. Like a growing number of landscape painters from his generation, Monet did much (and sometimes all) of his work outdoors. Portable paint tubes and easels, both of which had been developed in the mid-nineteenth century, enabled artists to spend more time painting *en plein air*. Monet crafted an image by priming the canvas

and then creating the outlines and structure of the composition through a series of colored slashes. This underpainting is commonly referred to as *ébauche* in French. Monet would then build up the image in layers, using free brushstrokes and the side-by-side placement of contrasting colors and tones. These working methods often gave his art the energy of unfinished sketches. In *Impression, Sunrise*, the blues and grays of the sky and sea were set against the lustrous orange shades of the clouds, the sun, and the sun's reflection on the water. The boats and structures of the harbor were only summarily sketched out, making them appear like floating ghosts in the water. Collectively, these elements gave the image a misty, contemplative character. Monet also used the term "Impression" in the work's title. In later life,

1861-1865: American Civil War

1877: Leo Tolstoy publishes *Anna Karenina*

1883: First petrol-engined automobile 1889: Completion of the Eiffel Tower

MONET **18/19**

1863 – 1935: Paul Signac 1869 – 1954: Henri Matisse 1876 – 1960: Jean Puy

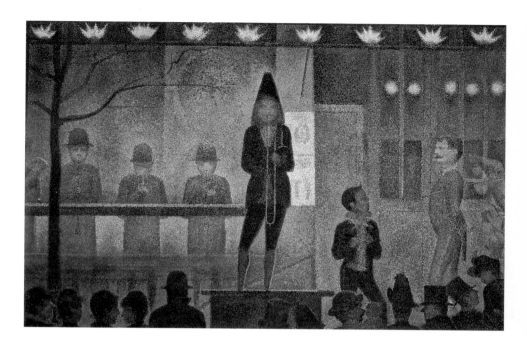

he explained this decision by saying that the image only represented an instantaneous perception of the scene, and "couldn't really be taken for a view of Le Havre."

Many critics who attended the exhibition derided the sketchiness of *Impression, Sunrise*. Louis Leroy of *Le Charivari*, a satirical journal, used Monet's title as the basis for his humorous critique. The piece was entitled "The Exhibition of the Impressionists," and it focused on Monet's Le Havre seascape, declaring the work less polished than ordinary wallpaper. For Leroy and many conservative critics, the *Société Anonyme* was lazily passing off crude, ugly sketches as finished works of art.

But other critics examined the works more sensitively. Theodore Duret, who would become one of Monet's champions, wrote a thoughtful description of the new style in his 1878 pamphlet "The Impressionist Painters," writing:

"The impressionists descend from the naturalistic painters; their fathers are Corot, Courbet, and Manet. ... After the Impressionists had taken from their immediate predecessors in the French school their forthright manner of painting out-of-doors from the first impression with vigorous brushwork ... they set off ... to develop their own originality and to abandon themselves to their personal sensations. The Impressionist sits on the banks of a river; depending on the condition of the sky, the angle of vision, the hour of the day, the calm or agitation of the atmosphere, the water takes on a complete range of tones; without hesitating, he paints on his canvas water which has all these tones."

Duret's words helped to establish Impressionism as a major force in the Paris art world. By the 1880s, painters with widely differing styles would accept the Impressionist label. Edgar Degas' (1834–1917) "Impressionism," for example, differed markedly from that of Monet and Renoir. Degas focused on

left——CLAUDE MONET, WATER LILIES | 1916-19 | oil on canvas 150 × 197 cm | Musée Marmottan | Paris.

above——GEORGES SEURAT, CIRCUS SIDESHOW | 1887/88 | oil on canvas | 99.7 × 149.9 cm | Metropolitan Museum of Art | New York.

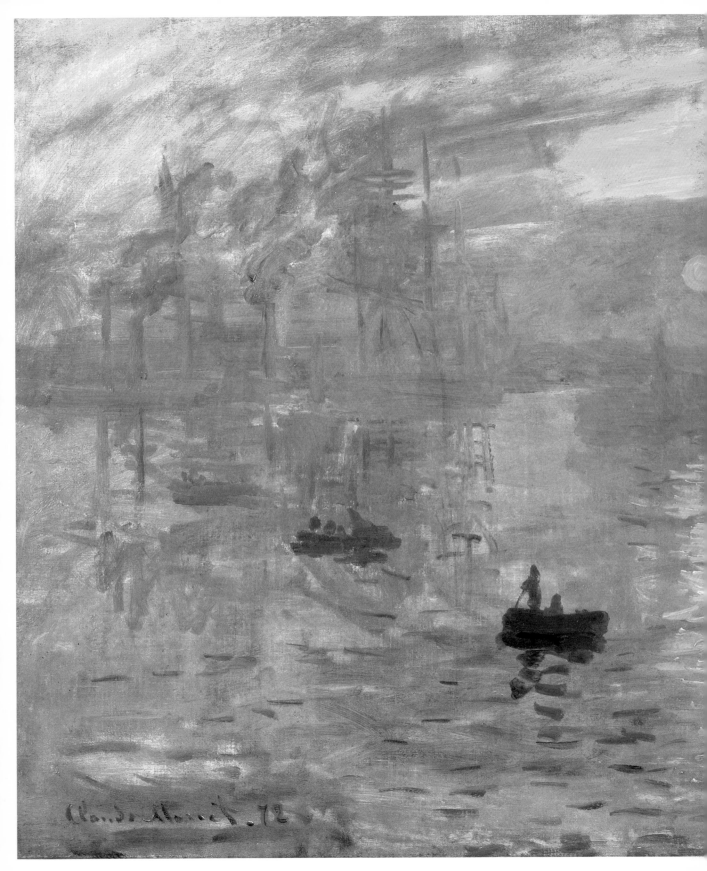

left——CLAUDE MONET, IMPRESSION, SOLEIL
LEVANT | 1872 | oil on canvas | 48 × 63 cm | Musée
Marmottan Monet | Paris.

1896: First modern Olympic Games

1909: Opening of Queensboro Bridge in New York

1914-1918: First World War

1919: Formation of the Bauhaus school

MONET 22/23

1898 – 1976: Alexander Calder 1910 – 1962: Franz Kline 1917 – 2004: Milton Resnick

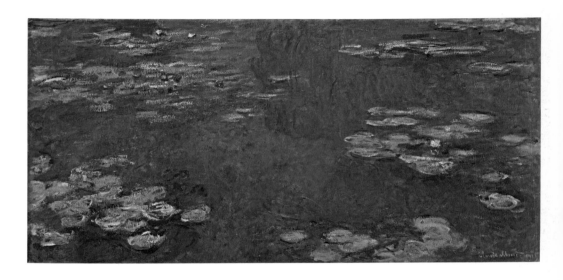

elegant draftsmanship and often jarring compositions to depict cafés, ballet theaters, and other aspects of urban culture. Other painters went through Impressionist phases before developing their own "Post-Impressionist" art. Two such artists, Georges Seurat (1859–1891) and Paul Signac (1863–1935), rejected Monet's sketchy brushwork for a more systematic method of applying color to canvas. Their "Pointillist" (or "Divisionist") technique built images out of mosaics of colored dots or blotches. Works such as Seurat's *Circus Sideshow* (1887–8) (fig. p. 19) possessed an austere geometric clarity distinct from "classic" Impressionism.

Monet's own art became more distinctive as he grew older. By the early 1900s, the painter had become wealthy and politically influential. Prime Minister Georges Clemenceau was a close friend and admirer, and he helped win for Monet a commission to decorate specially constructed rooms in Paris's Musée de l'Orangerie. The huge paintings he created for this project, which he called the *Grandes Décorations*, represented a culmination of his life's work. They featured the sensuous lily ponds of his rural estate at Giverny, 50 miles (80 kilometers) northwest of Paris. Each image contained multiple canvases that extended horizontally around the museum's curving walls. Monet's technique had become gradually more abstract—partially in response to failing eyesight —and his Giverny landscapes seemed to dissolve into a watery mixture of deep blue and green textures. Monet's late images influenced the work of many abstract artists during the 1950s and 1960s: painters who explored ways in which color alone could become the focus of art. Milton Resnick (1917–2004), for example, often worked on large canvases, creating vast fields of color enlivened by energetic brushstrokes. In one such work, *Wedding* (1962) (fig. left), the blue-green hues create a shimmering surface that clearly evokes Monet's lily ponds.

Today, the "unfinished" images of Claude Monet have become among the most desirable paintings in the world. Museums, including the Art Institute in Chicago, have built their entire collections around Impressionist works. In 2008, one of Monet's water lily paintings, *Le Bassin Aux Nymphéas*, sold in London for more than £40 million ($80 million) (fig. above).

left——MILTON RESNICK, WEDDING | 1962 | oil on canvas
276.2 × 260.7 cm | The Metropolitan Museum of Art | New York.

above——CLAUDE MONET, LE BASSIN AUX NYMPHÉAS | 1919
oil on canvas | 100.4 × 201 cm | Private collection.

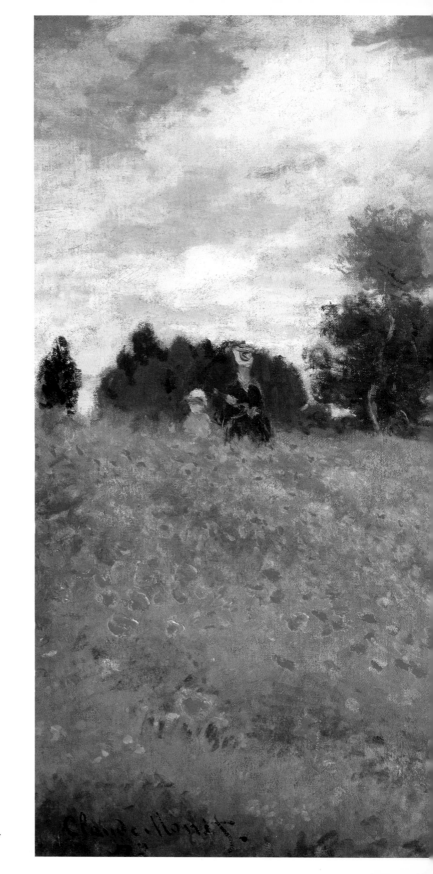

right——CLAUDE MONET, FIELD NEAR ARGENTEUIL

1873 | oil on canvas | 50 × 65 cm | Musée d'Orsay | Paris.

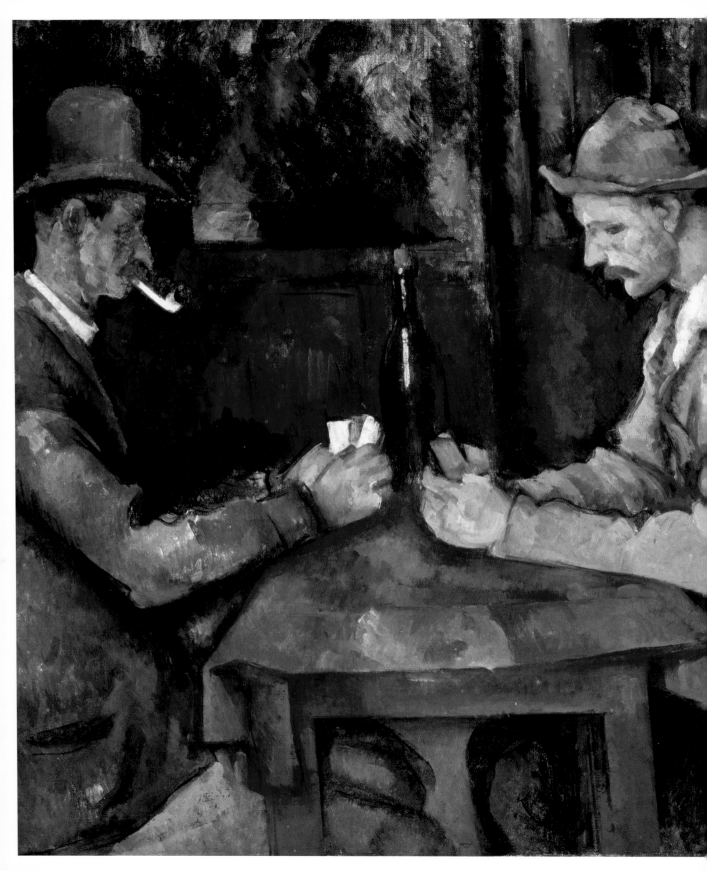

·········· **1826:** First photographs ···················· **1832:** Hambach Festival ··············
1827: Death of Beethoven···········
··········· **1831:** Nat Turner's slave rebellion in Virginia ·············

26/27

1830 – 1903: Camille Pissarro 1839 – 1906: Paul Cézanne 1840 – 1926: Claude Monet 1841 – 1919: Auguste Renoir

PAUL CÉZANNE: THE ARTISTIC PROCESS

Paul Cézanne (1839–1906) was a contemporary of Claude Monet (1840–1926) and the Impressionists. Like them, he spent many years in Paris developing his art; and he formed important friendships with Camille Pissarro (1830–1903) and Auguste Renoir (1841–1919). But Cézanne was a loner by temperament, and he devised an idiosyncratic method of painting that differed dramatically from Impressionism. Many Impressionist artists sought to use color and light to capture the transience of nature: the fleeting moments that are often missed or forgotten. And while Cézanne learned much from Pissarro, his art became more about solidity and permanence; exploring and reimagining the structure of natural forms and shapes.

When Cézanne first arrived in Paris in 1861, he was one of the few progressive artists from the remote southern region of Provence. He had grown up in Aix-en-Provence, the son of a prosperous banker. His family wealth enabled him to practice art with fewer financial pressures than those plaguing most Impressionists. However, Cézanne never much cared

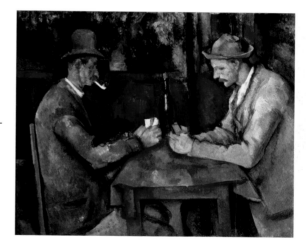

for Paris's hectic, competitive city life; and he would eventually spend his later career working in relative isolation back in Aix. During the 1860s, however, Cézanne was forced to overcome his natural shyness. His friendship with Pissarro inspired changes in his working method and choice of subject matter. Many of Cézanne's earliest pictures focused on small-scale portraits and still lifes, often using a dark palette with heavy, sweeping brush strokes. But during painting trips with Pissarro in the early 1870s—mostly to the

left—**PAUL CÉZANNE, THE CARD PLAYERS** | detail.
right—**PAUL CÉZANNE, THE CARD PLAYERS** | 1894/95
oil on canvas | 47.5 × 57 cm | Musée d'Orsay | Paris.

28/29 CÉZANNE

1848: Revolutions in Europe

1853-1856: Crimean War

1857-1859: First world economic crisis

1861-1865: American Civil War

1853 – 1890: Vincent van Gogh

1859 – 1891: Georges Seurat

1863 – 1935: Paul Signac

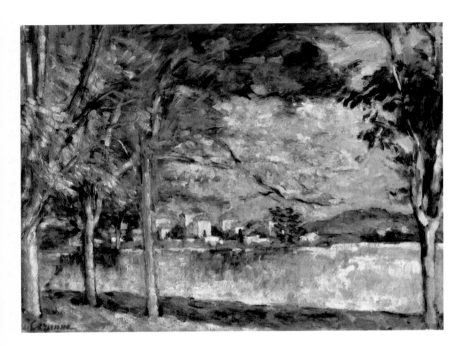

rural cities of Pontoise and Auvers, just outside of Paris—Cézanne began to experiment with Pissarro's favorite theme, the landscape.

The landscapes Cézanne created at this time reveal important changes in his style and working method. The somber coloring of his earlier work was replaced with a lighter, more complex palette. This change was influenced in part by Pissarro's own imagery, but it also reflected the fact that Cézanne was working more and more from nature—trying to reflect as accurately as possible the colors and forms that his eye perceived. Cézanne also abandoned his heavy brushwork for a method that would become his trademark—building up a composition from small, patch-like strokes of color. He had always been a deliberate craftsman, but he now developed a working method involving remarkable thoroughness and careful observation. For him, each individual brushstroke had to be carefully considered before being placed on the canvas, in order to construct the perfect blend of colors and shapes. Such efforts also involved long, intense study of the subject being painted, and they produced such early landscape masterpieces as *View of Auvers-sur-Oise—The Fence* (c. 1873) and *The Road* (1875–6) (fig. above). Soon the

artist would apply his new method to a variety of subjects, including still lifes and portraits. Cézanne's still lifes remain among the most famous in modern art. Often featuring his characteristic apples, these images achieve a remarkable aesthetic balance. Cézanne's strong, precise brushwork rendered the fruits and bowls with geometric precision. Yet the artist's sensual use of color, his subtle combinations of green, red, yellow, and orange hues, gave the fruits a palpable, organic solidity.

Thoroughout the 1870s and 1880s, Cézanne would continue to explore—carefully, almost painfully—the delicate balance between the abstract and the palpable elements of nature. He presented his works at several early Impressionist exhibitions in Paris, including the first show in 1874. But Cézanne's artistic temperament increasingly led him back to the solitude of Provence. In 1881, his brother-in-law Maxime Conil purchased land in the small medieval town of Gardenne, near Aix. His house overlooked the dramatic Mont Sainte-Victoire, in the Pic de Mouches mountain range. Cézanne was immediately captivated by this rocky peak, which the Mediterranean sunlight cloaked in an ever-changing array of colors. It provided him with the perfect subject

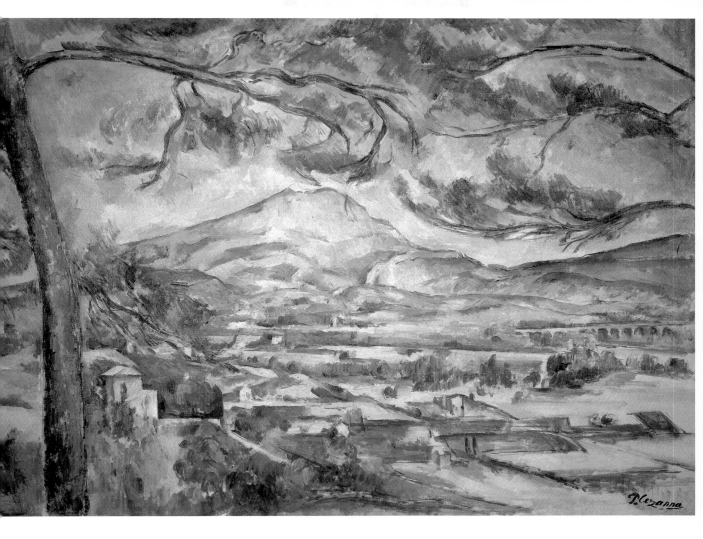

through which to develop his examination of form and color. Cézanne would produce numerous views of the region over the next 25 years.

One of these views, now at the Courtauld Institute of Art in London, was painted from 1885 to 1887 (fig. above). It expresses many of the most celebrated qualities of Cézanne's art. The mountain scene appears, in part, to be fracturing into well-defined geometric shapes: the cube-shaped farmhouses, the sharp angles of the cultivated fields, and the triangular and conic forms of the mountain. Yet, as with his

still lifes, Cézanne also uses a rich palette to animate his composition's individual forms. Mont Sainte-Victoire itself, with its soft blues, violets, and reds, evokes a slumbering giant from Gallic folklore.

As the nineteenth century closed, Cézanne developed diabetes and traveled less and less frequently from Aix. In 1901, he purchased on old olive grove and built his final working studio, where he would paint until his death five years later. In his final landscapes, including those of Mont Sainte-Victoire, compositional elements often become reduced to abstract, integrated blocks of color. The strikingly fractured nature of such works was often enhanced by large sections of unpainted canvas. In the last image of Mont Sainte-Victoire, farmland and trees have metamorphosed into a sea of green, blue, and ocher shapes, with the jagged peak floating above its surface. Cézanne, in a letter to his friend, the art

left—**Paul Cézanne, The Road** | 1875/76 | oil on canvas | 50 × 56 cm
Auckland Art Gallery | Auckland, New Zealand.

above—**Paul Cézanne, View of Mont Sainte-Victoire** | 1885–87
oil on canvas | 67 × 92 cm | Courtauld Institute of Art | London.

right——**PAUL CÉZANNE, STILL LIFE WITH CURTAIN** | c. 1899 | oil on canvas 54.7 × 74 cm | Hermitage Museum St. Petersburg.

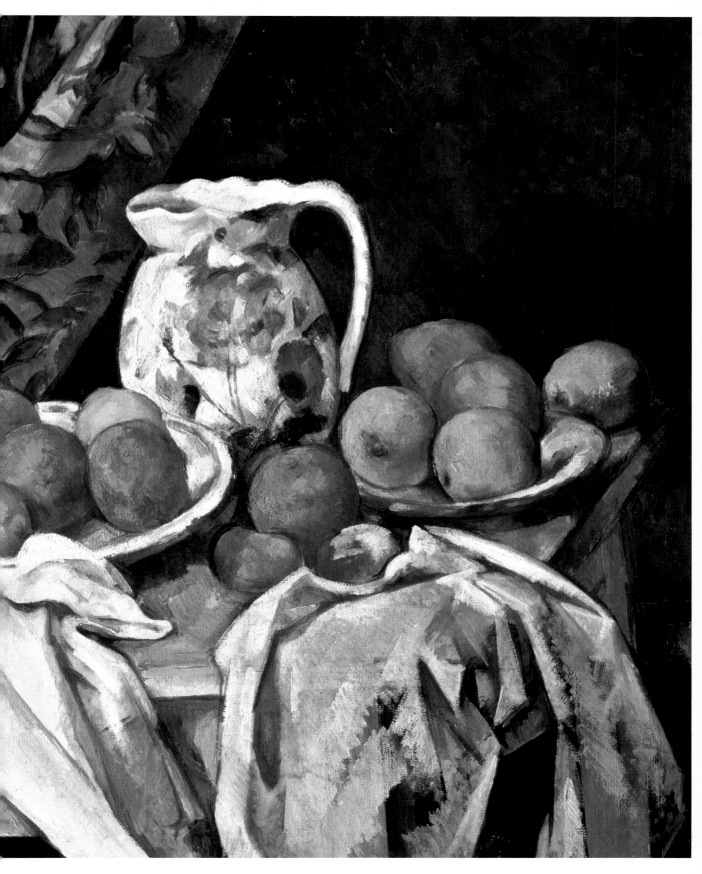

»*Léger has taken Cézanne's abstractions a step farther, so that the viewer must now mentally reconstitute the shapes in order to perceive the artist's original inspiration.*«

critic Emile Bernard, referred to these later works when he wrote, "Now old as I am, nearly 70,—color sensations, which make light in my painting, create abstractions that keep me from covering my canvas or defining the edges of objects where they delicately touch other objects, with the result that my image or picture is incomplete."

Cézanne's introspective character, and the often arresting "incompleteness" of his art, prevented him from achieving much commercial success during his lifetime. The first extensive showing of his works was organized by the famous art dealer Amboise Vollard in 1895, only a decade before the artist's death. Gradually, a number of younger artists were inspired by Cézanne's profound innovations and the stories of his exhaustive technique. The young Pablo Picasso (1881–1973) began purchasing lithographs of Cézanne's work as early as 1905. He would also view Cézanne's *Large Bathers* (1906), a vaguely mythological scene in which the female bathers, trees, and landscape form a dramatic triangular composition. In 1907, Picasso would use this work as a basis for his *Les Demoiselles d'Avignon*, the first great Cubist painting and a seminal work of modern art. Later that year, a retrospective of Cézanne's work—consisting of 56 paintings and a variety of watercolors—was held in Paris. Many of the artists who saw the exhibit, including Picasso, Georges Braque (1882–1963), and Fernand Léger, would later credit Cézanne with being the true forefather of Cubism. Like Cézanne, the Cubists transformed nature into building blocks of geometric color.

In his later years, Léger wrote "Cézanne allowed me to find my way in a more conscious manner ... for two years I manipulated shapes. I built, I was the most scrupulous brick layer. ... Slowly, color reappeared, blended, shy, calculated, as in Cézanne, by whom I was influenced." Léger's Cézanne-like focus on restructured space can be seen in many of his works. In *The Bargeman* (1918) (fig. right) , a coastal landscape has been shattered into a jumble of cones, cylinders, and diagonal shapes. Léger has taken Cézanne's abstractions a step farther, so that the viewer must now mentally reconstitute the shapes in order to perceive the artist's original inspiration. In *The Card Players* (1917), Léger performs the same deconstructive process on one of his mentor's iconic motifs (fig. pp. 34/35) . Cézanne's original series of works entitled *The Card Players*, painted in the 1890s, focuses attention away from the pictures' dramatic content and toward the artist's remarkable integration of forms. In Léger's later work, Cézanne's arms, heads, and cards have become completely dismembered in a labyrinthine jungle. Yet Léger's basic goal remains the same as that of the older master—he invites the viewer to focus his attention on technique, on the process of making art. Process has remained a dominant concern of modern art ever since, from the "drip" paintings of Jackson Pollock (1912–56) to the kaleidoscopic light experiments of twenty-first century installation artist Olafur Eliasson (b. 1967).

right——**FERNAND LÉGER, THE BARGEMAN** | 1918 | oil on canvas 48.6 × 54.3 cm | The Metropolitan Museum of Art | New York.

next double page spread——**FERNAND LÉGER, THE CARD PLAYERS** | 1917 oil on canvas | 129 × 193 cm | Rijksmuseum Kröller-Müller | Otterlo.

1897: Opening of the giant wheel in the Viennese Prater ⋯⋯⋯⋯⋯⋯⋯ **1905:** Formation of the expressionist group Die Brücke ⋯⋯⋯⋯⋯ CÉZANNE **32/33**

1903: First powered flight by the Wright brothers ⋯⋯⋯⋯⋯⋯⋯⋯⋯

⋯ **1889:** Completion of the Eiffel Tower ⋯⋯⋯⋯⋯⋯⋯⋯⋯

1893 – 1983: Joan Miró **1898 – 1967: René Magritte** **1903 – 1970: Mark Rothko**

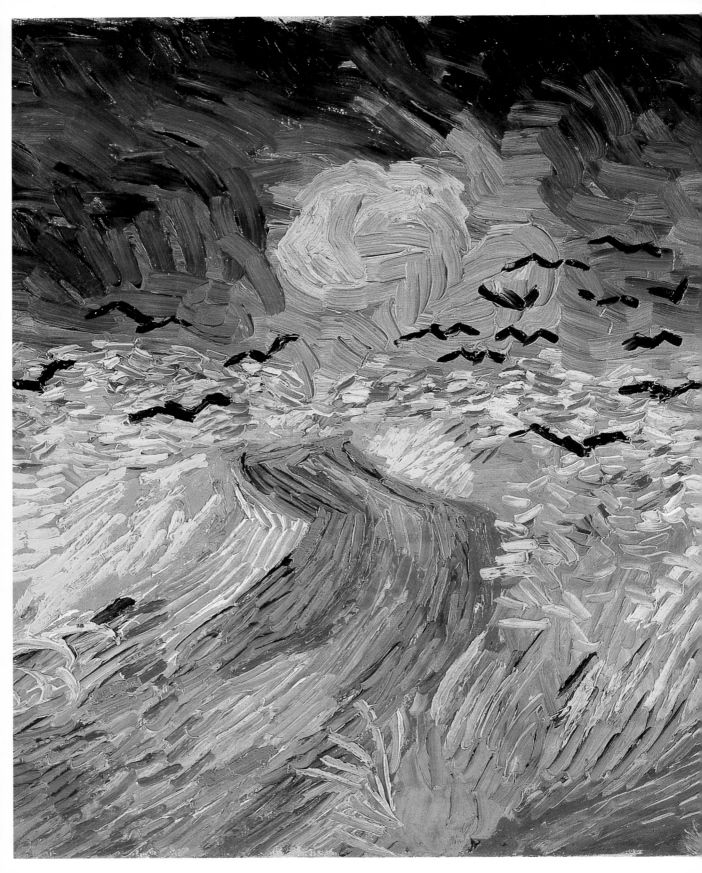

VINCENT VAN GOGH: *WHEATFIELD WITH CROWS*

For generations of art enthusiasts, Vincent van Gogh (1853–90) has been the archetypal modern painter. Little known during his lifetime, he led an often lonely and painful existence, spurned by lovers and colleagues and plagued with bouts of mental illness. Stories of van Gogh cutting off his ear, spending time in a mental hospital, and eventually taking his own life helped redefine the artist as a misunderstood genius; a neglected visionary who had to sacrifice himself to achieve his rightful fame. Yet the personal story of van Gogh often unfairly overshadows the true importance of his work, and the influence that that work had on modern art.

Among all the major nineteenth-century artists, van Gogh left us one of the most extensive collections of personal writings, largely in the form of letters to his brother Theo and his artist friend Émile Bernard. These writings provide invaluable evidence of his aesthetic goals and thought processes. Van Gogh was born in the small town of Zundert (then Groot-Zundert), in the southern part of the Netherlands. The son of a minister, he spent his life wrestling with

his faith. After conscientious but failed attempts at missionary work, Vincent accepted the advice of his brother Theo to study art in Brussels in 1881. Van Gogh had shown a talent for drawing in childhood, and he now immersed himself in the practice of art with focused intensity. His style evolved dramatically over the 1880s, as he became increasingly removed from the culture of his birth. His aesthetic pilgrimage began in rural Holland, took him to the cosmopolitan centers of Antwerp and Paris, and ended in the "exotic" sunlit land of Provence. In each new location, the change in environment inspired transformations in van Gogh's art. During his years in Holland and Antwerp, he captured local peasant life using dark, earthy colors and expressive draftsmanship. Such pictures reflected the region's dank northern climate. Their style was also indebted to the realist works of French painter Jean-François Millet (1814–75), a master portraitist of rural culture from the mid-1800s, whose peasants "look as if they were painted with the earth they were sowing." When he arrived in Paris, van Gogh met and worked with other young artists, including Henri de Toulouse-Lautrec (1864–1901) and Émile Bernard (1868–1941). Van Gogh's palette lightened considerably, and he experimented with the Pointillist technique of Georges Seurat (1859–91) and Paul Signac (1863–1935)—capturing views of the Seine, the

left——**VINCENT VAN GOGH, WHEATFIELD WITH CROWS** | detail | 1890
oil on canvas | 50.2 × 103 cm | Van Gogh Museum | Amsterdam.

1873: Jules Verne publishes *Around the World in Eighty Days* ··········**1876:** Battle of the Little Bighorn··········
1876: Invention of the telephone ··········
1877: Leo Tolstoy publishes *Anna Karenina*··········

1866 – 1944: Wassily Kandinsky **1871 – 1958: Giacomo Balla** **1876 – 1960: Jean Puy**

bohemian artist colony at Montmartre, and the city's luminous parks and cafés (fig. above) . He also began incorporating elements of the Japanese printmaker's art: its cropped, flattened spaces and its luxurious use of color. But it was not until his final move to Arles, in 1888, that van Gogh's style fully matured. For an artist who had spent most of his life in restrictive northern climates, Mediterranean Provence was a revelation. A few months after arriving in Arles, van Gogh wrote to Émile Bernard:
"The countryside here seems to me to be as beautiful as Japan in terms of the limpidity of the atmosphere and the brightness of the colors. Water makes patches of fine emerald green and rich blue in the landscape, such as we see in Japanese prints. There are pale orange sunsets that bring out the blue of the soil. And the sun is a splendid yellow. And I have still to see the area in its customary summer splendor."
The Provençal "atmosphere" had a profound effect on van Gogh's work. His pictures began to combine the "Japanese" compositions of his Paris years with a strikingly bright, intense color palette. These colors were made even more vivid by van Gogh's increasingly thick, energetic brush strokes. The surface of his canvases came to have an almost sculptural quality, which contrasted with the flatness of the overall image. The artist was looking for ways of "purposely exaggerating" nature and technique for expressive ends.
Van Gogh's subjects at this time are well known to even casual observers of art: his vividly tragic self-portraits (both with and without his right ear); his harshly luminous *Night Café*; and his barren interiors with their lonely chairs. But perhaps his most influential series of images features the wheatfields of Provence. They represent van Gogh's most daring experiments with technique, and their swirling forms embody his personal struggles to a remarkable

above——**Vincent van Gogh, A Suburb of Paris with a Man Carrying a Spade** | 1887 | oil on canvas | 48 × 73 cm | Private collection.
right——**Vincent van Gogh, Wheatfield with Crows** | 1890 oil on canvas | 50.2 × 103 cm | Van Gogh Museum | Amsterdam.

1883: First petrol-engined automobile ································ 1887: First Sherlock Holmes novel is published ················ VAN GOGH 38/39

1884: Mark Twain publishes the *Adventures of Huckleberry Finn* ······················

1889: Completion of the Eiffel Tower ······················

1880 – 1938: Ernst Ludwig Kirchner 1884 – 1950: Max Beckmann 1890 – 1918: Egon Schiele

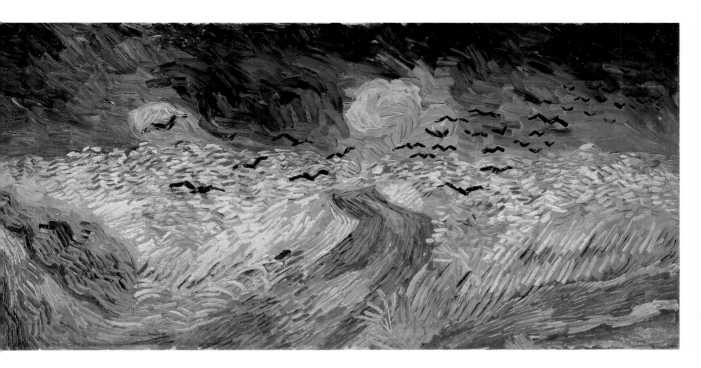

degree. The image of the wheatfield has strong Biblical connotations, and it may well have reminded van Gogh of his struggles with the Christian faith. It also gave him a format in which to express his painful, often contradictory feelings during his last months of life in 1890, when a series of mental breakdowns forced him to move to be near his physician in the town of Auvers-sur-Oise.

The best-known of van Gogh's wheatfield images was later titled *Wheatfield with Crows* (fig. above). In it, he used a technique that he had adopted only recently, that of combining two standard-sized canvases into one large, horizontal space measuring 50 x 500 cm (19.6 x 196 in.). This "double-square canvas" enabled him to capture the spreading vastness of the wheatfield.

During his years in Provence, Van Gogh's art had become more radiantly abstract. His brushwork and coloring had acquired an intense, almost savage power. In *Wheatfield with Crows*, the wheat stalks are rendered as thick, turbulent slashes of yellow. Cutting through the field, a river-like pathway of undulating greens and reds winds almost endlessly toward the horizon. Above, a swirling blue sky contains two ominous, circular white clouds, the eyes of an omnipotent demon. And flying across the scene are a flock of abstract black crows. Though their bodies contain only a few jagged lines, van Gogh brilliantly captures the manic energy of their flight. Van Gogh was probably referring to *Wheatfield with Crows* and two other works in a letter to Theo in July 1890, when he wrote:

"So—once back here I set to work again—though the brush was almost slipping from my fingers, but I knew what I wanted to do, and I've painted three more large canvases since then. They are of vast expanses of wheat under stormy skies, and I had little trouble in conveying the sense of sadness and extreme solitude. ... I somehow believe that these canvases will tell you what I can't put into words, what I find healthy and invigorating about the countryside."

These words suggest the complexities of van Gogh's mental state, and his desire to express contradictory

right——VINCENT VAN GOGH, STARRY NIGHT (CYPRESSES AND
VILLAGE) | 1889 | oil on canvas | 73.7 × 92.1 cm | Museum of Modern Art
New York.

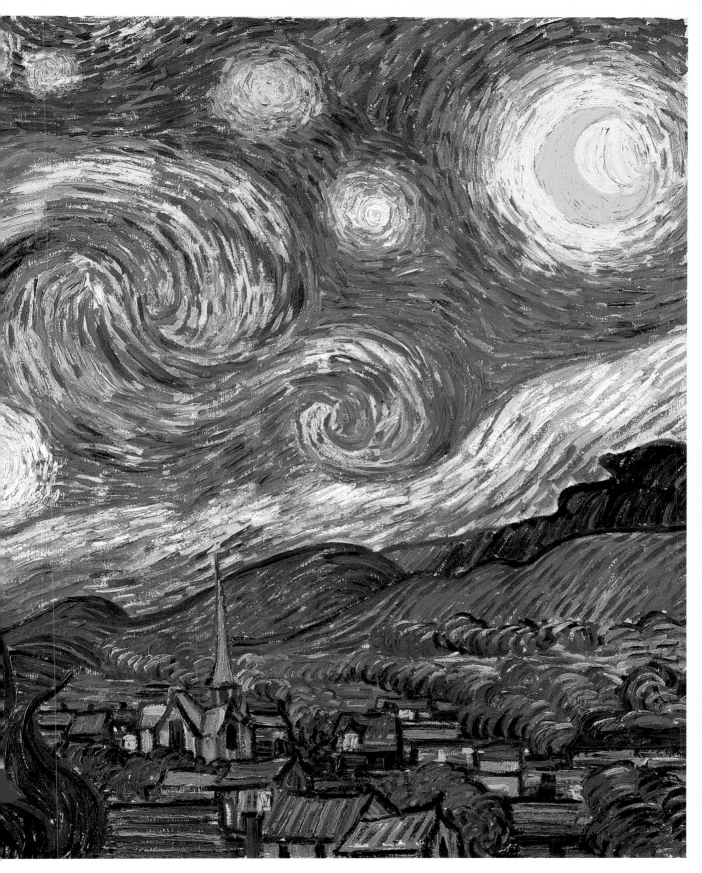

1896: First modern Olympic Games ············ 1903: First powered flight by the Wright brothers ············ VAN GOGH 42/43

1900: Sigmund Freud publishes *The Interpretation of Dreams* ············ 1906: San Francisco earthquake ············

1898 – 1986: Henry Moore 1901 – 1985: Jean Dubuffet 1904 – 1997: Willem de Kooning

>>*Like van Gogh, Schiele transforms his landscape into a living, and vaguely ominous, organism.*«

feelings in his work—both the sadness of his current condition and the desire for health and vigor that he felt the countryside could bring him. Even after experiencing several mental breakdowns and epileptic fits, van Gogh could still think and paint with great lucidity. His health, however, would never be fully restored, and he killed himself at the end of that month.

The expressive power of van Gogh's late works, especially *Wheatfield with Crows*, inspired several generations of artists. The Expressionist movement of the succeeding decades—beginning with *The Scream* (1893) (fig. p. 44) by Norwegian artist Edvard Munch (1863–1944)— owed much to van Gogh's example. Ernst Ludwig Kirchner (1880–1938), Egon Schiele (1890–1918) and other early Expressionists all explored ways of using dramatic color, brushwork, and composition to express human emotion. Schiele, an Austrian artist, also became famous for his tragically short life. In his painting *Landscape with Ravens* (1911), a title that possibly references van Gogh's earlier work, we see the same preoccupation with abstracting natural forms and colors for expressive

purposes (fig. left) . Here a cabin is perched precariously on a darkly amorphous hill, while a taller hill in the background seems to be lurching upward, devouring the wispy white clouds and tiny ravens. Like van Gogh, Schiele transforms his landscape into a living, and vaguely ominous, organism.

During the Abstract Expressionist period of the 1950s, artists like Willem de Kooning (1904–97) carried some of van Gogh's techniques even further. In his *Woman*, I (1950–52), for example, de Kooning takes the notion of expressive draftsmanship and color to a violent extreme (fig. p. 45) . His female figure seems to emerge out of a primordial stew of aggressively applied brushstrokes and glaring hues. Her hideous facial features and hulking body suggest the "brutality" of mid-century life—from the savagery of World War II to the more subtle violence inflicted by mass-media commercialism. Yet it also reflects the spirit of van Gogh, and his ability to reveal emotional landscapes.

left——EGON SCHIELE, LANDSCAPE WITH RAVENS | 1911
oil on canvas | 89 × 95.8 cm | Leopold Museum | Vienna.

left——**EDVARD MUNCH, THE SCREAM** | 1893 | oil, tempera and chalk
91 × 74 cm | Nationalgalerie | Oslo.
right——**WILLEM DE KOONING, WOMAN, I** | 1950–52 | oil on canvas
192.7 × 147.3 cm | Museum of Modern Art | New York.

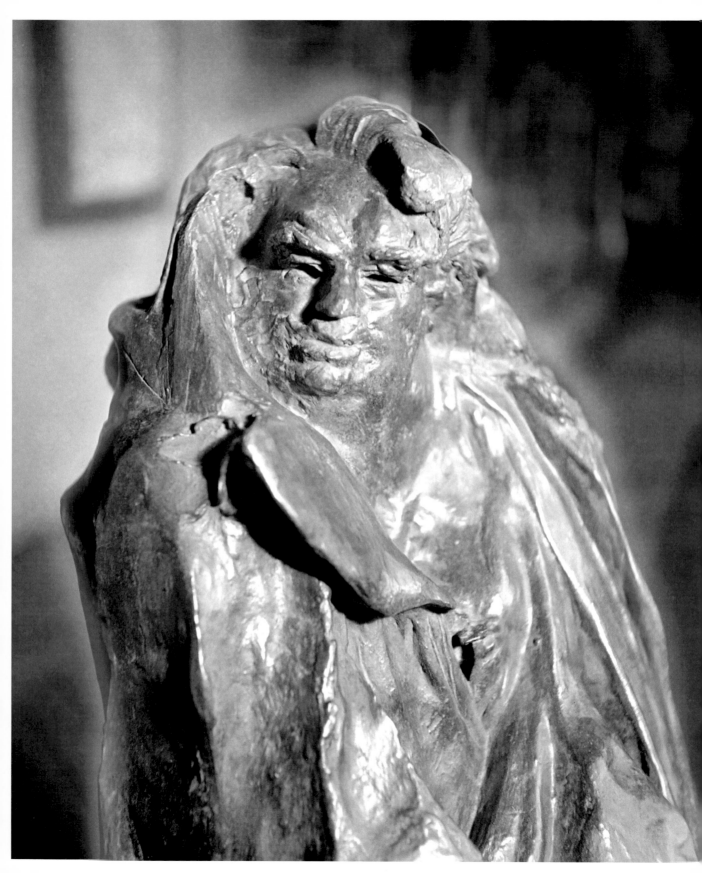

1826: First photographs .. 1831: Nat Turner's slave rebellion in Virginia ...

1827: Death of Beethoven .. 1832: Hambach Festival

46/47

1823 – 1889: Alexandre Cabanel 1830 – 1903: Camille Pissarro 1832 – 1883: Édouard Manet

AUGUSTE RODIN: *BALZAC*

On July 6, 1891, the French *Sociéte des gens de lettres* (*Society of Men of Letters*) organized a meeting of its committee. The Sociéte was one of the first organizations dedicated to protecting authors' rights, and it had recently commissioned a monumental sculpture of Honoré de Balzac, the great nineteenth-century novelist who was both a founding member of the group and its second president. However, the artist who had won the commission, Henri Chapu, had died earlier in the year, and another prominent artist was needed to take his place. After a fairly brief debate, the committee voted 12 to 8 to select Auguste Rodin as Chapu's replacement.

Rodin (1840–1917) had become one of the most influential and newsworthy artists in Paris. The son of working-class parents, he had only recently overcome a decades-long struggle to establish himself as an independent sculptor. Rodin had been rejected by the Académie des Beaux-Arts in the late 1850s, forcing the young man to make his living as an employee of other artists, most notably the decorative sculptor Albert-Ernest Carrier-Belleuse (1851–1932).

He later spent much of the 1870s studying and honing his craft outside of France. On a trip to Florence in 1875, Rodin enthusuastically absorbed the great Renaissance carvings of Michelangelo. By 1880, he had established a practice of sufficient renown to attract a major commission from the French government. This work, a doorway for a planned museum of decorative arts, would occupy Rodin for most of his life, eventually resulting in his monumental *Gates of Hell*. The commission also gave him lifelong access to a coveted studio in Paris.

Rodin's mature work differed from that of other nineteenth-century artists. The fashionable sculpture of the day tended to feature classically polished mythological scenes or elegant, finely detailed portrait busts in the manner of eighteenth-century Rococo art. Rodin tried his hand in all of these styles, but he preferred to create work that explored profound human emotions. In the *Age of Bronze* (1875–77) (fig. p. 48) , a Michelangelesque male nude is shown in passionate contemplation, his left arm raised over his head to highlight the figure's psychological turmoil. In another bronze work, *The Burghers of Calais* (1884–89), Rodin created a monument to thoughtful sacrifice (fig. p. 49). During the Hundred Years' War (1337–1453) between England and France, six citizens of Calais had agreed to relinquish their lives so that the rest of the population would be

left——AUGUSTE RODIN, BALZAC (DETAIL OF HEAD) | 1891 | bronze
Musée Rodin | Paris.

1848: Revolutions in Europe⋯⋯⋯⋯⋯⋯⋯⋯⋯⋯⋯⋯ **1849:** Death of Chopin⋯⋯⋯⋯⋯⋯⋯⋯⋯⋯⋯⋯
1848: Marx and Engels publish *The Communist Manifesto*⋯⋯⋯⋯⋯⋯⋯⋯⋯⋯⋯⋯⋯⋯⋯⋯⋯
1853-1856: Crimean War⋯⋯⋯⋯⋯⋯

1840 – 1917: Auguste Rodin 1840 – 1926: Claude Monet 1848 – 1894: Gustave Caillebotte

introspective quality; avoiding the simplistic heroism of most civic monuments. Both the *Age of Bronze* and *The Burghers of Calais* inspired intense debate, with the sculptor winning support among many influential critics.

One of these supporters, Émile Zola, was president of the *Sociéte des gens de lettres*, and he played a significant role in getting Rodin the commission for *Balzac* (fig. p. 46). The *Sociéte* awarded Rodin 10,000 francs, requesting that the sculptor complete his work within 18 months. Rodin, however, actually took more than seven years to finish the piece that would become his masterwork. He saw in Balzac an artistic personality much like himself. Both the sculptor and the writer were slow, painstaking craftsmen, and both were keen observers of human character. Balzac's great multi-volume work, *La comédie humaine* (The Human Comedy), brilliantly captured French society between the end of the Napoleonic Wars and the Revolution of 1848. His richly detailed characters often had to struggle against social and

spared. Rodin based these figures on living models, and he spent countless hours working on preparatory clay studies. Each individual was crafted with rough, exaggerated modeling, especially of their rippling, bony faces. Rodin used both facial expression and posture to capture a dramatic variety of mental states—from resignation to anguish. His arrangement of the figures was also complex, offering changing perspectives as the viewer moved around the monument. All of these elements gave the work a pensive,

left——**AUGUSTE RODIN, AGE OF BRONZE** | 1875-77 | bronze | H. 182.9 cm Alte Nationalgalerie | Berlin.

right——**AUGUSTE RODIN, THE BURGHERS OF CALAIS** | 1889 | plaster 231.5 × 248 × 200 cm | Musée Rodin | Paris.

1857-1859: First world economic crisis ⋯⋯⋯⋯⋯⋯⋯⋯⋯⋯⋯⋯⋯⋯⋯⋯⋯⋯⋯⋯ **1867:** Karl Marx publishes *Das Kapital* ⋯⋯⋯⋯⋯⋯⋯⋯ RODIN **48/49**

1861-1865: American Civil War ⋯⋯⋯⋯⋯⋯⋯⋯⋯⋯⋯⋯⋯⋯⋯⋯⋯⋯⋯⋯⋯⋯⋯⋯

1869: Opening of the Suez Canal ⋯⋯⋯⋯⋯⋯⋯

1859 – 1891: **Georges Seurat** 1864 – 1901: **Henri de Toulouse-Lautrec** 1867 – 1956: **Emil Nolde**

1876: Invention of the telephone ·············· 1883: First petrol-engined automobile ·····················
1876: Battle of the Little Bighorn ···················
1884: Mark Twain publishes the *Adventures of Huckleberry Finn* ···············

1872 – 1944: Piet Mondrian 1876 – 1957: Constantin Brâncuşi 1880 – 1938: Ernst Ludwig Kirchner

» *The glittering form of Brâncuşi's* Bird in Space *is as suggestive of energy and movement as Balzac's swelling robe.*«

class barriers. Balzac's working methods were sometimes Herculean, as he could write for several days at a time in his night robe with very little sleep. Rodin called *The Human Comedy* "the greatest piece of true humanity ever thrown on paper," and from the beginning of his commission he sought to express the spiritual effort that Balzac strove to achieve his art. Rodin immersed himself in the work, reading and re-reading all of Balzac's novels, visiting the places where he had lived, and even looking for models that resembled the great writer. While staying at the Château de l'Islette in the Loire Valley, Rodin found his perfect lookalike in a 35-year-old coachman named Estager, whom he subjected to many hours of sittings. Using Estager as inspiration, Rodin slowly developed the head of his statue. The longer he worked on the face, the more fantastical it became. Balzac's rotund cheeks and forehead were transformed into bulging hulks of skin, almost bubbling outwards like molten lava. The eyes became dramatically sunken, with the eyebrows and moustache grotesquely enlarged. Yet despite these mask-like exaggerations, the face was still clearly Balzac's. Over the course of the project's seven years, Rodin attempted two basic ideas for the figure's body. In the first concept, Balzac was presented in the nude, his legs spread wide apart on his massive frame. The figure's entire form now bulged forth, resembling the girth of a Japanese

Sumo wrestler. "I want him immense," the sculptor wrote of *Balzac*, "a dominator; a creator of the world." Needless to say, Rodin's "immense" warrior shocked the conservative members of the *Sociéte*, and they nearly dismissed him on the spot. But in the end, the sculptor was given an opportunity to revise his concept and present something more suitable. Yet the second version of *Balzac* was even more radical the the first. Rodin now cloaked his figure in the author's famous night robe, reducing Balzac's giant body to a single, hulking shape. The head, now modeled in an even more exaggerated manner, was thrown dramatically backward, giving the grotesque countenance an aura of defiant nobility. Rodin had created a monument to the artistic character he felt Balzac represented—an audacious, rebellious spirit. He had also achieved a new kind of expressiveness in European sculpture, through both the exaggeration and simplification of natural forms. The writer Camille Mauclair, a friend of Rodin's, described the sculptor's ambitions:
"He (Rodin) came to think that by the systematic exaggeration of the modeling of certain parts, of

right——**CONSTANTIN BRÂNCUŞI, BIRD IN SPACE** | c. 1940/41 | bronze
191.5 × 13.3 × 16 cm | Musée National d'Art Moderne | Paris.

1889: Completion of the Eiffel Tower .. **1900:** Beginning of the Boxer Rebellion in China
... **1896:** First modern Olympic Games ..
... **1895:** Discovery of X-rays

1890 – 1918: Egon Schiele **1898 – 1986: Henry Moore** **1901 – 1980: Len Lye**

above——**HENRY MOORE, DRAPED RECLINING FIGURE** | 1952/53 | bronze
1157.5 cm | Time-Life Building | London.

»*Moore's smoothly stylized figures share Balzac's monolithic power.*«

those which expressed the principal movement, the figure could only gain in vitality, in energy, in the clear revelation of his soul."

When the new plaster model of *Balzac* was formally unveiled at the Paris Salon of 1898, the work received both passionate support and furious denunciation. Rodin knew the Sociéte would not accept his design, and he ultimately relinquished his commission and his 10,000 francs. But Balzac had won wide acclaim among artists, including Claude Monet (1840–1926), Camille Pissarro (1830–1903), Alfred Sisley (1839–99), and Henri de Toulouse-Lautrec (1864–1901). So the sculptor decided to keep his plaster monument and display it at his garden in Meudon. Reproductions of the work soon spread around the world. In 1902, the American photographer Edward Steichen took dramatic portraits of *Balzac*, his indomitable figure glistening in the faded light of sunset. Not until 1939 was the monument finally cast in bronze, as Rodin intended, and placed in Paris' boulevard Raspail.

As the twentieth century progressed, Rodin's use of expressive abstraction was taken up by other artists, leading to the first truly abstract sculpture. The Romanian artist Constantin Brâncuşi (1876–1957) had studied in Rodin's studio for a short time, and his pioneering abstract works owed something to *Balzac*. In Brâncuşi's iconic *Bird in Space* (1923) (fig. p. 51), the elongated, aerodynamic shape stands proudly on its tiny pedestal. Its glittering form is as suggestive of energy and movement as *Balzac*'s swelling robe. Later in the 1900s, British artist Henry Moore (1898-1986) created his own synthesis of stylized monumentality, movement, and aesthetic passion. His reclining women (fig. left) were inspired by the Toltec and Mayan sculpture of ancient Mexico, rather than by Greek or Renaissance models. Moore also eschewed the Romantic, emotional fervor of Rodin's art; preferring instead a more ambiguous, laconic aura. Yet Moore's smoothly stylized figures share *Balzac*'s monolithic power. And some of them incorporate *Balzac*-like garments, which seem to flow across the body like an ancient river.

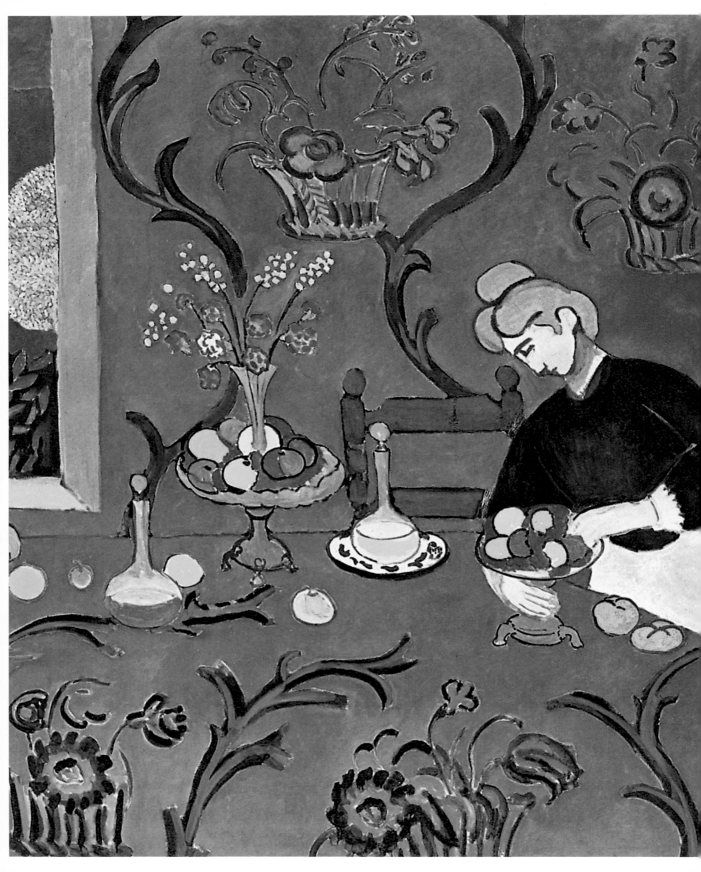

1839 – 1906: Paul Cézanne　　　　1840 – 1926: Claude Monet　　　　　　1853 – 1890: Vincent van Gogh

HENRI MATISSE: THE HARMONY OF FAUVISM

Paris in 1905 was teeming with young artists. Only thirty years before, Claude Monet and the Impressionists had founded the *Société Anonyme Coopérative des Artistes Peintres, Sculpteurs, Graveurs,* marking the start of a tradition of progressive art organizations. These groups often held their own salons, and many chose to assert their independence by abolishing the juries and prizes of the traditional Salon de Paris. Such practices were considered elitist, the outmoded ideals of the increasingly conservative École des Beaux-Arts. Yet without formal methods of judging and selecting art, the new salons were unable to maintain consistent levels of quality.

In response to this problem, a group of young artists, whose work was inspired by the Impressionists, decided to organize a more structured, juried event. They chose to meet in the fall, the "off season" in the Paris art world, and they selected the neoclassical Petit Palais as their setting. This flamboyant building was also new, having been constructed for the 1900 Paris Exposition. The exhibit was called the Salon d'Automne (Autumn Salon), and its organizers hoped to offer a more prestigious venue for the city's

finest young talent, most of whom were still struggling to find either critical or commercial success. The first Salon d'Automne took place in 1903, under the direction of the architect Frantz Jourdain, and it featured the work of painters soon to achieve great fame, including Georges Roualt, Albert Marquet, and a quiet, studious 32-year-old named Henri Matisse (1869–1954).

Matisse was born in the French village of Le Cateau-Cambresis, near the Belgian border. A former law

left——HENRI MATISSE, THE DESSERT: HARMONY IN RED | detail.
right——HENRI MATISSE, THE DESSERT: HARMONY IN RED | 1908
oil on canvas | 180 × 220 cm | Hermitage Museum | St. Petersburg.

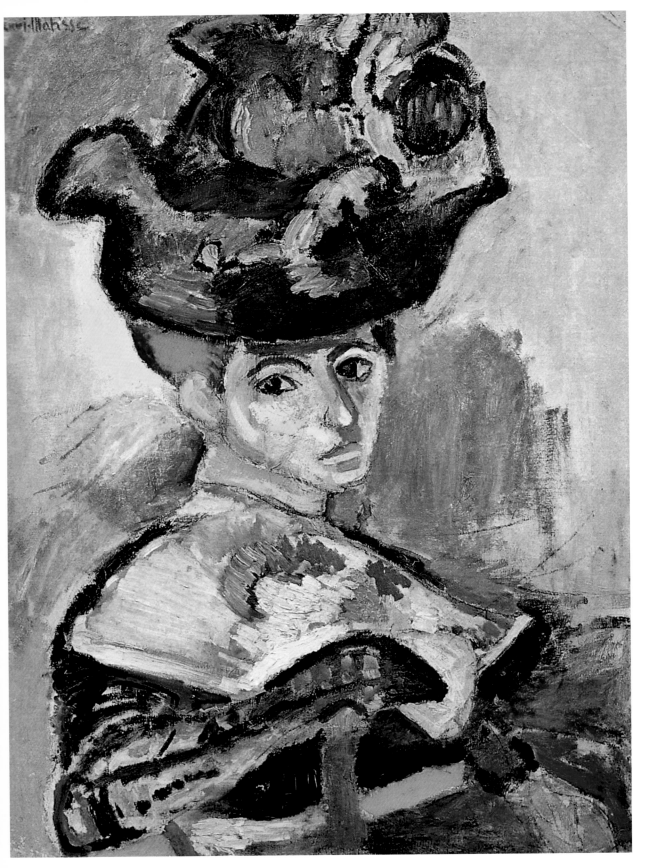

1876: Invention of the telephone ... **1886:** Completion of the Statue of Liberty **MATISSE** 56/57

.. **1883:** First petrol-engined automobile.............................

.. **1889:** Completion of the Eiffel Tower

1863 – 1935: Paul Signac 1869 – 1954: Henri Matisse 1881 – 1973: Pablo Picasso

»*Matisse's human faces, flowers, and windows became defined by supple brushstrokes of pure color.*«

pupil, he began studying art in 1891 at the École des Beaux-Arts in Paris. Matisse quickly became an eclectic consumer of art, exploring eighteenth-century still lifes, Japanese prints, African tribal art, and the contemporary pictures of Paul Gaugin (1848–1903), Vincent van Gogh (1853–1890), Paul Signac (1863–1935), and Paul Cézanne (1839–1906). Henri also collected art voraciously, nearly bankrupting himself in the process.

From the beginning, Matisse was fascinated by color. His early paintings often show the influence of van Gogh, using strong hues and brushwork to give the work a palpable vitality. Around 1900, Matisse began to experiment more boldly with technique. He tested the effects of nonrealistic colors, and he explored Cézanne's method of abstracting natural forms in geometric brushstrokes. The artist Jean Puy would remember one of his painting sessions with Matisse, remarking on how he represented the gray studio "as a massive blue, and the form of the model, orange," a color scheme "wholly outside reality." But despite Matisse's growing confidence, his increasingly radical style made it difficult for him to sell or exhibit his works. At the first Salon d'Automne in 1903, Matisse showed only two paintings, neither of which displayed his latest technical innovations. Then in 1904, he followed the example of his artistic

role models, van Gogh and Cézanne, and travelled to the south of France. In Saint-Tropez, Matisse experimented with Pointillism, spending time with one of its leading exponents, Paul Signac. Pointillists "reconstructed" the effects of natural light, building their images with colored dots or blotches. This technique, though painstaking, helped give Matisse a more refined, analytical understanding of color. The next summer, he returned to southern France, this time to the coastal town of Collioure. He painted local landscapes, city scenes, and portraits; synthesizing the techniques of his mentors: van Gogh's energetic brushwork, Cézanne's geometrical abstractions, and the Pointillists' color schemes. Matisse's human faces, flowers, and windows became defined by supple brushstrokes of pure color. But these colors and lines were not meant to represent the natural effects of light and form; they were being used as a means of expressing visual sensations.

When Matisse returned to Paris from Collioure, he continued to develop his new artistic synthesis. Several of the works from this landmark year were shown at the 1905 Salon d'Automne. One of them, *La femme au chapeau* (Woman with a Hat) (fig. left), probably depicts Matisse's wife, Amélie. The work dramatically simplifies her image in splashy brushstrokes of color and line. The face is a patchwork of green, orange, and yellow, with thickly drawn eyes and eyebrows, all of which seem to merge into a background of abstract green, purple, violet, blue, and green fields. Most dramatic of all is the huge hat, which nearly submerges the face under its swirl

left——**HENRI MATISSE, WOMAN WITH A HAT** | 1905 | oil on canvas
79.4 × 59.7 cm | San Francisco Museum of Modern Art | San Francisco.

1895: Discovery of X-rays .. **1914-1918:** First World War ..

1906: San Francisco earthquake .. **1919:** Formation of the Bauhaus school

1891 – 1976: Max Ernst 1908 – 1984: Lee Krasner 1917 – 2004: Milton Resnick

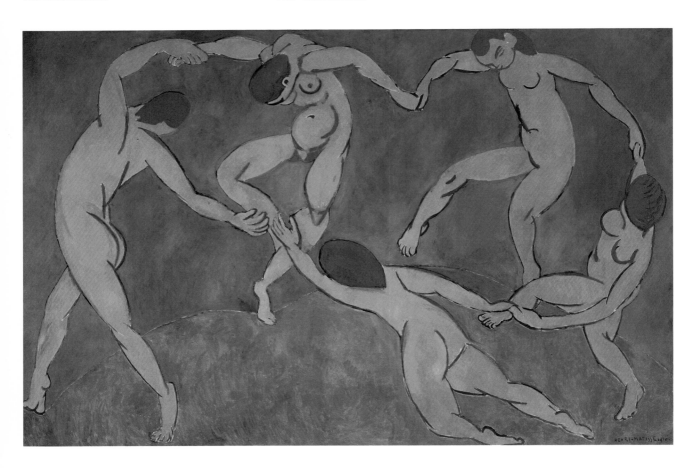

of vivid fabric and fruit. The vibrancy of this work stems not only from its dynamic color combinations, but also from Matisse's roughly applied paint—all of which seems strangely at odds with the calm, open expression on the model's face. *Woman with a Hat* caused a stir at the Salon d'Automne, with critics claiming that it represented "a pot of colors flung at the face of the public." The art critic Louis Vauxcelles, though not unimpressed with Matisse's work, referred to the overall exhibit as a collection of "fauves [wild beasts]." The name "Fauvism" would soon be used to describe the early work of Matisse and his followers.

Though Matisse was stung by the critics of the Salon, he was able to exploit his new-found notoriety and acquire important clients. The American-born collectors Leo and Gertrude Stein purchased *Woman with a Hat* for 500 francs, and their continuing patronage of Matisse's work helped him to achieve a modicum of financial success. The Steins also introduced Matisse to another rising painter, Pablo Picasso (1881–1973), beginning a career-long friendship that would greatly benefit both men.

The 1905 Salon also inspired Matisse—a lifelong workaholic—to immerse himself even more completely in his art. By the end of the decade, works such as *Harmony in Red* (1908) (fig. pp. 54/55) would show Matisse's ability to create a completely imaginary world. This image is based on a traditional domestic scene of a woman setting her kitchen table. But Matisse has completely reshaped the space in which the scene takes place. The patterned red tablecloth seems to be an extension of the identically colored and patterned wall, giving the kitchen a restless, flattened appearance. Through the window we see a similarly two-dimensional outdoor landscape

1931: Completion of the Empire State Building ········· **1949:** Founding of the Federal Republic of Germany ········· MATISSE 58/59

1939 – 1945: Second World War ········

1941: Pearl Harbor attack ·········

1928 – 1987: Andy Warhol b. 1935: Christo b. 1940: Chuck Close

of white tissue-paper trees and a spreading, deep green field. Objects, trees, and woman have all been reduced to Matisse's elegantly decorative lines and shapes—a tightly ordered world awash with flowing colors and forms.

In the year Matisse created *Harmony in Red*, he wrote a landmark essay explaining his art. *Notes of a Painter* describes composition as "the art of arranging in a decorative manner the diverse elements at the painter's command to express his feelings." Matisse goes on to say that "I cannot copy nature in a servile way; I am forced to interpret nature and submit it to the spirit of the picture. From the relationship I have found in all the tones there must result a living harmony of colors, a harmony analogous to that of a musical composition."

It was also in 1908 that Matisse opened his own school, teaching his rigorous, musical style of art to many eager students in Paris. Some of these students later developed significant careers, including the American painter Max Weber (1881–1913) and the British artist Sir Matthew Smith (1879–1959).

But Matisse's own work had a far more profound influence than his teachings. Through his graceful abstractions, he helped elevate the basic techniques of painting—color, line, and composition—from secondary tools to primary artistic subjects. Matisse's later works embody this concept even more dramatically. In the 1940s, poor health forced him to abandon painting and create prints based on paper collages. Matisse referred to these works as "cutouts," in which his talent with the brush was transferred to scissors and colored paper. The silhouetted forms of the cutouts reveal in stark form Matisse's ability to produce expressive line and coloristic sophistication. In one series of prints, collected in a book entitled *Jazz* (1947), the artist continued exploring the connections between musical and pictorial energy (fig. pp. 60/61) .

Matisse's influence on twentieth-century art has been deep and widespread, providing fertile ground for Expressionism, Surrealism, and abstract art. The joyous still lifes of Lee Krasner (1908–1984), an Abstract Expressionist who was the wife of Jackson Pollock, seem almost directly inspired by Matisse. In *The Seasons* (1957), Krasner's fruits and vegetal forms burst forth in a dance-like composition of glowing colors and vigorous brushwork (fig. above). Matisse's influence has even extended into commercial art. His cutout technique has been widely imitated by designers seeking to create potent brand images. The recently developed logo for the 2012 Olympic Games in London shares some of the restless ebullience of the *Jazz* prints.

left——**Henri Matisse, La Danse** | 1909/10 | oil on canvas 260 × 391 cm | Hermitage Museum | St. Petersburg.

right——**Lee Krasner, The Seasons** | 1957 | oil on canvas | 235.5 × 517.5 Whitney Museum of American Art | New York.

next double page spread——**Henri Matisse, The Circus II** from the series Jazz | 1947 | lithograph | 63.2 × 44.7 cm | Städelscher Museums-Verein Frankfurt am Main.

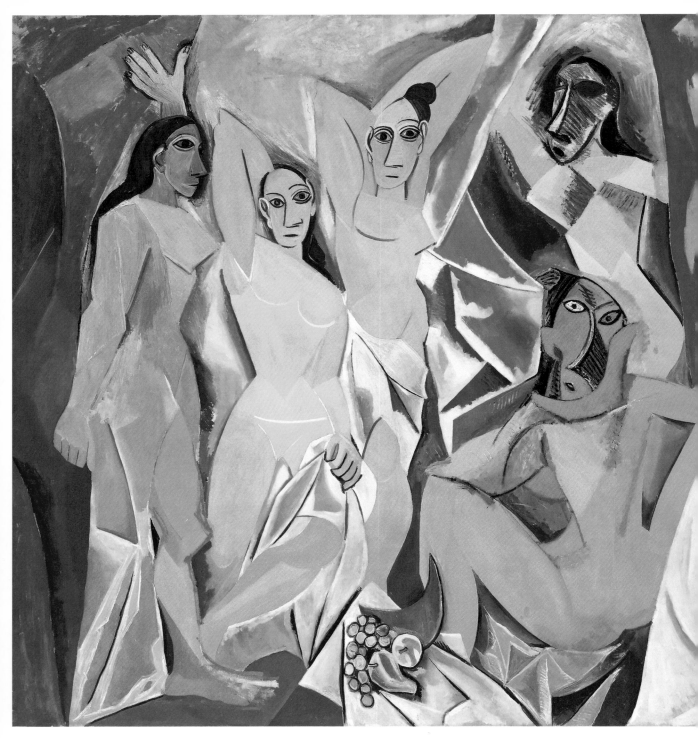

1848: Revolutions in Europe.. **1849:** Death of Chopin

1848: Marx and Engels publish *The Communist Manifesto*

1853-1856: Crimean War................................

62/63

1841 – 1919: Auguste Renoir 1848 – 1903: Paul Gauguin 1853 – 1890: Vincent van Gogh

PABLO PICASSO:
LES DEMOISELLES D'AVIGNON

The full flowering of modern art took place just as the twentieth century began. Much of it sprang specifically from the fertile ground of avant-garde Paris. But modernism also owed its existence to larger-scale forces. During the nineteenth century the development of the steamship helped promote a new era of exploration, which saw Europeans discovering the art of far-flung civilizations—especially those in sub-Saharan Africa, southeast Asia, and the Pacific Islands. As Western colonial empires spread into these regions, new cultural artifacts made their way into European museums. At the same time, developments in modern archeology began to reveal the proto-Classical art of Europe. Many of these foreign and ancient relics were dismissed as "primitive" by Western viewers in London, Paris, Berlin, and elsewhere. But for a few progressive artists, they inspired the development of new modes of expression that helped define a new century.

The most prominent of these artists, Pablo Picasso (1881–1973), was the son of a painter and teacher, an artistic prodigy who quickly mastered the formal techniques of European draftsmanship. By the age of thirteen, he could already produce remarkably naturalistic and supple human figures. Perceiving his son's immense talent, Ruiz Picasso was able to get Pablo admitted to the school of fine arts in Barcelona, where Ruiz had accepted a teaching position. Barcelona was the most industrialized and liberal corner of Spain at that time. The city's *Modernista* architects, led by Antoni Gaudí (1852–1926), were using radical engineering techniques to design buildings with organic, undulating sensuality. But the opportunities for young painters in Spain were limited, even in Barcelona, and Picasso's restless nature ultimately led him to Paris, where he settled in 1904.

Cultural traditions in turn-of-the-century Paris were undergoing dramatic change. Long-established venues for art, such as the Salon of the Académie des Beaux-Arts, were being replaced by private galleries and independent exhibits. Artists' works were being advertised and sold by professional dealers, who had emerged only a few decades earlier; and a small but influential group of wealthy collectors were beginning to support young talent. Picasso would take advantage of these new commercial avenues in 1905, when Leo and Gertrude Stein became his patrons. The American-born Steins helped establish vital social connections for Picasso, introducing him to Henri Matisse (1869–1954) and to their circle of

left——**PABLO PICASSO, LES DEMOISELLES D'AVIGNON** | 1907
oil on canvas | 243.9 × 233.7 cm | Museum of Modern Art | New York.

friends and art connoisseurs. Gertrude Stein was impressed with Picasso's intense personal charisma. In her 1938 essay on the artist, she recalled her earliest years with him:

"The first picture we had of his is ... The Young Girl with a Basket of Flowers; it was painted at the great moment of the harlequin period, full of grace and delicacy and charm. After that little by little his drawing hardened, his line became firmer, his color more vigorous, naturally he was no longer a boy he was a man, ..."

This "hardening" of Picasso's style was, in part, a reaction to the work of Paul Cézanne. Like many early modernists, Picasso was influenced by Cézanne's method of abstracting natural forms into strong, carefully integrated planar shapes. Picasso was also being exposed to "abstract" ritual art—both first-hand and through the work of other painters. In 1906, he attended an exhibit of antique Iberian sculpture at the Louvre. The show's highly stylized bronze figurines had been discovered near the Andalusian town of Osuna. Picasso also discovered the art of sub-Saharan Africa, viewing a collection of African masks at Paris's ethnographic museum. Such imagery was already influencing the work of Picasso's contemporaries. The mask-like faces in *The Bathers* (1907) by André Derain (1880–1954) were inspired by African art (fig. right) ; while the erotic Tahitian women of Paul Gauguin (1848–1903) were based on traditional Polynesian carvings.

In 1907, Picasso would incorporate all of these influences in what many critics consider the first great work of twentieth-century art: *Les Demoiselles d'Avignon* (fig. p. 62). Picasso toiled over the picture

right—**ANDRÉ DERAIN, THE BATHERS** | 1907 | oil on canvas | 132.1 × 195 cm
Museum of Modern Art | New York.

1873: Jules Verne publishes *Around the World in Eighty Days*
1876: Invention of the telephone
1877: Leo Tolstoy publishes *Anna Karenina*
1879: Birth of Albert Einstein

1880 – 1954: André Derain

1881 – 1973: Pablo Picasso

PICASSO 64/65

1886: Completion of the Statue of Liberty

1895: Discovery of X-rays

PICASSO 66/67

1889: Completion of the Eiffel Tower

1896: First modern Olympic Games

1886 – 1966: Jean Arp 1890 – 1918: Egon Schiele 1893 – 1983: Joan Miró

»Braque and Picasso developed an analytical method for splintering natural forms into basic shapes and then reconstructing them into highly personal compositions.«

for several months, working and re-working an image that had initially been inspired by the eponymous brothel on Carrer d'Avinyó in Barcelona. Early preparatory drawings indicate that, at first, Picasso wanted to create a more realistic depiction of seedy brothel life, featuring both prostitutes and the men who solicited their services. Over time, the male figures from the early studies were eliminated, and the female figures became more abstract. Background details such as the curtain, table, and fruit were reduced to the simplest of shapes. In the final image, Picasso revealed a completely flat, nonrealistic space of jagged forms and angles. The women's bodies, which are similarly angular, appear on the verge of breaking apart and merging into the background. The aesthetic intensity of *Les Demoiselles* was enhanced by the mask-like faces of the women, whose features stare out at the viewer—somehow both aggressive and remote.

Les Demoiselles d'Avignon was rarely seen in the months and years after its completion. Picasso kept it largely hidden in his studio, and only showed the work to a small group of artists and friends. One of these artists was the French painter Georges Braque (1882–1963), who was both impressed and confused by the work. Braque had been exploring the bold colors and simplified landscapes of Fauvism, but he now devoted himself to creating, as he said, "a new sort of beauty, the beauty which appears to me in terms of volume, line, mass and weight, and through that beauty ... my subjective impression." Together, Braque and Picasso developed an analytical method for splintering natural forms into basic shapes and then reconstructing them into highly personal compositions (fig. left). This technique, which came to be known as Cubism, spread from Paris throughout the Western art world. It became the first truly systematic method of producing "modern" art, and it influenced a variety of media—sculpture, architecture, and even dance. For the first time since the Renaissance, people were given an entirely new way of perceiving the aesthetic image. The centuries-old objective of reproducing the natural world, a goal even the Impressionists had adhered to, had been thrown aside. As Braque said, nature was now "a mere pretext for decorative composition, plus feeling."

Around 1912, Picasso's experiments with Cubism led to a second major breakthrough. He began incorporating non-painterly materials into his images.

left——**GEORGES BRAQUE, MAN WITH A GUITAR** | c. 1910
oil on canvas | 130 × 72.5 cm | Musée national d'Art moderne,
Centre Georges Pompidou | Paris.

1903: First powered flight by the Wright brothers ··············· **1909:** Opening of Queensboro Bridge in New York ··············

1906: San Francisco earthquake ·················

1912: Sinking of the Titanic ···············

1901 – 1985: Jean Dubuffet 1904 – 1997: Willem de Kooning 1910 – 1962: Franz Kline

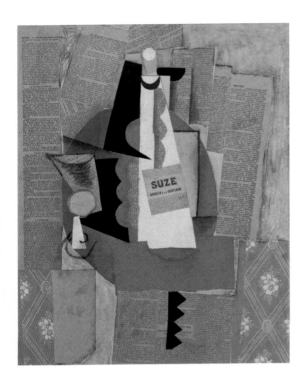

Newspaper clippings, cardboard, and other found objects were arranged and glued onto the canvas, along with the artist's own charcoal drawing, to produce the first modern collages. *Glass and Bottle of Suze* (1912) nicely exemplifies this style (fig. above). The painted geometric forms in his earlier Cubist work have been replaced with "real" puzzle pieces. As with other works of "Synthetic Cubism," Picasso invites the viewer to detect in the composition the "objects" that are listed in the work's title. Here, the abstract bottle contains an authentic commercial label, an ironic touch that foreshadows the mock commercialism of Pop Art.

For Picasso, the Cubist era was a brief one. After the chaotic struggles of World War I and the Russian Revolution, he and many other artists suspended their pursuit of revolutionary art. A "return to order" movement involved the re-establishment of traditional figural styles in the 1920s. Picasso's images from this period often feature stark, naturalistically drawn portraits. One of these works features the composer Igor Stravinsky, who had made his own aesthetic journey from abstract dissonance to spare, melodic neoclassicism.

But the basic feature of Cubism—the patterned "surface" in which foreground and background distinctions are obscured—went on to dominate much of modern painting's subsequent history. A few painters acknowledged their debt to Picasso and Braque directly. For example, the African-American artist Jacob Lawrence (1917–2000) developed a style he called "Dynamic Cubism." Lawrence's imagery incorporates the vigorous, overlapping shapes of Picasso and Braque, but it generally refrains from splintering its human figures and objects. Lawrence is primarily a story-teller, and his works portray important moments in black history; such as the "great migration" of the 1920s and 30s, in which thousands of southern blacks migrated to northern cities to escape the 'Jim Crow' south and find economic opportunity. Lawrence also depicts his own working methods, as in his richly colorful *Self-Portrait* (1977) (fig. right). Though Cubism was initially inspired by Europe's fascination with "primitive" Africa, it has since helped produce a truly cross-cultural, dynamic art world.

left——**Pablo Picasso, Glass and Bottle of Suze** | 1912
pasted papers, gouache, and charcoal | 65.4 × 50.1 cm | Mildred Lane Kemper Art Museum | St. Louis.
right——**Jacob Lawrence, Self-Portrait** | 1977 | gouache and tempera on paper | 58.4 × 78.7 cm | National Academy of Design, New York.

1917 – 2000: Jacob Lawrence 1921 – 1986: Joseph Beuys 1925 – 2008: Robert Rauschenberg

>>Jacob Lawrence's imagery incorporates the vigorous, overlapping shapes of Picasso and Braque, but it generally refrains from splintering its human figures and objects.<<

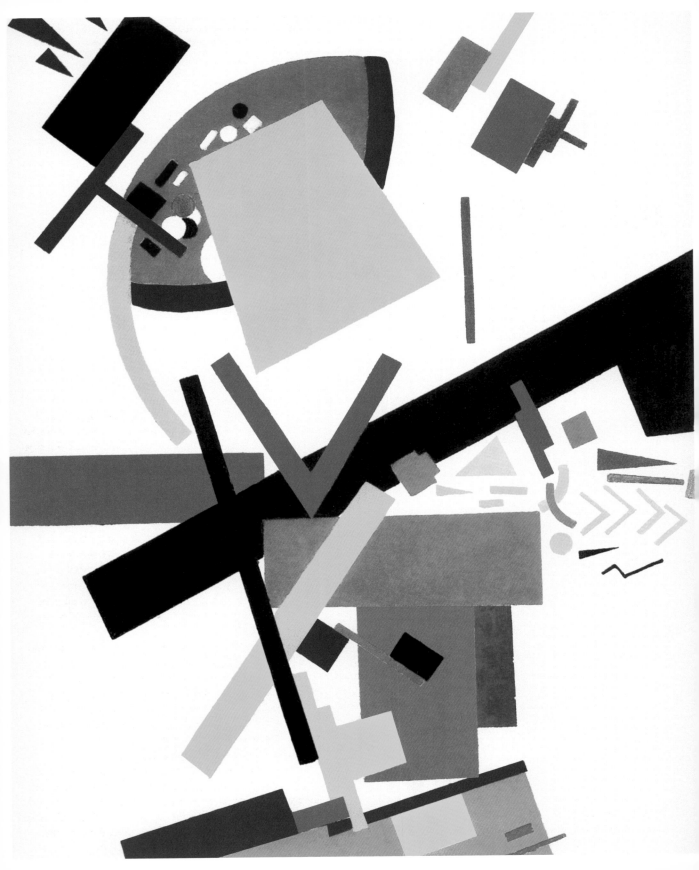

KAZIMIR MALEVICH: THE COSMIC ART OF SUPREMATISM

Early modern art was distinctive not only for its revolutionary forms, content, and techniques, but also for the unprecedented breadth and rapidity of its dissemination. Improvements in photography, printing, and transportation meant that the latest products of avant-garde Paris could be seen by aspiring modernists throughout Europe, North America, and elsewhere. One remote corner of the West that benefited most from this revolution was Russia. Since the early eighteenth century, the Russian elite had tried to "modernize" its rural, culturally isolated nation by incorporating Western technology and art. For two hundred years, this process had been slow and uneven, but the pace of change sped up rapidly as the twentieth century approached.

During the first decade of the 1900s, Russia's print media began to distribute modern art in slick photographic reproductions. A leading Moscow journal, *Zolotoe runo* (Golden Fleece), disseminated the works of Gaugin and Van Gogh, as well as scholarly essays on Post-Impressionism and Fauvism. Journal-sponsored exhibitions of modern painting also took place, giving Muscovites a chance to see the works in person. But the most important promoters of the new art were probably Russia's wealthy collectors. Sergei Shchukin, heir to a Moscow textile fortune, amassed a remarkable array of Impressionist and post-Impressionist works—Monets, Pissarros, and Cézannes. He was also an early patron of Matisse and Picasso, owning more than fifty of their works by 1913. And beginning in 1909, Shchukin made his collection available to Moscow art students, thus creating one of the world's first modern art museums. Among the many students who spent time at Shchukin's collection was a young painter from Kiev named Kazimir Malevich (1878–1935).

Malevich was from a restless, middle-class Ukrainian-Polish family; his father worked as a manager of rural sugar refineries. The young Kazimir took art classes in Kiev and the provincial Russian city of Kursk. But his artistic studies did not begin in earnest until he moved to Moscow in 1904. Malevich spent the next few years absorbing and experimenting with the latest art styles. His early paintings explored the Pointillism of Georges Seurat (1859–91), the inventive coloring of the Fauvists, the revolutionary geometrical structures of Cubism, and the rounded, abstract forms of Italian Futurism. Malevich even designed sets and costumes for a modernist opera,

left——KAZIMIR MALEVICH, SUPREMATISM | 1916 | oil on canvas
87.5 × 72 cm | State Russian Museum | St. Petersburg.

········1873: Jules Verne publishes *Around the World in Eighty Days*···1879: Birth of Albert Einstein············
···1876: Invention of the telephone··
···1876: Battle of the Little Bighorn···

»Malevich felt that Suprematism could liberate people emotionally and spiritually by revealing the true nature of space.«

Victory over the Sun (1913), which combined elements of Cubism and Futurism. The opera was performed only twice at the Luna Park Theater in St. Petersburg, but it marked a turning point in Malevich's development. Russian poet Benedict Livshitz, who witnessed the production, wrote that Malevich's designs were "cut up by the blades of light ... merely geometric bodies subject to total disillusion." *Victory over the Sun* sprang from theoretical ideas that Malevich and his colleagues had recently adopted. They centered around a concept called *zaum* (or that which is "beyond the mind"), which urged artists to express forms and ideas that lie beyond easily-perceived reality. Malevich's search for a "hidden" reality, which he first sensed in Cubism, led him to develop an entirely new form of art.

By the beginning of 1915, Malevich had begun to experiment with simple "geometric bodies" that were not based on abstractions from nature. These untitled works often featured a composition of squares, rectangles, and trapezoids on a white background. The precise arrangement, size, and coloring of the figures endowed them with a strong feeling of agitated movement. Malevich later wrote that these images reflected the human desire for spiritual flight. "My new painting does not belong to the Earth exclusively." he said, "The Earth has been abandoned like a house of termites. And in fact, in man, there is a striving toward space. An urge to take off from Earth ..."

In other paintings from that year onwards, Malevich focused on the expressive power of a single form. *Black Square* (fig. right) presents its large black shape in the center of the white canvas, but slightly askew. Here again, Malevich's precise composition gives energy to an inherently inert feature. The square seems to be floating upward and hovering over the white background. *Black Square* also became, for Malevich and his followers, a kind of contemporary icon; the flattened imagery of Russian religious art had been reduced to its barest essentials. Malevich felt his new art—which he called "Suprematism"—could become part of a larger philosophical movement: one that could supplant the "outmoded" teachings of traditional religion. He also felt that Suprematism could liberate people emotionally and spiritually by revealing the true nature of space. "Christ revealed heaven on earth," he wrote in a 1916 treatise, "which put an end to space, established two limits, two poles, wherever they may be—in oneself or 'out there.' But we will go past thousands of poles, ... Space is bigger

right——**KAZIMIR MALEVICH, BLACK SQUARE** | c. 1929 | oil on canvas 106 × 106 cm | State Russian Museum | St. Petersburg.

1883: First petrol-engined automobile .. 1887: First Sherlock Holmes novel is published MALEVICH **72/73**

1886: Completion of the Statue of Liberty

1889: Completion of the Eiffel Tower

1882 – 1967: Edward Hopper 1884 – 1950: Max Beckmann 1887 – 1985: Marc Chagall

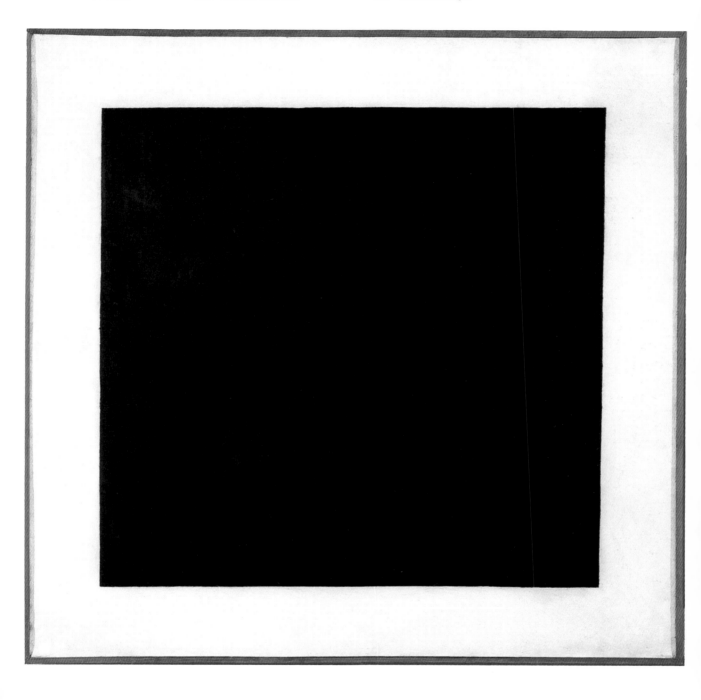

1895: Discovery of X-rays·· **1897:** Opening of the giant wheel in the Viennese Prater··
1896: First modern Olympic Games··

1891 – 1976: Max Ernst **1893 – 1983: Joan Miró** **1898 – 1986: Henry Moore**

1903: First powered flight by the Wright brothers 1906: San Francisco earthquake

1905: Formation of the expressionist group Die Brücke

1909: Opening of Queensboro Bridge in New Yorkk

MALEVICH 74/75

1903 – 1970: Mark Rothko 1905 – 1970: Barnett Newman 1908 – 1984: Lee Krasner

than heaven, stronger, more powerful." Malevich's desire to reimagine religious symbols was made even more explicit in his work *Black Cross*. Here the artist used the shape of a traditional Greek cross, in which all four arms are the same length. He also positioned the shape in the same slightly off-center way that he had placed his black square. For Malevich, this work had separated the cross from its purely Christian associations, revealing the shape itself as an expressive creation liberated in space.

Malevich's Suprematism developed quickly. By the end of 1915, he was able to exhibit 39 of his works in St. Petersburg (which was now called Petrograd) under the cryptic title *0.10 The Last Futurist Exhibit*. A well-known photograph from the exhibition revealed that *Black Square* took pride of place, hovering over the other works and striving towards space. This photo effectively captured the radical nature of Malevich's floating shapes, which seem to pierce through the walls and neoclassical molding of the exhibition room. Two years after *0.10*, Russia itself would break free from its antiquated Czarist govern-

ment, establishing a new Communist state in 1917. In the first years after the Russian Revolution, Malevich and other modernists tried to establish a foothold in the new country. Malevich's explorations with Suprematism reached a kind of conclusion with a group of paintings he referred to as "white on white." In the most famous example, *Suprematist Composition: White on White* (1919), Malevich again placed a square within the larger square format of his canvas (fig. left). But this time the smaller square was positioned more expressively off-center—rotated slightly clockwise and nearly touching two points on the top and right edges of the frame. Moreover, the smaller square was colored in nearly the same off-white as the background, making it seem to emerge out of the canvas. Malevich wrote that such art spoke of "creation," where the form "does not imitate nature, but instead emanates from the pictorial mass, without repeating or modifying the primordial forms of natural objects." He also wrote, "Our century is a huge boulder aimed with all its weight into space. From this follows the collapse of all the foundations in Art, as our consciousness is transferred onto completely different ground.

The field of color must be annihilated, that is, it must transform itself into white." Malevich had created an "objectless" art at almost the same time as his countryman, Wassily Kandinsky (1866–1944), had

left——KAZIMIR MALEVICH, WHITE ON WHITE | 1919 | oil on canvas 79.4 × 79.4 cm | Museum of Modern Art | New York.

76/77 MALEVICH

1919: Formation of the Bauhaus school
1912: Sinking of the Titanic ... **1914-1918:** First World War
1911: Roald Amundsen reaches the South Pole

1912 – 1956: Jackson Pollock 1917 – 2004: Milton Resnick 1917 – 2000: Jacob Lawrence

»Dan Flavin interpreted Suprematist
art through the use of artificial light and
fluorescent tubing.«

developed his own abstract landscapes of vibrant color and swirling form.

Malevich's art would initially inspire the work of many Soviet artists, who used the expressive power of basic shapes in "Constructivist" posters, furniture, and architecture. But by the end of the 1920s, such art was seen as increasingly anti-proletarian by the Soviet government. Possibly in response to the changing political climate of his country, Malevich returned to painting figural scenes of Russian peasant life, a theme he had explored at the very beginning of his career. In 1927, Malevich was able to travel to Western Europe for the first and only time, spending several months in Berlin and visiting the avant-garde Bauhaus school in nearby Dessau. While there, the Russian artist exhibited several of his earlier paintings, including *White on White*, all of which he purposely left in Germany. Several of the pictures subsequently made their way to different parts of Europe and North America, with *White on White* becoming part of New York's Museum of Modern Art in 1935. For decades, they would be the only Malevich pictures that Western audiences would see. Most of Malevich's art remained out of sight in the Soviet Union, especially after the artist's death. Yet despite Malevich's relative obscurity, Suprematism became a major inspiration after World War II. Minimalists like Barnett Newman (1905–70) and

Dan Flavin (1933–96) conducted similar explorations with playful color and stripped-down shapes. In Newman's *Who's Afraid of Red, Yellow and Blue IV* (1969/70) (fig. pp. 78/79), a prime example of "color field painting," giant red and yellow squares assert their own space on either side of the blue-gray stripe. Dan Flavin interpreted Suprematist art through the use of artificial light and fluorescent tubing. In his installation *Untitled (To Virginia Dwan)* I (1971), Flavin mounted a single fluorescent tube horizontally across the corner of an exhibition room (fig. right) . The tube projected a diamond of prismatic light at the joining of the two walls behind, its color gradually shifting from yellow to red. Flavin's ethereal shape suggested the same "cosmic" essence as Malevich's hovering squares.

right——**DAN FLAVIN, UNTITLED (TO VIRGINIA DWAN) I** | 1971 | neon tubes: fluorescent light | 10.2 × 243.8 × 20.2 cm | Lenbachhaus Munich.
next double page spread——**BARNETT NEWMAN, WHO'S AFRAID OF RED, YELLOW AND BLUE IV** | 1969–70 | acrylic on canvas | 276.92 × 610.26 cm Neue Nationalgalerie | Berlin.

1922: Discovery of Tutankhamun's Tomb ·· **1927:** Charles Lindbergh flies nonstop from New York to Paris ···············

··············· **1925:** Invention of television ··

······· **1929:** Black Friday ·················

1921 – 1986: Joseph Beuys 1923 – 1997: Roy Lichtenstein 1928 – 1962: Yves Klein

............ **1931:** Completion of the Empire State Building...

1933: Adolf Hitler seizes power..

1939-1945: Second World War...................................

MALEVICH **78/79**

WASSILY KANDINSKY: ABSTRACT ART

Wassily Kandinsky (1866–1944) was an intellectual by nature. Born in Moscow as the son of a successful tea merchant, Kandinsky studied law, economics, and anthropology. In 1889, he took part in an ethnographic study of Russian folk life in the Vologda region north of Moscow. Kandinsky's love of folk traditions and his penchant for analytical theory would help shape his artistic career, which he began in 1896. The center of progressive art at that time was Paris, but Kandinsky decided to settle in Munich. Though its cultural atmosphere was predominantly conservative, in 1892 the Bavarian capital had become the first city outside Paris to establish a "Secessionist" artists' group. Munich's Secession rebelled against academic traditions and ushered in the flowery, highly stylized *Jugendstil* movement, the Germanic equivalent of Art Nouveau. Munich was also becoming a destination for many young Russian artists wishing to study abroad. Kandinsky was soon working with several of these men and women, including Alexej von Jawlensky (1865–1941) and Marianne von Werefkin (1860–1938).

Kandinsky's first teacher was the Slovenian painter Anton Ažbe (1862–1905). An avowed eccentric, Ažbe championed a number of unusual techniques. One of them became known as the "crystallization of colors," which promoted the use of pure, unmixed paints on the canvas. Kandinsky had long had a fascination with color, especially the way Monet provocatively "hid" his subjects and focused the viewer's attention on his palette. By the time Kandinsky began practicing art himself, around 1901, he had become an obsessive colorist. His earliest surviving landscapes were constructed from thick, fluid brushstrokes of orange, blue, yellow, and green. Kandinsky also began his life-long association with progressive artists' groups, in which he could discuss and teach his art. He helped organize the Jugendstil Phalanx group in 1901, which would conduct significant Impressionist exhibitions in Munich and run a small art school. During his short stint as the Phalanx painting teacher, Kandinsky met Gabriele Münter (1877–1962), his partner and artistic collaborator for nearly two decades.

When the Phalanx disbanded in 1904, Kandinsky and Münter travelled around Europe. Living in Paris from 1906 to 1907, they met the Russian impresario Sergei Diaghilev, who had an important collection of works by Pablo Picasso (1881–1973), Odilon Redon (1840–1916), and Henri Matisse (1869–1954).

left——WASSILY KANDINSKY, MURNAU WITH CHURCH I | 1910
oil and watercolor on cardboard | 64.9 × 50.2 cm | Städtische Galerie im Lenbachhaus | Munich.

1861-1865: American Civil War ·· **1884:** Mark Twain publishes the *Adventures of Huckleberry Finn* ···········

1873: Jules Verne publishes *Around the World in Eighty Days* ··

1879: Birth of Albert Einstein ···

1866 – 1944: Wassily Kandinsky 1877 – 1962: Gabriele Münter 1880 – 1916: Franz Marc 1887 – 1914: August Macke

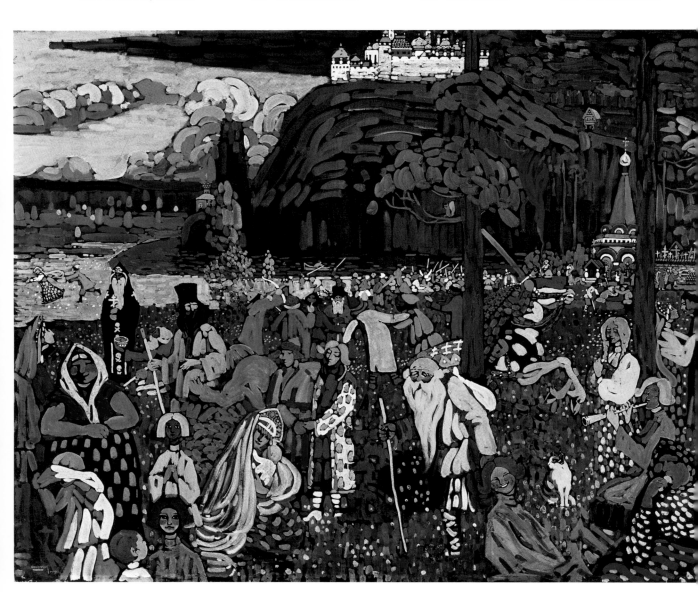

above——WASSILY KANDINSKY, COLORFUL LIFE | 1907 | tempera on canvas
130 × 162.5 cm | Städtische Galerie im Lenbachhaus | Munich

1895: Discovery of X-rays .. **1909:** Opening of Queensboro Bridge in New York **KANDINSKY** 82/83
1900: Beginning of the Boxer Rebellion in China ..

1914-1918: First World War.................................

1891 – 1976: Max Ernst 1903 – 1970: Mark Rothko 1912 – 1956: Jackson Pollock

»Kandinsky claimed that A Colorful Life *developed out of ›confused dreams‹ in which ›harmonious pictures ... left me on awakening with only an indistinct trace of phantom details.‹«*

Kandinsky also began producing some of his best known works based on Russian folk themes. *Colorful Life* (1907) uses a mosaic of dots, blotches, and short brushstrokes on a black background (fig. left) . Its hallucinatory mountain scene features a bewildering mixture of traditional Russian characters—from travelling priests to itinerant musicians; medieval lovers to bearded beggars. The work was inspired by the flattened compositions of Russian icons, but Kandinsky also claimed that *A Colorful Life* developed out of "confused dreams" in which "harmonious pictures ... left me on awakening with only an indistinct trace of phantom details."

When Kandinsky and Münter moved back to Munich, the Russian artist continued to move his style away from representation and toward a more dreamlike world of color and shape. He produced an important series of images at the nearby village of Murnau. In *Murnau with Church I* (1910), individual elements of the landscape are nearly submerged into the image's geometric patterns (fig. p. 89). Mountains, trees, and buildings have become boldly-colored triangles, squares, and lines within the composition. Other works from 1910 and 1911 transform religious imagery, such as the legend of St. George, the Resurrection, the Deluge, and the Last Judgment. Bold, sweeping black lines and vivid fields of color provide only the barest hints of saints, horses, and Christian iconography.

Kandinsky's interest in religious themes reflected his own search for spiritual fulfillment, a search he felt his art could help him achieve. In his treatise *Concerning the Spiritual in Art* (first published in 1910), he argued that basic forms and colors have their own inherent spirituality and musicality. Blue, for example, is "the typical heavenly color. The ultimate feeling it creates is one of rest. When it sinks to black, it echoes a grief that is hardly human. ... In music a light blue is like a flute, a darker blue a cello; a still darker a thunderous bass; and the darkest blue of all—an organ." Because forms and colors had their own emotional value, Kandinsky then described composition as the harnessing of these emotions: "opposites and contradictions—this is our harmony. Composition on the basis of this harmony is the juxtaposition of coloristic and linear forms that have an independent existence as such, derived from internal necessity, ..."

For many art historians, Kandinsky's slow progression towards abstract art—the creation of "coloristic and linear forms with an independent existence"—came to full fruition in his *Composition VII* (1913) (fig. p. 84). This work integrated many themes that the artist had been exploring for more than a decade: his love of Russian culture, his search for spirituality, the expressiveness of the natural landscape, and the bold colors of Impressionism and Fauvism.

84/85 KANDINSKY ·········· **1925:** Invention of television ·· **1946:** First computer ····························

··· **1939-1945:** Second World War ·····················

·· **1931:** Completion of the Empire State Building ···

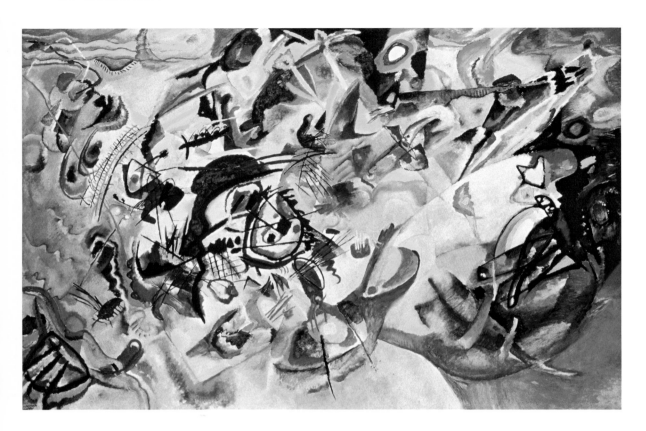

Composition VII employed contrasting colors and forms to achieve a musical energy and movement. Shapes that had once been used to represent mountains or horses were now liberated from their representational sources, and their own innate energy—or spirituality—was now unleashed onto the canvas. A kaleidoscope of rich blues, violets, greens, and yellows were set into motion by Kandinsky's swirling, vibrant brushwork, creating an overall "harmonic" clarity out of the disparate elements.

By the time *Composition VII* was completed, Kandinsky had already helped establish another new art society in Munich. Called the *Der Blaue Reiter (The Blue Rider)*, it included Kandinsky, Franz Marc (1880–1916), Alexej von Jawlensky, Gabriele Münter, Auguste Macke (1887–1914), and Lyonel Feininger (1871–1956). While not all of these artists were devoted to abstract art per se, they all had similar beliefs in the spiritual power of color and form. Marc's work in particular, with its elegantly simplified,

emotionally potent landscapes, would help provide the groundwork for Expressionism in the 1920s. Blauer Reiter exhibits also promoted modern art as an international movement that made no distinction between ethnic origin or gender. The first annual Blauer Reiter almanac would declare: "The national, like the personal, is bound to be reflected in every great work of art, yet ultimately is only secondary. The work in its totality, also known as art, knows no borders and no nations, but only humanity." Sadly, the international idealism of these years ended in 1914, with the outbreak of World War I. Kandinsky

above——**WASSILY KANDINSKY, COMPOSITION VII** | 1913 | oil on canvas 200 × 300 cm | State Tretyakov Gallery | Moscow.

right——**MARK ROTHKO, UNTITLED (VIOLET, BLACK, ORANGE, YELLOW ON WHITE AND RED)** | 1949 | oil on canvas | 207 × 167.6 cm | Solomon R. Guggenheim Museum | New York.

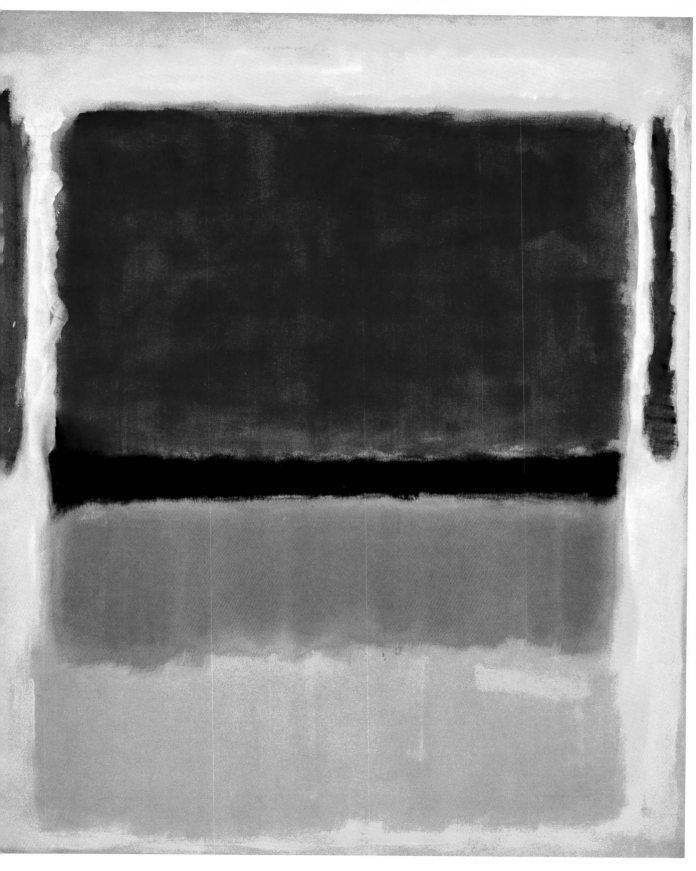

1969: Neil Armstrong lands on the moon

1961: Construction of the Berlin Wall **1977:** Jimmy Carter sworn in as president of the U.S.

1959: Completion of the Solomon R. Guggenheim Museum in New York

b. 1957: Ai Weiwei b. 1968: Wolfgang Tillmans b. 1970: Jonathan Meese

» Wolfgang Tillmans' images feature swirling lines and billowing forms reminiscent of Kandinsky. «

was forced to leave Munich and Gabriele Münter. After spending the war years in Moscow, he was invited to teach painting and art theory at the Bauhaus, Europe's leading school of modern art and design. Along with other former Blauer Reiter members Paul Klee (1849–1940) and Lyonel Feininger, Kandinsky would inspire a generation of young painters.

But the art that Kandinsky pioneered would affect modern culture long after the Bauhaus closed its doors in 1933. Many artists of the mid-1900s were desperately seeking emotional peace after the psychological and physical devastation of World War II. Jackson Pollock (1912–56), Clyfford Still (1904–80), and the Abstract Expressionists would adopt non-representational styles, often as a means of personal revelation. Another painter of the era, Mark Rothko (1903–70), was sometimes categorized as an Abstract Expressionist, though he rejected the label. Like Kandinsky, Rothko developed an art that consciously strove for spirituality. His mature style featured amorphous, horizontal blocks of color that were arranged one on top of the other. With their wispy, undefined edges, these shapes seemed to move and interact with one another. In one untitled painting from 1949, the sensual combination of violet, orange, and yellow gives the work an energy that is both meditative and passionate (fig. p. 85).

Since the 1960s, postmodern artists have explored and scrutinized the very concept of abstract art. Wolfgang Tillmans (b. 1968), for example, has created abstract imagery using photographic procedures. These darkroom experiments, with titles such as *Blushes* and *Freischwimmer* (fig. right), were developed by exposing plain photographic paper to fibre optic light. Tillmans' images feature swirling lines and billowing forms reminiscent of Kandinsky. But as they are derived from the same processes that create the photograph, the most "representational" of all images, these works also question the distinctions between abstract and realistic art.

right——WOLFGANG TILLMANS, FREISCHWIMMER 78 | 2004 | C-Print 239 × 181 cm | Courtesy the artist and Andrea Rosen Gallery | New York.

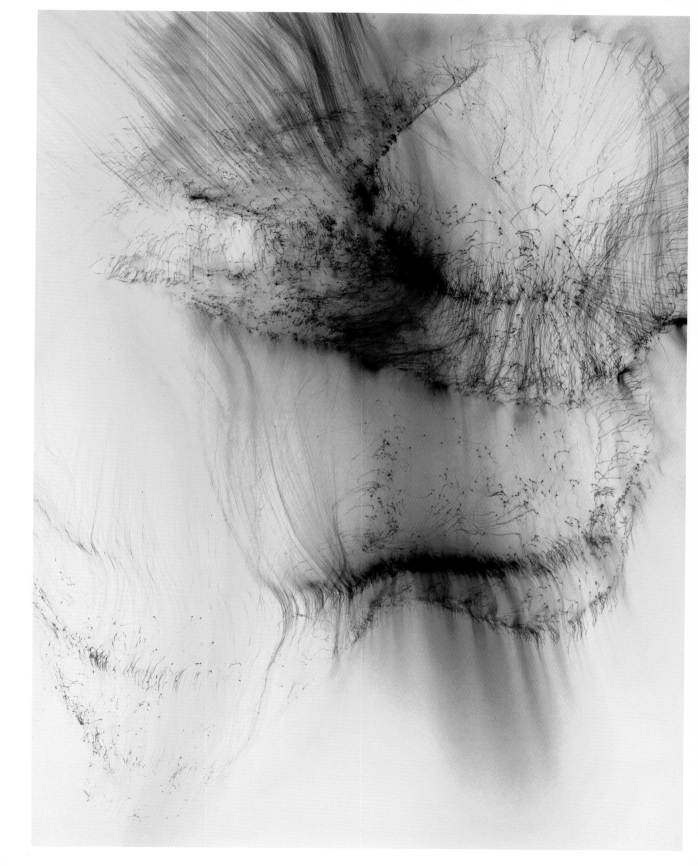

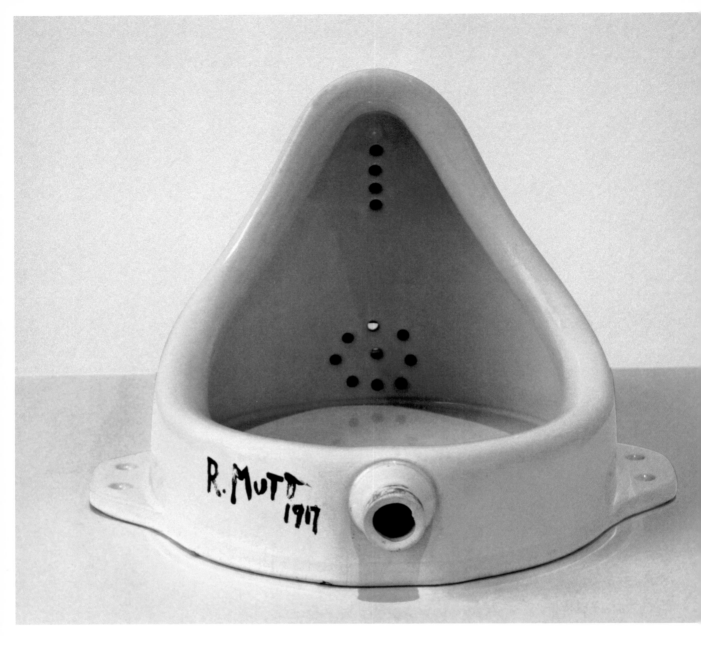

···········**1883:** First petrol-engined automobile···········**1884:** Mark Twain publishes the *Adventures of Huckleberry Finn*···········
···········**1883:** Friedrich Nietzsche publishes *Thus Spoke Zarathustra*···········
···········**1886:** Completion of the Statue of Liberty···········

88/89

| 1881 – 1973: Pablo Picasso | 1886 – 1966: Jean Arp | 1887 – 1968: Marcel Duchamp | 1887 – 1927: Juan Gris |

MARCEL DUCHAMP: ART REDEFINED

Marcel Duchamp (1887–1968) did not fit the image of a radical. Growing up in an upper-class home in Blainville, near Rouen, France, he was the shy youngest brother in a family of artists. Following in the footsteps of his older siblings, Gaston and Raymond, Marcel settled in Paris, where he studied at the upscale Académie Julien and lived in the artistic melting pot of Montmartre. Yet as Duchamp would say later in life, he "had no aim" at this time—"I just wanted to be left alone to do what I wished." But the reserved, seemingly unambitious Duchamp was becoming a keen interpreter of art and the artist's lifestyle. He spent much of his time in Montmartre as an illustrator of humorous visual puns and vignettes, many of which poked fun at stylish Parisian culture. He also made some of his first important artistic contacts, notably the Spanish painter Juan Gris (1887–1927), a close associate of Pablo Picasso (1881–1973). In 1908, Duchamp left Montmartre for the suburb of Neuilly, where he set up his studio. Neuilly not only offered Duchamp a relaxed environment in which he could focus on work, but it also lay near the town of Puteaux, where his brother Gaston (now known as Jacques Villon) was living.

Over the next few years, the three Duchamp brothers organized regular meetings with a growing circle of artists and writers, including the painter Francis Picabia (1879–1953) and the poet and critic Guillaume Apollinaire. By 1911, many members of the group had become swept up in the new Cubist movement. Marcel, a keen mathematician, was drawn to the analytical nature of the style. He soon began creating Cubist images that were inspired by the time-lapse photography of Eadweard Muybridge and Etienne-Jules Marey. These new paintings, which attempted to display movement in "static" form, included a work entitled *Nude Descending a Staircase, No.2* (1912) (fig. p. 91). Duchamp based the picture on studies of a nude model, "keeping only the abstract lines of some twenty different static positions in the successive act of descending." In doing so, the form of the model was abstracted to such an extent that she "does not exist, or at least cannot be seen." Instead, the viewer is presented with a "parallelism of lines describing movement." The result is a Cubist work that paid homage to modern mechanical processes. Duchamp also added a daring literary touch to *Nude Descending*, inscribing the picture's title in bold letters at the bottom of the canvas. The explicit use of the word "nude" soon caused an international scandal. When

left——**MARCEL DUCHAMP, FOUNTAIN** | reconstruction of the original from 1917 | 1964 | porcelain | 33 × 42 × 52 cm | Moderna Museet | Stockholm.

90/91 DUCHAMP ·············· **1900:** Beginning of the Boxer Rebellion in China············· **1914-1918:** First World War ················
·· **1903:** First powered flight by the Wright brothers·······························
·· **1906:** San Francisco earthquake ···································

» *In Duchamp's* Nude Descending a Staircase, No.2, *the viewer is presented with a* ›parallelism of lines describing movement.‹«

Duchamp tried to exhibit the work at the 1912 Salon des Indépendants in Paris, the Salon's organizers requested that Duchamp either revise or eliminate the title. Indignant, the artist "took a taxi to the show and got my painting and took it away." The following year, *Nude Descending* was successfully displayed at the famous Armory Show in New York City, one of the first major exhibitions of modern art in the United States. The work became one of the show's highlights, eliciting both praise and disgust and inspiring numerous caricatures in American magazines and newspapers.

The eventful history of *Nude Descending* had a two-pronged effect on Duchamp's career. First, it strengthened his cynical view of the art establishment. As Duchamp would later say, "I saw that I would never be much interested in groups after that." Second, he became something of an artistic celebrity in America, the country to which he would emigrate only a few years later.

Never satisfied with pursuing one activity for long, Duchamp created only a few Cubist-inspired paintings. In 1913, he decided to make a complete break from the painterly life he had led. He became a librarian at the Bibliothèque Sainte-Geneviève in Paris, devoting himself to the study of mathematics, science, and art history. While there, he began to experiment with a new way of making art—through the use of random acts. He dropped three one-meter strips of thread onto a glass surface, each of which formed a curving pattern. Repeating this act three times, the shapes "thus obtained" were then "fixed onto the canvas by drops of varnish." In this way, Duchamp was able to create an aesthetic image out of "forms obtained by chance." At about the same time, back in his studio, he made another experiment with mechanical movement and chance actions—he turned a bicycle wheel upside down and mounted it on top of a stool (fig. p. 92) . This humorous creation enabled him to experience the wheel's movement in a new way: "To see that wheel turning was very soothing, very comforting, a sort of opening of avenues on other things than material life of every day...."

Duchamp's new creations, which he later titled *Network of Stoppages* and *Bicycle Wheel*, would lead him to question the traditional understanding of art. The "hand" of the painter or sculptor was no longer required for a piece to be called "artwork." For Duchamp, in fact, an over-reliance on manual craftsmanship could produce shallow "retinal art," or art made purely "to please the retina, to be judged

right——**MARCEL DUCHAMP, NUDE DESCENDING A STAIRCASE, NO. 2** | 1912 oil on canvas | 147 × 89.2 cm | Philadelphia Museum of Art | Philadelphia.

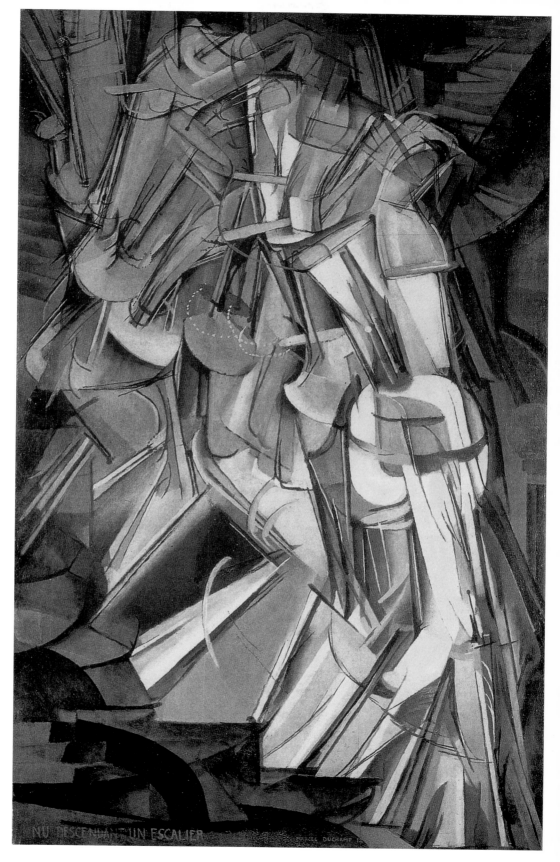

NU DESCENDANT UN ESCALIER MARCEL DUCHAMP

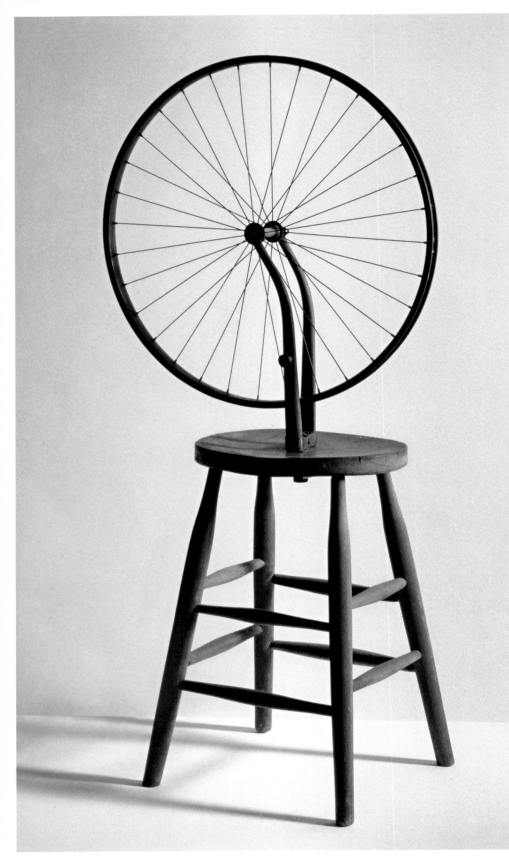

1917 – 2000: Jacob Lawrence 1922 – 2011: Richard Hamilton b. 1929: Claes Oldenburg

for the retinal effect of the picture." Marcel felt the highest artwork should engage the "grey matter" of the brain, inviting viewers to interpret its meaning for themselves.

Duchamp took these ideas a step further in 1917, when he decided to play "an exercise in the question of taste." He was now living in the United States, and the fame he had received from *Nude Descending* had helped earn him important patrons—including the wealthy art collector Walter Arensberg. According to many accounts, Duchamp, Arensberg, and the artist Joseph Stella (1877–1946) searched for an object they could try to pass off as "art" at the 1917 Society of

Independent Artists exhibition in New York City. They eventually settled on a Bedfordshire-style porcelain urinal from a New York plumbing store (fig. p. 88). When Duchamp took the urinal to his studio, he turned it on its side and painted "R. MUTT 1917" in black ink on the urinal's rim. He then had the piece submitted to the exhibition, using the assumed name with which he had "signed" the work. The exhibition's organizing committee reviewed the strange object and even debated its aesthetic merits, but ultimately the piece was rejected as "by no definition, a work of art."

The following week, Duchamp's urinal was taken to 291, the pioneering modern art gallery of photographer Alfred Stieglitz. Stieglitz took a suggestive "portrait" of the work, which was then published in the avant-garde art magazine *The Blind Man*. The accompanying text, possibly written by both Duchamp and art critic Louise Norton, read: "THE RICHARD MUTT CASE
They say any artist paying six dollars may exhibit. Mr. Richard Mutt sent in a fountain. Without

left——**MARCEL DUCHAMP, BICYCLE WHEEL** | reconstruction of the original from 1913 | 1963 | stool, bicycle | 128 × 64 × 33 cm | Sammlung Richard Hamilton Henley-on-Thames.

right——**JEAN ARP, BIRDS IN AN AQUARIUM** | c. 1920 | painted wood 25.1 × 20.3 × 11.4 cm | Museum of Modern Art | New York.

1959: Completion of the Solomon R. Guggenheim Museum in New York ... **1967:** Six-Day War DUCHAMP **94/95**

1961: Construction of the Berlin Wall ...

1969: Neil Armstrong lands on the moon

b. 1957: Ai Weiwei 1960–1988: Jean-Michel Basquiat b. 1965: Damien Hirst

»Like Duchamp's Fountain, *Damien Hirst's works are intended to startle the viewer«*

discussion this article disappeared and was never exhibited.

What were the grounds for refusing Mr. Mutt's fountain:—

1. Some contend it was immoral, vulgar.
2. Others, it was plagiarism, a plain piece of plumbing.

Now Mr. Mutt's fountain is not immoral, that is absurd, no more than a bathtub is immoral. It is a fixture that you see every day in plumbers' show windows.

Whether Mr. Mutt with his own hands made the fountain or not has no importance. He chose it. He took an ordinary article of life, placed it so that its usual significance disappeared under the new title and point of view—created a new thought for that object. ..."

Duchamp's "exercise in the question of taste" soon expanded the role of the artist—and the very concept of art. *Fountain* would be included among many objects that Duchamp called *readymades*, objects that had become works of art through the choices and manipulations of their artist. Marcel's intellectual breakthrough came at a time when many artists were questioning traditional values. The ravages of World War I were being seen as an inevitable result of "rational," paternalistic Western culture. In response, groups of artists and writers were beginning to create intentionally absurdist works. The leaders of the Dada movement, including the German-French artist Jean Arp (1886–1966), were devoted to absurdity. In his sculpture *Birds in an Aquarium* (c.1920), Arp uses humorous, abstract forms reminiscent of children's art (fig. p. 93). The result is a colorful aesthetic joke worthy of Duchamp.

After World War II, Duchamp's ideas would continue to have great resonance. Postmodern conceptual art owes much to these innovations. Artists like Damien Hirst (b. 1965) have spent their careers reworking and reinterpreting the object. Hirst's *The Physical Impossibility of Death in The Mind of Someone Living* (1991) (fig. left) features a shark preserved in formaldehyde and displayed in an eerily antiseptic glass container. Like *Fountain*, it is a work intended to startle the viewer. But it is also richly suggestive, touching upon themes from environmental degradation to the hubris of modern science.

left——**Damien Hirst, The Physical Impossibility of Death in The Mind of Someone Living** | 1991 | tiger shark, glass, steel, formaldehyde solution | 213 × 518 × 213 cm | Saatchi collection | London.

1883: First petrol-engined automobile 1889: Completion of the Eiffel Tower 96/97
1886: Completion of the Statue of Liberty
1895: Discovery of X-rays

MAX ERNST: THE SURREALIST MELTING POT

World War I (1914–18) was the first global conflict during the era of modern art. The extreme brutality of the war, which involved the use of trench combat, machine guns, and other horrors of modern technology, made many Europeans question the motives of their governments and the value of "rational" culture. Even before the war, many young artists were already skeptical of the West's crass imperialism and the stagnant nature of "official" European education and aesthetic taste. The radical works of Picasso, Matisse, and Kandinsky in the early 1900s seemed to represent a violent break with centuries-old traditions. But these early modernists were mostly confined to Paris and a few other European cities. The Great War spread notions of cultural upheaval worldwide. In Russia, where the war led to a dramatic political revolution, the artistic avant-garde attempted to create a new "official" art for a new communist nation—one that, for a time, utilized abstract form and modern technology in constructive ways. For Western Europe, the "revolution" often materialized in more cynical forms.

One movement that developed in this environment was Dada, its very name suggesting its absurdist bent. Founded during the war in Zurich and elsewhere, the Dadaists began in part as a literary cause. Poets such as Paul Éluard and Kurt Schwitters explored "anti-rational" themes. They were inspired by the writings of Friedrich Nietzsche, Sigmund Freud, and other philosophers who eschewed notions of universal truths and promoted the study of dreams and the subconscious mind. Dada writers also used non-logical word play to heighten their works' absurdist quality.

For the visual artists of the movement, inspiration would come from many pre-World War I sources. Marc Chagall's (1887–1985) hallucinatory village scenes, including *I and the Village* (1911) (fig. p. 104), contained disembodied heads, distorted perspective, and glowing colors. The warped townscapes of Italian painter Giorgio de Chirico (1888–1978), such as *The Duo* (1914–5) (fig. 101) , transformed a classical symbol of European rationalism—the Renaissance Italian piazza—into a nightmarish world of mechanical human figures and unnervingly vast, empty spaces. Both painters suggested the possibilities of dreamlike images and psychic states in art. In addition, the energetic, tightly ordered collages of synthetic Cubism brought non-traditional materials into art. Picasso's *Guitar* (1913) transformed

left——MAX ERNST, LONG LIVE LOVE or PAYS CHARMANT | 1923
oil on canvas | 131.5 × 98 cm | St. Louis Art Museum | St. Louis.

98/99 ERNST ·············· **1900:** Sigmund Freud publishes *The Interpretation of Dreams* ·············· **1912:** Sinking of the Titanic ··············

·············· **1903:** First powered flight by the Wright brothers ··············

1909: Opening of Queensboro Bridge in New York ··············

1898 – 1967: René Magritte 1904 – 1989: Salvador Dalí 1910 – 1962: Franz Kline

»*Max Ernst's earliest experiments with Dadaism reflect an ambiguous use of space and the human form.*«

newspaper clippings and other found objects into potent imagery. One Dadaist who effectively synthesized all of these visual and thematic innovations was Max Ernst (1891–1976).

Born near Cologne, Germany, Ernst studied art history, philosophy, and literature at the University of Bonn, and he became well acquainted with the writings of Freud and Nietzsche. He also began his artistic career there, befriending the German painter August Macke and adopting Macke's Expressionistic painting style. Yet like many artists, Ernst's life would be overturned by the war. He witnessed the war's savagery at first hand while serving in the German army, and he also grieved over the death of August Macke, who died in battle. Some of Ernst's final Expressionist images, from 1918, were line drawings that showed the twisted bodies of dying soldiers. But soon the young artist turned away from Expressionism and towards an art that better expressed his own feelings of uncertainty and skepticism.

Ernst's earliest experiments with Dadaism reflect a close study of Giorgio de Chirico's art, especially his ambiguous use of space and the human form. *Aquis submersus* (1919) features a toylike male figure lacking arms or genitalia (fig. right). This emasculated "chess piece" is set amidst a decidedly artificial, cramped Italianate courtyard, with the nocturnal sky resembling the back wall of a stage set. Ernst

also began to explore a wide variety of compositional techniques. Taking inspiration from the synthetic Cubists, he made sophisticated collages of found materials. Many of these works featured illustrations from a catalogue of teaching aids called the *Bibliotheca Pedagogica*. Later in life, Ernst's description of the catalogue neatly summed up the stylistic revolution he was undergoing:

"One rainy day in Cologne on the Rhine, the catalogue of a teaching-aids company caught my attention. It was illustrated with models of all kinds—mathematical, geometrical, anthropological, zoological, botanical, anatomical, mineralogical, paleontological, and so forth—elements of such a diverse nature that the absurdity of the collection confused the eye and mind, producing hallucinations and lending the objects depicted new and rapidly changing meanings. I suddenly felt my 'visionary faculties' so intensified that I began seeing the newly emerged objects against a new background."

Ernst spent years manipulating such hallucinatory images, synthesizing their "diverse" elements in surprising, poignant, and often humorously vague ways.

right——**MAX ERNST, AQUIS SUBMERSUS** | 1919 | oil on canvas | 54 × 43.8 cm Städelsches Kunstinstitut und Städtische Galerie | Frankfurt am Main.

Aquis submersus

1919: Formation of the Bauhaus school
1925: Invention of television
1917: October Revolution in Russia
1931: Completion of the Empire State Building

1917 – 2009: Andrew Wyeth 1921 – 1986: Joseph Beuys 1925 – 2008: Robert Rauschenberg

In some instances, he would isolate an entire page from a catalogue and then paint over it, leaving the printed images in their original positions but creating "a new background"—a new reality—for them. In other instances, he built true collages out of photographs and printed reproductions. In *Anatomy of a Bride* (1921), for example, banal illustrations of female body parts and industrial products are fused together to construct a "female body" that eerily combines the organic with the mechanical (fig. above). Ernst then places his "exposed" woman over an altered photograph of a barren field, further disorienting the viewer. Such works expressed Ernst's desire—and the desire of many Dadaists—to juxtapose seemingly random elements in ways that heightened the senses and invited viewers to find their own meanings in the works' confusing tapestries.

In the same year that he produced *Anatomy of a Bride*, Ernst also began making paintings based on his collage style. One of the best known of these images, *Celebes* (1921), perhaps best exemplifies the artist's heterogeneous style (fig. p. 103). The image is dominated by a metallic, elephantine figure, which stares intently towards a headless female torso. The trunk of the creature resembles a giant vacuum cleaner hose, extending out of its head and snaking upwards and into its body. On the creature's back sits a brightly colored, engine-like contraption.

Yet despite the mechanized elements of the beast, Ernst models its lower body in swelling, undulating forms—giving the creature a true organic power. At first glance, Celebes seems ominous, a figure of overwhelming and possibly abusive sexual intent. But the beast also has an ungainly, almost comical bearing, a humorous note that is echoed in the awkwardly receptive "come hither" arm gesture of the female torso. *Celebes'* enigmatic nature is enhanced by its ambiguous spatial composition. The vast mountain landscape seems to exist far in the distance, yet the sky has been converted into an enveloping ocean, complete with swimming fish. Ernst consulted a wide variety of sources for this work. The headless torso and landscape are derived from De Chirico's playfully "classical" imagery, while the elephant's body is based on a photograph of a massive Sudanese corn bin. Thus the work also mixes Western and non-Western elements, subtly exploring the conflicted relationship between European nations

above——**Max Ernst, The Anatomy as Bride** | 1921 | photographic enlargement of a collage with gouache and ink mounted on paperboard 23.1 × 17.1 cm | Private collection.

left——**Giorgio de Chirico, The Duo** | 1914–15 | oil on canvas 81.9 × 59 cm | Museum of Modern Art | New York.

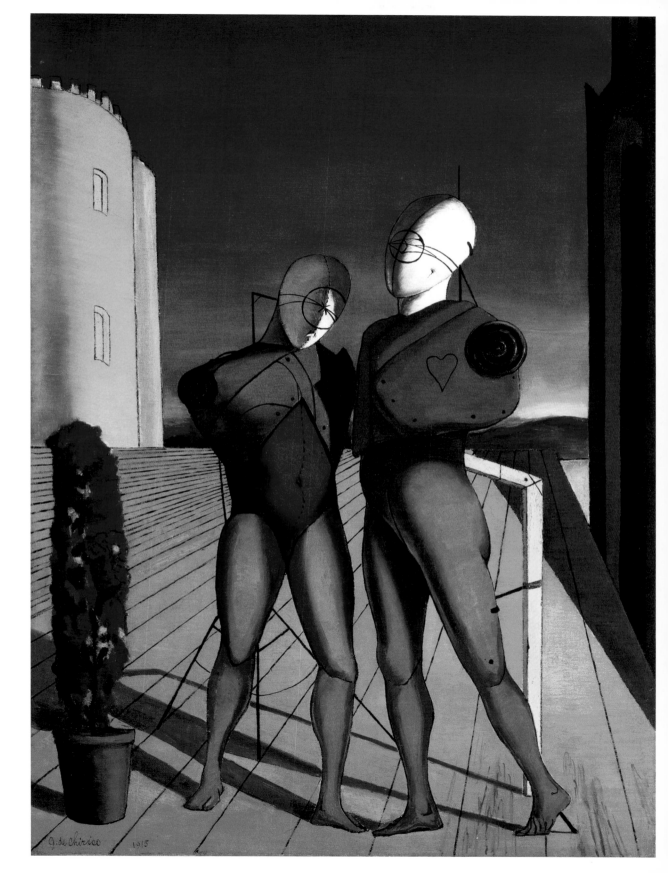

1933: Adolf Hitler seizes power ·· **1941:** Pearl Harbor attack ···

1939-1945: Second World War ···

1946: First computer ···························

1933 – 1996: Dan Flavin **b. 1938: Georg Baselitz** **b. 1940: Chuck Close**

» *Max Ernst's* Celebes *also mixes Western and non-Western elements, subtly exploring the conflicted relationship between European nations and colonized peoples.«*

and colonized peoples. Ernst's painted collage may defy easy analysis, yet its harmonious composition produces a cogent, iconic image of twentieth-century modernism.

The works of Ernst, de Chirico, and other Dadaists would inspire the French writer André Breton to found the Surrealist movement in 1924. Surrealism was "based on the belief in the superior reality of certain forms of previously neglected associations, in the omnipotence of dream, in the disinterested play of thought." Such goals would inspire an array of cultural celebrities during the 1930s, including Salvador Dalí, Joan Miró, and Yves Tanguy, and they would influence nearly every artistic medium: from painting to architecture to the animated cartoon. Later generations of artists, including those in the Pop Art movement, would also search for suggestive connections between seemingly unrelated objects. Robert Rauschenberg's (1925–2008) *Combines* further break down the barriers between artistic

and non-artistic materials and themes—combining painted elements with old clothing, urban refuse, taxidermized animals, and various commercial products. These spirited postmodern collages include such titles as *Monogram* (1955–59) and *Canyon* (1959). In *Canyon* (fig. p. 105), Rauschenberg not only mixes materials, but also the mythic imagery of America and ancient Europe. A stuffed bald eagle appears to burst out of a canvas covered with faded materials, including old newspaper clippings and an image of the Statue of Liberty. Attached to the bottom of the canvas is a rope that holds up an old pillow. Art historians have linked *Canyon* to a Greek myth in which Zeus takes on the form of an eagle to abduct Ganymede, the beautiful prince of ancient Troy. Rauschenberg's bald eagle represents an "American Zeus;" while the supple, organic pillow suggests the body of young Ganymede. This multilayered work seems to grow directly out of the oeuvre of Max Ernst and his dreamlike "catalogue" of imagery.

right——**MAX ERNST, CELEBES** | 1921 | oil on canvas | 125.4 × 107.9 cm
Tate | London.

1949: Founding of the Federal Republic of Germany

·1948: Founding of the State of Israel

1959: Completion of the Solomon R. Guggenheim Museum in New York

1961: Construction of the Berlin Wall

ERNST 102 /103

b. 1958: Julian Opie b. 1960: Neo Rauch b. 1962: Takashi Murakami

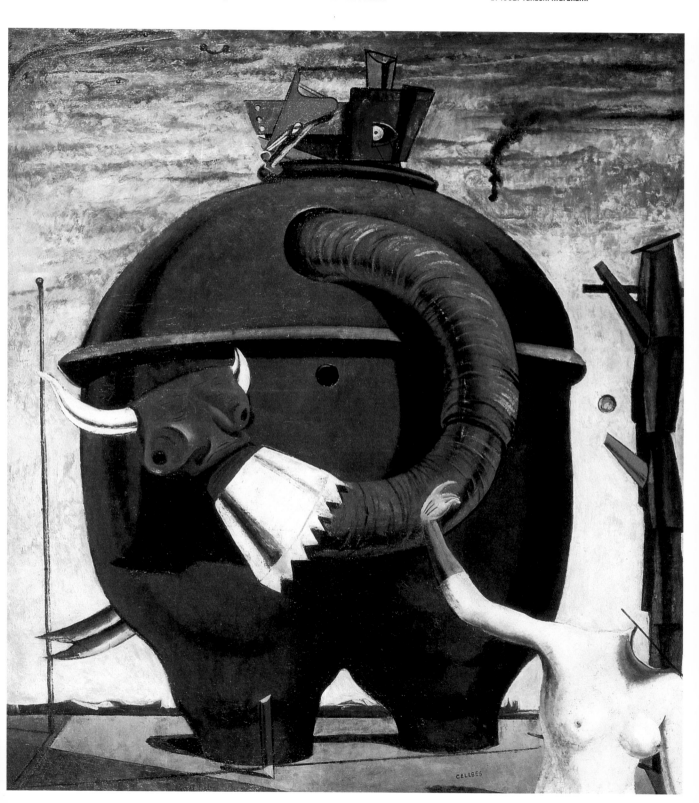

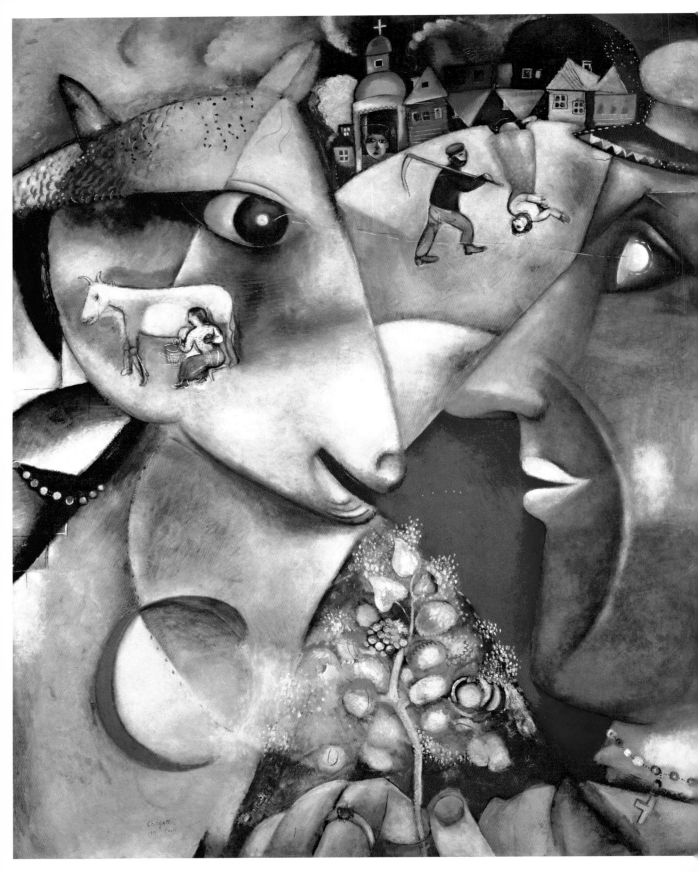

b. 1967: Olafur Eliasson b. 1970: Jonathan Meese b. 1974: Anri Sala

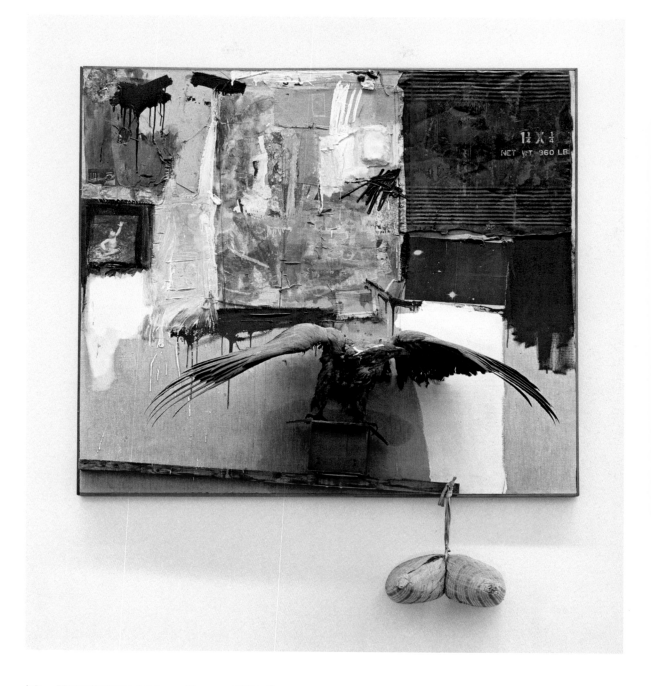

left——MARC CHAGALL, I AND THE VILLAGE | 1911 | oil on canvas
192.1 × 151.4 cm | Museum of Modern Art | New York.
above—— ROBERT RAUSCHENBERG, CANYON | 1959 | different techniques
and materials on canvas | 208 × 178 × 61 cm | Ileana Sonnabend Collection
New York.

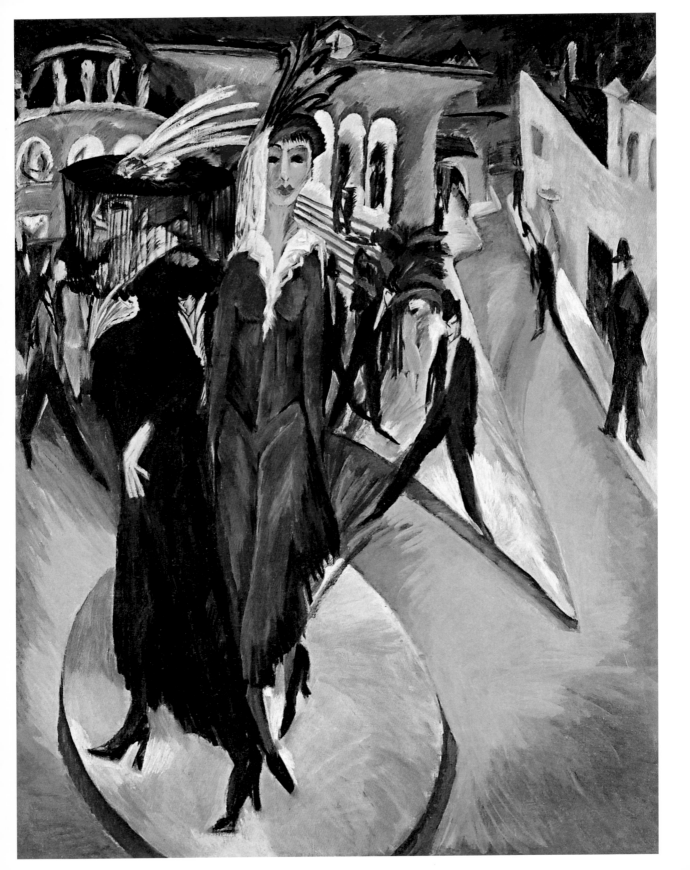

1853-1856: Crimean War 1861-1865: American Civil War ..

........... 1857-1859: First world economic crisis ...

106/107

.. 1876: Battle of the Little Bighorn

1853 – 1890: Vincent van Gogh 1862 – 1918: Gustav Klimt 1867 – 1956: Emil Nolde 1869 – 1954: Henri Matisse

ERNST LUDWIG KIRCHNER: *DIE BRÜCKE* AND EXPRESSIONISM

Progressive art movements in late nineteenth-century Europe took different forms in different countries. In the German-speaking nations of central Europe—primarily Germany and Austria-Hungary—the new Jugendstil art incorporated many different kinds of artists under one umbrella. The architect Joseph Maria Olbrich (1867–1908), the graphic artist Alphonse Mucha (1860–1939), and the painter Gustav Klimt (1862–1918) all broke with the neo-classical traditions that dominated most art academies. They also responded to the growing industrialization of society, and the assembly-line manufacturing processes that seemed to be driving out traditional craftsmanship. For many Jugendstil artists, the revolt against neoclassical purity and industrial mechanization led to a "back-to-nature" style. In buildings, paintings, sculptures, books, glassware, and other media, this style most often featured expressive, curving shapes based on natural forms. Jugendstil also inspired the development of numerous artist groups, especially in the Austrian capital. The Vienna Secession (1897) organized important avant-garde exhibitions, while the Wiener Werk-

stätte (Vienna Workshop) (1903) provided a robust working environment for the production of modern, hand-crafted art and design. In other German cities, smaller artists' groups often pursued even more radical ideas.

Dresden was the historic capital of Saxony and a treasure house of Baroque art and architecture. The city's Technische Hochschule (technical university) had one of the finest schools of architecture in the region; and in 1901 a gregarious, temperamental Bavarian art student from Aschaffenburg enrolled there. Ernst Ludwig Kirchner (1880–1938) had been sent to Dresden by his father to study architecture, but his own artistic goals were very different. He wanted to become a painter and illustrator, and he had a passion for the expressive, emotionally-charged imagery of Albrecht Dürer (1471–1528) and Rembrandt van Rijn (1606–69). Though Kirchner was able to take drawing classes at the university, he felt stifled by the constraints of academic life. Over the next four years, Kirchner met three other art students that shared his passions—Fritz Bleyl (1880–1966), Erich Heckel (1883–1970), and Karl Schmidt-Rotluff (1884–1976). Bleyl's own description of Kirchner would suggest the powerful impression that Kirchner made on his younger colleagues:

"I encountered a well-built, upright youth of the greatest self-assertion and the most passionate

temper, who possessed a gloriously untroubled disposition and an infectiously candid laugh, and who was possessed by a sheer mania to draw, to paint, to busy himself and come to terms with artistic things and ideas. His 'digs' were those of an avowed bohemian, full of pictures, drawings, books, painting and drawing gear colorfully lying around everywhere—much more the romantic lodgings of a painter than the dwelling of an orderly student of architecture."

In 1905, after Kirchner had completed his architectural studies, the four friends decided to establish a working group in which they could pursue their own artistic interests. They called the group *Die Brücke* (The Bridge), partly in reference to philosopher Friedrich Nietzsche's line from *Also Sprach Zarathustra*: "What is great in man is that he is a bridge ..." Nietzsche's belief in the need for people to improve themselves through asserting their individual genius spoke directly to Kirchner. Die Brücke was also influenced by the Jugendstil era's "compulsion to integrate art and life." The artists' bohemian headquarters were located in a working-class district of Dresden, and they were soon filled not only with paintings and drawings but also with hand-made furniture, kitchenware, and other household items of their own design. Within this aesthetically integrated environment, Kirchner and his group spent countless hours working, discussing, and arguing over the development of their art. They also began to bring their bohemian lifestyle out of doors, scandalizing the conservative citizens of Dresden with their open-air studies of nude models, both male and female. The members of Die Brücke benefited from Dresden's prominent cultural status, and they immersed themselves in the city's museums and libraries and its growing schedule of avant-garde exhibits. Kirchner absorbed at first-hand the images and techniques that profoundly influenced his own art—the thick, passionate brushwork of Vincent van Gogh (1853–90); the swirling, emotionally raw images of Edvard Munch (1863–1944); the nightmarish depictions of Parisian subculture by Henri de Toulouse-Lautrec (1864–1901); and the suggestive coloring and spatial constructions of Henri Matisse (1869–1954). Kirchner would also take in ideas from non-Western sources—from the abstract masks of tribal Africa and the South Pacific, which he saw at the Dresden Ethnographic Museum, to illustrations of the erotic Indian cave paintings from ancient Ajanta, which Kirchner had found at the city library.

Using this eclectic array of sources, Kirchner developed a particularly aggressive, emotionally probing art. He became famous for working quickly and producing work that had the freshness and immediacy of a sketch. In *Franzi in a Carved Chair* (1910) (fig. right), the young girl's mask-like facial features and the thickly-applied Fauvist coloring give the image an intense, almost threatening aura. The vaguely anthropomorphic form of the chair seems to hover over the girl, ready to engulf her at a moment's notice. *Franzi* displays Kirchner's talent for suggesting extreme psychological intensity. Similar results were also achieved in the artist's woodcut prints (fig. p. 112). Kirchner's facility with the medium stemmed in part from his study of Dürer's and Rembrandt's graphic works. Kirchner's prints, however, dispense with the fine detail of these earlier masters, focusing instead on rough, often angular simplifications of human form. Like the artist's paintings, these

right——**ERNST LUDWIG KIRCHNER, FRANZI IN A CARVED CHAIR** | 1910
oil on canvas | 71 × 49.5 cm | Museo Thyssen-Bornemisza | Madrid.

right——**Ernst Ludwig Kirchner, Winter in Davos** | 1923
oil on canvas | 121 × 150 cm | Kunstmuseum | Basel.

1919: Founding of the Weimar Republic ·· **1925:** Invention of television ··

······························ **1922:** Discovery of Tutankhamun's Tomb ·······················

·· **1931:** Completion of the Empire State Building ······················

1912 – 1956: Jackson Pollock 423 – 1997: Roy Lichtenstein b. 1931: Bridget Riley

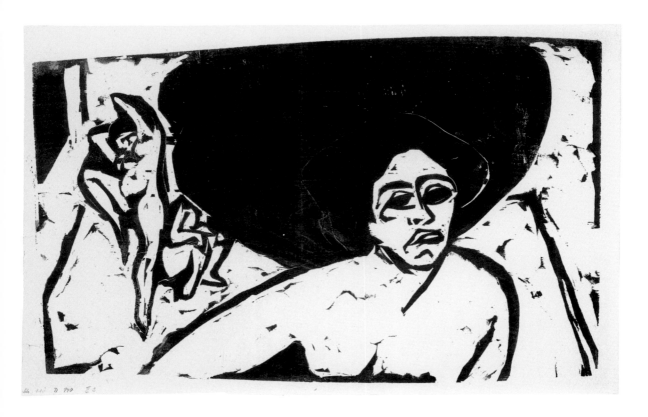

works were designed to reveal psychic states. They also expressed the natural coarseness of the wood from which they were made, showing in Kirchner a feel for materials that linked him with Jugendstil craftsmen.

The growing maturity of Kirchner's art helped to raise the profile of Die Brücke outside Dresden. Other artists, including Emil Nolde (1867–1956) and Max Pechstein (1881–1955), joined the group for short periods. But by 1913, two years after the group moved from Dresden to Berlin, internal disputes forced it to disband. Yet Kirchner's own style continued to evolve. His move to the German capital had placed him in a far larger city with a particularly liberal nightlife. This new environment brought a heightened sense of drama to his works, and it led to a series of remarkable paintings of Berlin street culture. In one of the most famous of these works, *Potsdamer Platz* (1914), Kirchner reveals all of the elements of his stylistic maturity (fig. p.106). Every facet of the painting is designed to suggest the nihilistic,

decadent nature of the modern city. Though the image is based on a real location in Berlin, Kirchner has transformed the city square into a brooding dreamscape. Street corners and traffic circles have been warped and stretched into rubbery, gray shapes; which seem to float precariously above the fiery green streets. In the foreground, two prostitutes confront the viewer directly, their mask-like green faces partially hidden by hideously elaborate feathered hats. Behind them, anonymous men in bowler hats appear as flattened, black shapes— holograms making their way through a collage-like jumble of buildings. One of the men is shown stepping off the street corner, his legs placed wide apart and advancing predatorily towards the women. The nightmarish quality of this scene is amplified by the agitated brushwork and the surreal color scheme of greenish hues, fiery pinks, deep blues, and grays. *Potsdamer Platz* not only presents the viewer with an "impression" of decadent nightlife; it also draws the the viewer into that world.

b. 1945: Paul McCarthy 1960 – 1988: Jean-Michel Basquiat b. 1965: Zhang Huan

The works of Kirchner and his circle were now being referred to as "Expressionist," a style in which the artist, according to one contemporary critic, "looks at the world with eyes that understand hidden inner life." Kirchner's neurotic images also reflected the corrosive nature of European political life, and they augured the political collapse of World War I. Many young artists fell victim to that war, but Expressionism would survive for decades, especially in Germany.

Emil Nolde was one of the earliest members of Die Brücke, and for a long time he used Expressionist color to examine religious themes and the natural world. From the 1920s through the 1950s, Nolde cre-

ated a series of watercolors that capture the maritime landscapes of his north German homeland. These images reduce the visual details of nature to its simplest forms, and they incorporate an astonishing variety of cloud-like hues and color gradations (fig. pp. 114/115). The restless tonal complexity of this work, though non-naturalistic, still evokes the windswept "essence" of Nolde's North Sea environment, as well as his emotional ties to that landscape.

In the late twentieth century, other artists co-opted the more politically-charged aspects of early Expressionism. The decaying environments of urban America—and the accompanying racial tensions—provoked much of the same cynicism and outrage as did Berlin's seedy prewar streets. New York painter Jean-Michel Basquiat (1960–88) produced "neo-Expressionist" works that embodied this anger (fig. above). His decomposing human skulls and human figures incorporated the symbols and colors of urban graffiti art, but they also evinced some of the raw, fiery spirit of Ernst Ludwig Kirchner.

left——**Ernst Ludwig Kirchner, Nude Dancers (Nackte Tänzerinnen)** | 1909 | woodcut on laid paper | 35 × 57.3 cm | Private collection.
above——**Jean Michel Basquiat, Untitled Skull** | 1982 | oilstick on paper | 21.5 × 16.5 cm | Private collection.

right——**EMIL NOLDE,**
FARMHOUSE IN
THE MARCHES
1920–25 | watercolor on
Japanese tissue paper
33.1 × 47.8 cm
Staatliche Graphische
Sammlung | Munich.

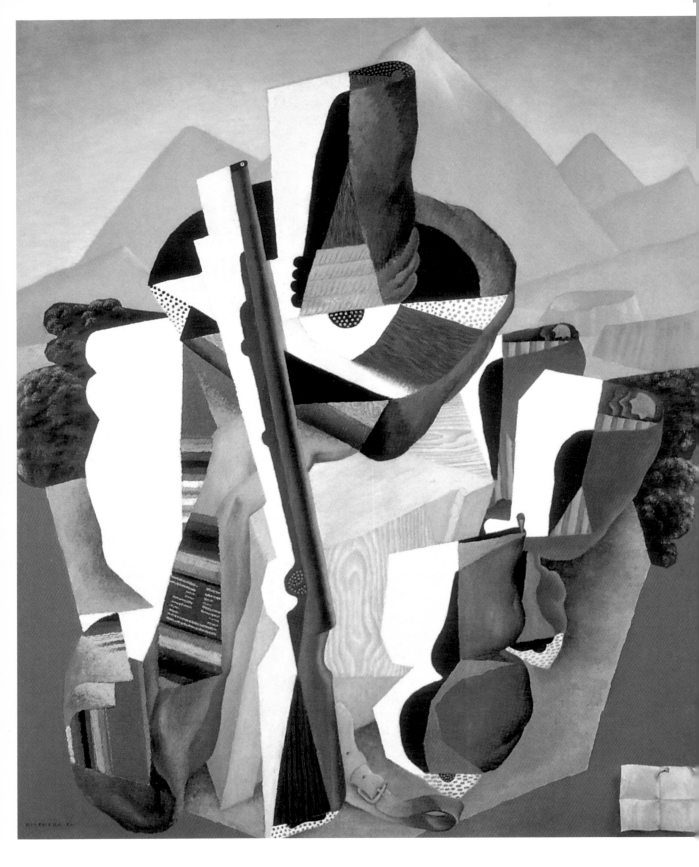

1876: Invention of the telephone ... 1879: Birth of Albert Einstein .. 116/117

1877: Leo Tolstoy publishes *Anna Karenina* ...

1883: First petrol-engined automobile

1872 – 1944: Piet Mondrian 1877 – 1962: Gabriele Münter 1881 – 1973: Pablo Picasso

DIEGO RIVERA:
THE COURT OF THE FIESTAS AND MODERN POLITICAL ART

During the early 1900s, the winds of cultural and political revolution that swept through Europe also affected other places around the globe. Mexico, like most of Latin America, had been independent for nearly a century. Yet those first hundred years had been tumultuous ones—with the country losing much of its northern territory in wars against the United States and then suffering an occupation by the French army. During the late nineteenth century, under the dictatorial rule of Porfirio Díaz, Mexico saw greater stability, industrialization, and economic growth. But such changes had little effect on the nation's cultural and economic inequalities, which had developed during Mexico's centuries-long Spanish colonial era. A small, largely white aristocracy still controlled most of the country's wealth, with the vast majority of the population—either indigenous Mexicans or *mestizos* (people with a mixture of white and indigenous heritage)—left largely uneducated, disenfranchised, and trapped as laborers for overbearing land owners.

Late nineteenth-century Mexico also suffered from a sense of cultural inferiority. Locally produced art was often dismissed in favor of European imports, and the indigenous cultural heritage of the Maya and the Aztecs was only beginning to be recognized. The few Mexican art schools that did exist taught the most conservative academic techniques, with an emphasis on highly detailed and polished realism. In 1897, the most prominent of these schools, the Academy of San Carlos in Mexico City, admitted a gifted 10-year-old student named Diego Rivera (1886–1957). Rivera came from a liberal-minded family, but he benefited greatly from the academy's rigorous, old-fashioned instruction. His teachers included Santiago Rebull (1829–1902) and José María Velasco Gómez (1840–1912), both among Mexico's finest Victorian painters, and they honed Diego's innate talents for draftsmanship, color, and portraiture.

In 1906, the year Rivera graduated, he was able to obtain a government-sponsored scholarship (300 pesos a month) to study in Europe. The gregarious young Mexican spent most of the next fourteen years in Paris, exposing himself to the latest currents in European art. Rivera counted Amadeo Modigliani (1884–1920), Piet Mondrian (1872–1944), and Pablo Picasso (1881–1973) among his friends, and by 1913 he began experimenting with Picasso's nascent Cubist style. For Diego, the radical geometric constructions of Cubism were an effective "expression of the Mexican mood," which was now focused on national

left——**Diego Rivera, Zapatista landscape** | 1915 | oil on canvas 144.8 × 124.4 cm | Museo Nacional de Arte/INBA | Mexico City.

········· **1889:** Completion of the Eiffel Tower ·····················

1895: Discovery of X-rays ·····························

········· **1887:** First Sherlock Holmes novel is published ·················· **1897:** Opening of the giant wheel in the Viennese Prater ···············

1886 – 1957: Diego Rivera **1890 – 1918: Egon Schiele** **1895 – 1965: Dorothea Lange**

»*Diego Rivera pursued a subtle visual style that blended the streamlined forms of both European modernism and pre-Columbian sculpture.*«

revolution. Mexico's long-standing Diaz government had recently been overthrown, and a series of insurgents—including Francisco "Pancho" Villa and Emiliano Zapata—were battling for control of the government. Rivera, however, spent the entire Mexican Revolution in Europe, unable to participate in the struggle directly. So he responded to the momentous events by producing artworks that were often overtly political. In his *Zapatista Landscape* (1915) (fig. p. 116), a Cubist jumble of sarapes, sombreros, and guns seems to erupt out of a Mexican landscape of cool blue mountains. These disquieting juxtapositions made the work famous in Paris, greatly enhancing Rivera's prominence in both Europe and his home country. By 1920, the Mexican Revolution had ended and a socialist constitution had been set in place. The new government led by President Álvaro Obregón began a program to modernize Mexican culture. Obregón's Minister of Education, José Vasconcelos, opened up hundreds of new schools and libraries, and he announced an ambitious plan to sponsor public art. Vasconcelos believed this new art might take the form of public murals, so as "to put the public in contact with great artists." As one of Mexico's acknowledged "great artists," Rivera was given the opportunity by Vasconcelos and Alberto Pani, the Mexican ambassador in Paris, to study the great Renaissance frescoes of Italy. So in 1921, Diego spent his final months in Europe scouring the museums and churches of Florence, Padua, Rome, Verona, and Ravenna. After returning to Mexico later that year, Rivera continued his study of antique art. He went with

Vasconcelos on a tour of Mayan ruins in Yucatán, and he took subsequent trips to rural Mexico, absorbing its agricultural lifestyle. Now ready to put his studies into practice, Rivera convinced Vasconcelos in 1923 to give him his first major commission—the painting of over 100 frescoes in the courtyards of Mexico City's new Ministry of Education building. Rivera would use the commission to explore a remarkable variety of social and political themes, including the struggles of the revolution and the concept of "Mexicanidad," or "Mexicanness." The huge scale of the project required an army of assistants, all of whom had to master the difficult techniques of fresco painting, which involved carefully preparing the walls with plaster and then completing the painting before the plaster dried. Rivera's first fresco series, which adorned the building's "Labor Courtyard," depicted scenes of industrious rural workers—symbols of the "liberated" Mexican peasantry. Yet Rivera's images never devolved into shallow propaganda. The artist was pursuing a subtle visual style that blended the streamlined forms of both European modernism and pre-Columbian sculpture.

After completing the frescoes in the Labor Courtyard, Rivera turned his attention to a neighboring courtyard that he called the "Court of the Fiestas."

right——**DIEGO RIVERA, FRIDAY OF SORROWS ON THE CANAL OF SANTA ANITA** | 1923/24 | fresco | 4.56 × 3.56 m | Court of the Fiestas, Ministry of Education | Mexico City.

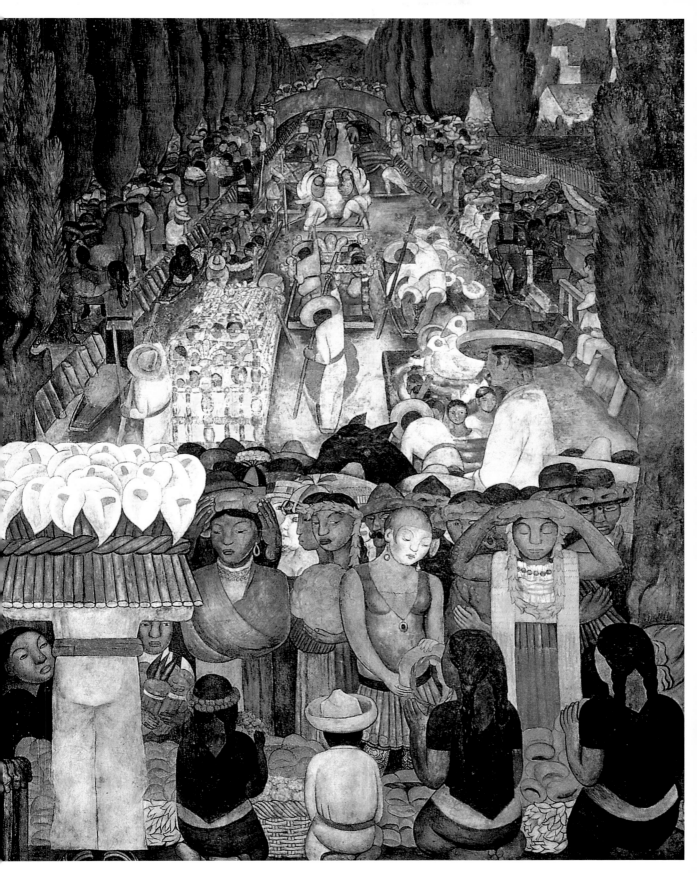

1905: Formation of the expressionist group Die Brücke
1903: First powered flight by the Wright brothers
1909: Opening of Queensboro Bridge in New York

1903 – 1970: Mark Rothko 1908 – 1997: Victor Vasarely 1912 – 1956: Jackson Pollock

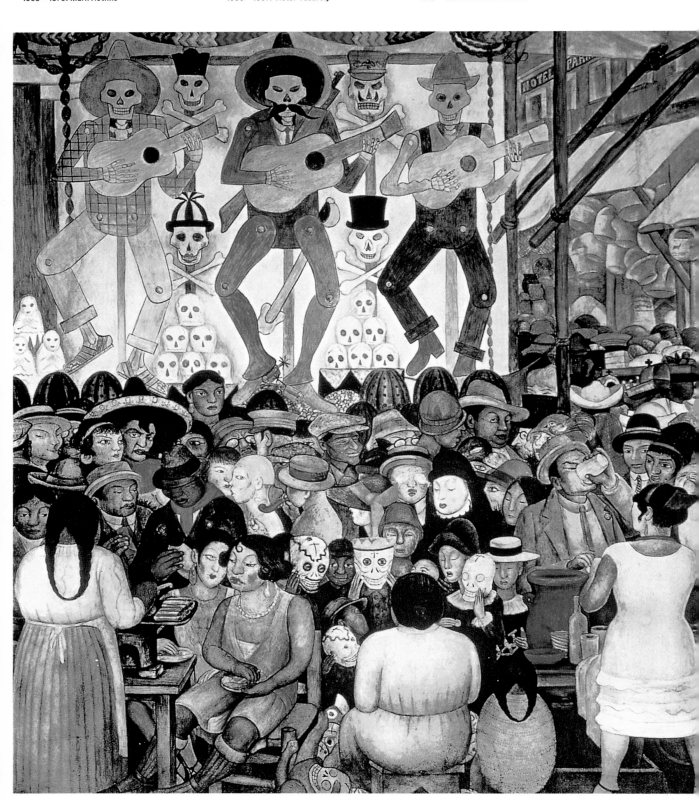

1919: Founding of the Weimar Republic
1922: Discovery of Tutankhamun's Tomb
1925: Invention of television
1931: Completion of the Empire State Building

RIVERA **120/121**

1904 – 1989: Salvador Dalí 1907 – 1954: Frida Kahlo 1912 – 1956: Jackson Pollock

The mural cycle he painted there, from 1923 to 1924, marked the full flowering of his art. Now more confident with his fresco technique, Rivera experimented with bold compositions that often involved huge crowds of people. He also used a wider array of colors, reflecting the vitality of Mexican street life. The imagery depicted festivals that represented "Mexicanidad" in all its complexity. Three of the iconic works were *Friday of Sorrows on the Canal of Santa Anita, Day of the Dead—City Fiesta,* and *The Burning of the Judases.*

In *Friday of Sorrows*, Rivera captured the festival's remarkable amalgamation of Spanish and pre-Columbian traditions (fig. p. 119) . The scene depicts a Catholic ritual held in an Aztec setting. In the foreground, a mestizo woman in 1920s attire is shown among "pure-blood" indigenous women with stylized, sculptural heads and traditional costumes. Behind them, ceremonial floats are paddled by sombreroed oarsmen, a procession that extends dramatically into the distance along the canal. Images used to represent Mexican Christianity, including the stylized bundle of white calla lilies, are juxtaposed against the ancient canal and its associations with pre-Columbian agriculture. Defining this grand space are two rows of receding trees along the canal, which possibly suggest the Renaissance Italian art on which the fresco's overall design is based.

In *Day of the Dead* (fig. left) , Rivera explores another Aztec tradition that had been absorbed by the Mexican Church. The ancient ritual of the Day of the Dead, in which deceased ancestors are memo-

rialized, had long been celebrated in Mexico as a Catholic festival. Here, however, Rivera depicts the holiday as a raucous street scene. Giant puppets with the traditional skull heads overlook a remarkable sea of humanity. Nuns, prostitutes, bankers, and even Rivera himself are shown drinking and celebrating together. Each face is impressively individualized, revealing the artist's mastery of portraiture, a skill he shared with El Greco and other Spanish old masters. Rivera's use of color—his combinations of blue, orange, and yellow hues—is striking, especially in his depiction of the native Mexican prostitute in the foreground. Her unflattering "flapper" outfit and heavily applied makeup contrast markedly, and almost humorously, with her strong facial features. Yet Rivera avoids caricature here, imbuing her with a dignity that belies her modern trappings.

In *The Burning of the Judases* (fig. p. 122), Rivera used another Catholic ritual to create one of his most politically-charged images. In the traditional fiesta, papier-mâché Judas puppets are burned to rid the community symbolically of evil. But Rivera's puppets here depict three political "evils" that the Revolution was meant to overcome—the greedy aristocrat, the repressive military leader, and the arrogant Catholic hierarchy. The scene is one of great violence. As explosives blow apart the puppets' bodies, the "celebrants" below are engaged in a heated battle with paving stones. Yet Rivera also achieves a remarkable balance of stylized form, movement, and color. The puppets and smoke seem to float ominously above the riotous crowd, symbolizing both the aloofness and the destructive power of an oppressive regime. Rivera's Court of the Fiestas helped create a new kind of political art. Here he fused traditional techniques, sophisticated modernist abstraction, and comprehensible folk imagery to express the political

left——**DIEGO RIVERA, DAY OF THE DEAD—CITY FIESTA** | 1923-24 | fresco 4.17 × 3.75 m | Court of the Fiestas, Ministry of Education | Mexico City.

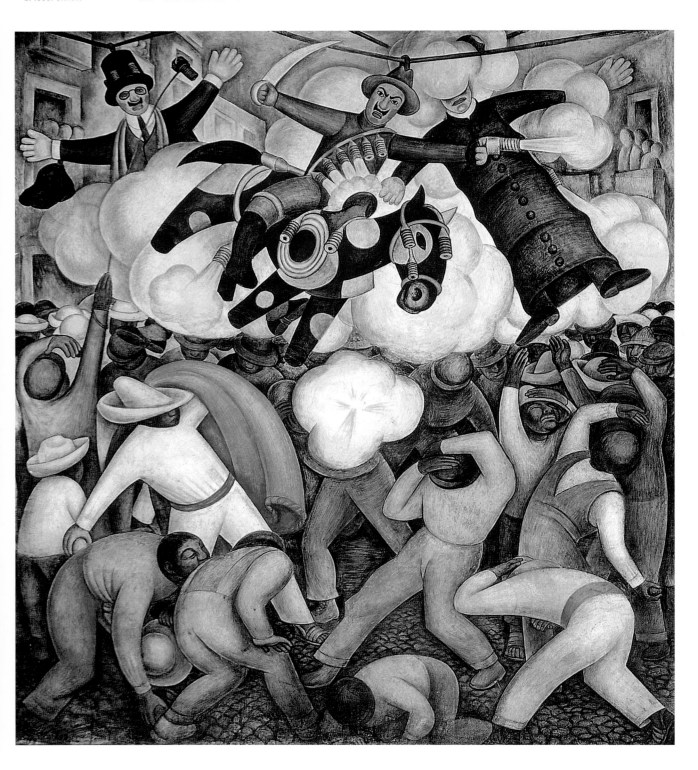

fears and aspirations of a newly restructured nation. Rivera was joined by other talented Mexican muralists in this effort, including José Clemente Orozco (1883–1949) and David Alfaro Siqueiros (1896–1974). Their expressive, often passionate work tended to avoid the pitfalls that afflicted much political art in the twentieth century. In the Soviet Union, which like modern Mexico had grown out of revolution, Stalinist repression led to the static, blandly idealized images of Socialist Realism. The most effective state-sponsored art programs tended to leave aesthetic decisions to the artists themselves. Ameri-

can photographer Dorothea Lange (1895–1965) used her position in the Depression-era Farm Security Administration to produce images such as *Migrant Mother* (1936) (fig. above left). These works share the passion of Rivera's art, vividly exposing the effects of economic collapse on ordinary people. Artists in more recent years have used "political art" as the basis for their own ironic imagery. In *Weiche* (1999) and other works, German painter Neo Rauch (b. 1960) transformed the art of East European Socialist Realism into a flamboyant, collage-like scene of postmodern angst (fig. above right).

left——**DIEGO RIVERA, THE BURNING OF THE JUDASES** | 1923/24 | fresco 4.43 × 2.14 m | Court of the Fiestas, Ministry of Education | Mexico City.

above left——**DOROTHEA LANGE, MIGRANT MOTHER, NIPOMO, CALIFORNIA** | 1936 | gelatin silver print | 28.3 × 21.8 cm | Library of Congress | Washington, DC.

above right——**NEO RAUCH, WEICHE** | 1999 | oil on paper | 215 × 190 cm Deutsche Bank Collection.

1876: Invention of the telephone .. **1883:** First petrol-engined automobile **124/125**

1876: Battle of the Little Bighorn ..

................................ **1879:** Birth of Albert Einstein ..

1872 – 1944: Piet Mondrian 1877 – 1962: Gabriele Münter 1881 – 1955: Fernand Léger

ALEXANDER CALDER: KINETIC ART AND THE CONTEMPORARY MUSEUM

The study of motion has long been a basic concern for artists, especially sculptors. Baroque master Gian Lorenzo Bernini (1598–1680) could work marble into delicate swirling cloaks, flowing hair, and dancing limbs. In his *Apollo and Daphne* (1622–25), the nature goddess's transformation into a laurel tree is depicted as an acrobatic leap away from her pursuer—the upward force of her body seeming to stretch and reconstitute her skin into leaves, branches, and trunk. This fascination with movement, and its often mystical power, increased during the industrial age. The image of the churning factory engine became a potent symbol, one that represented both progress and the cold, dehumanizing aspects of modern life. By the early 1900s, artists had begun to look for ways of expressing this new mechanical energy in their pictures.

While working in his studio in 1913, Marcel Duchamp (1887–1968) placed an upside-down wheel on top of a kitchen stool, emphasizing its kinetic, spinning action. He later said that the wheel's motion was "somewhat similar to the dance of a wood fire; it was

like the reverence to the useless side of a thing generally used for other ends I was probably delighted with the movement of the wheel as an antidote to the habitual movement of an individual around the contemplated object." *Bicycle Wheel* helped inspire other artists to to find ways of projecting human movement into objects and abstract shapes. Man Ray (1890–1976) and Fernand Léger (1881–1955) experimented with the relatively new medium of cinema. Their short silent films, including *Emak-Bakia* (1926), *Le Retour à La Raison* (1923), and *Ballet Mécanique* (1924), featured stop-motion animated forms, details of machines, and electric light displays—fetishizing these objects' turning, twisting movements. Hungarian artist László Moholy-Nagy (1895–1946) engineered some of the first mechanized art. His elaborate projectors could create aesthetic, flickering effects with light. One such work, entitled *Light Prop for an Electric Stage* (1922–30), was composed with almost Cubist sophistication—complete with a perforated disk, turning glass spiral, and sliding ball. These early kinetic experiments received little attention outside of avante-garde circles. Duchamp himself did not consider *Bicycle Wheel* to be a work of art at all. But in the autumn of 1931, Duchamp would play a significant role in making kinetic art an international phenomenon. He was visiting the studio of Alexander Calder (1898–1976), and he was impressed

left——**ALEXANDER CALDER, JOSEPHINE BAKER, III** | c. 1927 | steel wire 99 × 56.6 × 24.5 cm | MoMA | New York.

1889: Completion of the Eiffel Tower ···

1895: Discovery of X-rays·································· **1900:** Beginning of the Boxer Rebellion in China··················

1896: First modern Olympic Games··

1887 – 1968: Marcel Duchamp 1890 – 1976: Man Ray 1898 – 1976: Alexander Calder 1901 – 1980: Len Lye

»*In* Lobster Trap and Fish Tail, *Calder transformed mechanical motion into an artwork of witty, shimmering beauty.*«

with Calder's latest sculptures. Delicate wire shapes were strewn about the room. Some had been placed on stands, while others were hung from the ceiling —and most were set into action by tiny electric motors. When Calder asked Duchamp what he might call them, the French artist immediately replied "mobiles," a cunning double-entendre that meant both "motion" and "motive" in French.

Calder had first arrived in Paris in 1926, a trained engineer who decided to pursue his father's career as a professional sculptor. He soon became a popular figure among the Parisian intelligentsia—performing his *Cirque Calder* (1926–30) for a glittering array of artists, writers, and actors . In this surreal puppet show, Calder manipulated delicately formed circus figures using tiny wires. The success of *Cirque Calder* led the young artist to devise other ways of using his circus materials. He produced a number of humorous, impressionistic portraits from metal wire, capturing the personalities of his famous friends: Joan Miró, Fernand Léger, and, most famously, the exiled American stage sensation Josephine Baker (fig. p. 124). Then in 1930, a visit to the studio of abstract painter Piet Mondrian set Calder on a new artistic path. He was fascinated with part of the studio's layout: "a white wall, rather high, with rectangles of cardboard painted yellow, red, blue, black and a variety of whites, tacked upon it so as to form a fine,

big composition." Mondrian used this movable wall as a guide for designing his famous grid paintings. For Calder, it inspired his first exercises in combining abstract design and motion.

Calder displayed his earliest kinetic art at his studio on the rue de la Colonie; it was these works that Marcel Duchamp so aptly named in 1931. Their wire bodies had been manipulated into the simplest of shapes; circular or globular forms spinning around pyramidal bases. Over the course of the 1930s, Calder would gradually refine the mobiles, replacing the rigid geometries of the early works with a more supple, expressive type of abstraction. Calder's friendship with the Surrealist Joan Miró (1893–1983) proved a continuing source of inspiration. Miró's undulating shapes seemed to have a watery, sensual exuberance (fig. p. 128). Calder also befriended the sculptor Jean Arp (1886–1966), another artist exploring the aesthetic possibilities of organic curvature. As his style reached full maturity, Calder would come to absorb elements of both these artists. He also worked to refine the kinetic function of his work. He began

right——ALEXANDER CALDER, LOBSTER TRAP AND FISH TAIL
1939 | painted steel wire and sheet aluminum | 260 × 290 cm in diameter
Museum of Modern Art | New York.

1905: Formation of the expressionist group Die Brücke ·· **1914-1918:** First World War ················ CALDER **126/127**

1906: San Francisco earthquake ··

1909: Opening of Queensboro Bridge in New York ··

1905 – 1970: Barnett Newman 1908 – 1984: Lee Krasner 1912 – 1956: Jackson Pollock

creating more complex wire structures, at the ends of
which he attached colored shapes of wood and metal.
These new constructions were often hung from the
ceiling, and the slightest touch or gust of wind could
set off a complex series of motions.

One of Calder's most impressive mobiles, and one that
fully represented the potential of his art, was a piece
commissioned by the Museum of Modern Art in New
York. Called *Lobster Trap and Fish Tail* (1939), it was
created to be hung in the stairway of the museum's
recently constructed home (fig. above). The new
MoMA building was designed in the International
style, a modernist showpiece of rigidly angular forms
and wide expanses of steel and glass windows (fig. p.
129) . Within this severe environment, Calder placed
his joyous, curvaceous masterpiece. The work was
made of steel wire and sheet aluminum, measuring
8 ½ feet by 9 ½ feet (2.5 meters by 3 meters) and
featuring three main forms—a tail-like red and black

shape at the top, a series of nine black shapes resem-
bling fish bones at the lower left, and a simplified
wire "net" at right. All of these shapes were con-
nected to an elegant network of curving wires
—some of which appeared as thin as silk thread. The
work's supple forms and lines reflected the Surreal-
ism of Miró and Arp, and they also paid tribute to
the marine culture of New England, where Calder
had now established his studio. The work's subtle
construction, developed by an artist steeped in the
principles of engineering, enabled each individual
shape—as well as the supporting frame—to turn and
twist in its own direction and at its own speed. Such
movement allowed light to play off the aluminum
surfaces in ever-changing ways. Calder had trans-
formed mechanical motion into an artwork of witty,
shimmering beauty.

After World War II, Calder would become an elder
statesman among the American avant-garde, earning

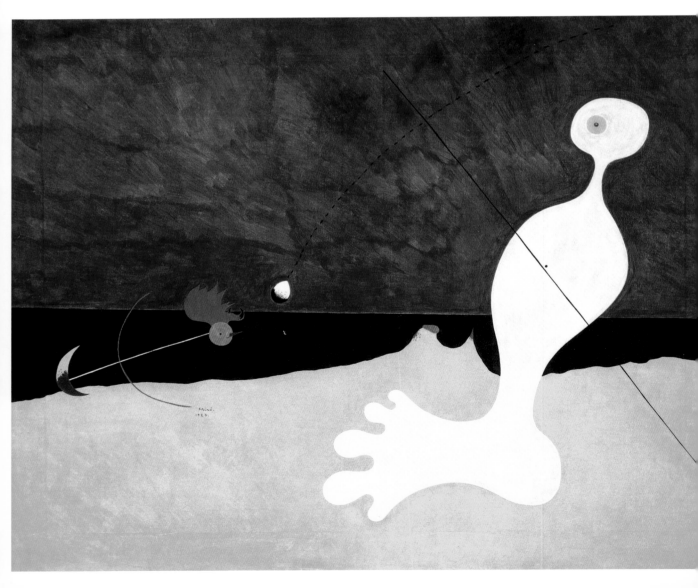

1939–1945: Second World War .. 1946: First computer CALDER **128/129**

1941: Pearl Harbor attack ..

1949: Founding of the Federal Republic of Germany

b. 1937: David Hockney b. 1939: Richard Serra b. 1945: Paul McCarthy

large-scale commissions in New York, Chicago, and other major U.S. cities. His mobiles would inspire generations of kinetic artists. In recent years, such artists have brought moving sculpture out of the museum and into the environment. The twisting "wind sculptures" of American artist Lyman Whitaker and the "tangibles" of New Zealand sculptor Len Lye give artistic form to the energy of air and water currents (fig. p. 130/131) . These works suggest themes related to the power of natural processes, as well as the challenges of harnessing those powers for human use. Calder's *Lobster Trap and Fish Tail*—and its integration into the 1939 MoMA building—also helped revolutionize the contemporary art museum.

left——**JOAN MIRÓ, PERSON THROWING A STONE AT A BIRD** | 1926 oil on canvas | 73.7 × 92.1 cm | Museum of Modern Art | New York. above——**HERBERT GEHR, EXTERIOR OF MOMA (MUSEUM OF MODERN ART) ON THE DAY OF ITS OPENING** | 1939 | photograph.

MoMA's architects, Philip Goodwin and Edward Durell Stone, were steeped in the modernist traditions of the Bauhaus school. As such, they sought to create an environment that not only showcased modern art but also expressed, in an integrated way, the values and aesthetic goals of that art. The museum building itself was becoming both an artwork and a cultural icon, a trend that would lead to the mega-museums of the late 1900s and early 2000s. In structures such as Frank Gehry's titanic Guggenheim Museum in Bilbao (1997), the visitor would be completely immersed in the architect's own personal vision (fig. p. 132) . The Guggenheim's billowing, wave-like external forms were reflected on the inside—both architecturally and in the sculptures commissioned for its permanent collection. Richard Serra's maze of curving steel sheets, a work originally known as *Snake* (fig. p. 133) , complements and enlivens Gehry's vision; just as Calder's pioneering wire fish had done for MoMA sixty years earlier.

1956: Grace Kelly marries Rainier III., Prince of Monaco .. **1961:** Construction of the Berlin Wall ..

1959: Completion of the Solomon R. Guggenheim Museum in New York ..

b. 1959: Peter Doig .. b. 1962: Takashi Murakami .. b. 1965: Damien Hirst

previous double page spread——**LEN LYE, WIND WAND** | 1999–2001
fiberglass, carbon fiber | H: 48 m, 20 cm in diameter | New Plymouth,
New Zealand.
above——**DOMINIQUE FAGET,** View of the new Guggenheim museum by
the river Bilbao | 1997 | photograph.
right——**RICHARD SERRA, SNAKE** | 1994–97 | weathering steel;
three units, each comprised of two conical sections, each section:
4 × 15.85 m; overall: 4 × 31.7 × 7.84 m; plate thickness: 5 cm
Guggenheim Museum | Bilbao.

1968: Assassination of Martin Luther King

1975: Death of General Francisco Franco

CALDER **132/133**

1969: Neil Armstrong lands on the moon

1977: Jimmy Carter sworn in as president of the U.S.

b. 1967: Tal R b. 1968: Wolfgang Tillmans b. 1974: Anri Sala

»Richard Serra's Snake *is a maze of curving steel sheets that complements and enlivens Gehry's vision for the Guggenheim Museum in Bilbao.*«

1903: First powered flight by the Wright brothers
1905: Formation of the expressionist group Die Brücke
1906: San Francisco earthquake **1909:** Opening of Queensboro Bridge in New York
134/135

1904 – 1997: Willem de Kooning 1905 – 1970: Barnett Newman 1908 – 1984: Lee Krasner 1910 – 1962: Franz Kline

JACKSON POLLOCK: ABSTRACT EXPRESSIONISM AND THE CULTURAL REBEL

Like Vincent van Gogh (1853–1890), Jackson Pollock (1912–56) became a cultural anti-hero. His turbulent, self-destructive life, and the violent car crash that killed him, reinforced popular notions of the artist as neglected rebel. Pollock's highly-strung personality also seemed to be reflected in his idiosyncratic drip painting method. This merging of personality and technique was reminiscent of Paul Cézanne (1861–1906), whose painfully introverted nature had always been linked to his assiduous working practices. Yet while Pollock's character and fate may connect him to the nineteenth-century beginnings of modern art, his work helped bring Western painting—especially in the United States—fully into the post-World War II world.

During the late 1930s and early 1940s, the center of art was shifting from Paris to New York City, as many leading European masters—from Piet Mondrian (1872–1944) to Max Ernst (1891–1976)—sought refuge from the growing authoritarianism in Fascist Europe. But the United States was also embracing modernism as never before, and many young American artists were getting unprecedented opportunities to explore their craft.

One of these artists was Jackson Pollock, an independent but psychologically fragile character. He had grown up in a broken family amidst the vast spaces of America's West—Wyoming, Arizona, and California. A high-school dropout, Pollock moved to New York City in 1930 to live with his brother, Charles, and to study on scholarship at the city's Art Students League. There he became a favorite student of the painter and muralist Thomas Hart Benton (1889–1975). Benton's scenes of rural life, with their rhythmic energy and thickly sculptural figures, are some of the best-known depictions of Americana. Pollock used his connection to Benton to get work with the United States Federal Art Project, a federally-funded program that provided employment to artists during the Great Depression. At this time he worked briefly with the left-wing Mexican muralist David Siqueiros (1896–1974), who was then experimenting with new ways of applying his industrial "Duco" paint—including the use of pouring and dripping techniques. Pollock was also introduced to the Freudian ideas of ex-patriot Surrealists like André Masson (1896–1987) and Roberto Matta Echaurren (1911–2002). Surrealism advocated the practice of *automatism*, in which random acts were incorporated into the art-making

left—**JACKSON POLLOCK, FULL FATHOM FIVE** | 1947 | oil on canvas with nails, tacks, buttons, key, coins, cigarettes, matches, etc. | 129.2 × 76.5 cm Museum of Modern Art | New York.

1914-1918: First World War .. 1919: Formation of the Bauhaus school ...

1917: October Revolution in Russia

1922: Discovery of Tutankhamun's Tomb

1912 – 1956: Jackson Pollock 1917 – 2000: Jacob Lawrence 1921 – 1986: Joseph Beuys

»The She Wolf *(1943) captures*
Pollock's furious energy, as well as the
ominous wartime environment.«

process. Such acts were designed to "unlock" the artist's unconscious mind, enabling the images express their creator's deepest emotional layers. Pollock himself was experiencing violent emotional mood swings, which were probably exacerbated by alcoholism, and he was undergoing extensive —though ultimately unsuccessful—psychiatric therapy. He had even been declared unfit for military service in World War II, based on the recommendation of his therapist, Violet de Laszlo. Freed from military duty, Pollock was able to spend the war years developing his artistic style. Works such as *The She Wolf* (1943) (fig. right) capture the artist's furious energy, as well as the ominous wartime environment. In it, the classical Roman figure of the *She Wolf* seems to decompose into thick, swirling lines and colors, which were often applied directly with the artist's fingers. The psychological extremes suggested by the image also seemed to reflect Pollock's inner demons. The year *She Wolf* was created, Pollock showed his works at an exhibition for young artists organized by the art collector Peggy Guggenheim. Pollock's art attracted the admiration of Piet Mondrian, who was impressed by their "tremendous energy," and he helped convince Guggenheim that Pollock was an artist worthy of patronage. Peggy Guggenheim soon "dedicated" herself to Pollock, commissioning major works that included *Mural* (1943), which was given

pride of place in her impressive private collection of modern art (fig. pp. 138/139) . *Mural* was designed for the grand entrance way of Guggenheim's newly built town house, and its vast dimensions—8 x 20 feet (2.5 x 6 meters)—enabled Pollock to create a horizontal "stampede" of swirling lines and colors. The artist again based his design on animal forms, this time the "cows and horses and antelopes and buffaloes" of the American West. But here such forms had become completely submerged into a composition of brutal force. As Pollock later wrote, "Everything is charging across the goddamn landscape."

In 1945, Pollock and his new wife, the artist Lee Krasner (1908–1984), used Guggenheim's financial assistance to move out of the city and into a farmhouse on nearby Long Island. Pollock converted one of the building's bedrooms into his new studio. There he began to develop the technique that would make him famous. He discarded the traditional easel and placed his canvases on the floor. "I need the resistance of a hard surface." he would write in 1947, "On the floor I am more at ease, I feel nearer, more a part of the painting, since this way I can walk around

right——**JACKSON POLLOCK, THE SHE WOLF** | 1943 | oil, gouache, and plaster on canvas | 106.4 × 170.2 cm | Museum of Modern Art | New York.

1925: Invention of television ..

..**1931:** Completion of the Empire State Building.. POLLOCK **136/137**

...**1933:** Adolf Hitler seizes power ...

1925 – 2008: Robert Rauschenberg **b. 1929: Claes Oldenburg** **1933 – 1996: Dan Flavin**

it, work from the four sides and literally *be* in the painting. ... I continue to get further away from the usual painter's tools such as easel, palette, brushes, etc. I prefer sticks, trowels, knives and dripping fluid paint or a heavy impasto with sand, broken glass and other foreign matter added." Pollock claimed that his "drip" technique originated from "the method of Indian sand painters of the West," painters he saw while travelling with his father on surveying expeditions. The method may also have been inspired from his studies with Siqueiros, and a desire to incorporate "automatic," random actions in his art.

Yet despite all its possible antecedents and influences, Jackson Pollock's drip technique was uniquely his own. One of the earliest drip paintings was titled *Full Fathom Five* (1947) (fig. p. 134), a reference to a line from Shakespeare's *The Tempest*, which describes the life-consuming depths of the sea. Here, the thick, swirling forms of his earlier work have been transformed into a chaotic tapestry of dripped lines,

splashes of color, and small applied objects—nails, tacks, and buttons. Pollock created the work in multiple layers. The bottom layer was produced rather traditionally, using a palette knife and brush. On top of this under-layer, the artist poured and dripped paint, sometimes flinging it onto the canvas as he moved about. Such methods imbued the composition with a sense of nautical depth, a visual metaphor for the artistic psyche. *Full Fathom Five* helped re-imagine abstract art, which had traditionally been derived from the simplification of natural forms. Pollock's work had no organic source of inspiration. Instead, it grew out of the painter's unique process.

Initially, Pollock's drip paintings found little favor with the art-buying public. But they had an almost immediate impact on a group of artists working in New York—including Willem de Kooning (1904–97), Barnett Newman (1905–70), and Franz Kline (1910–62). Soon to be known as the Abstract Expressionists, they based their art around

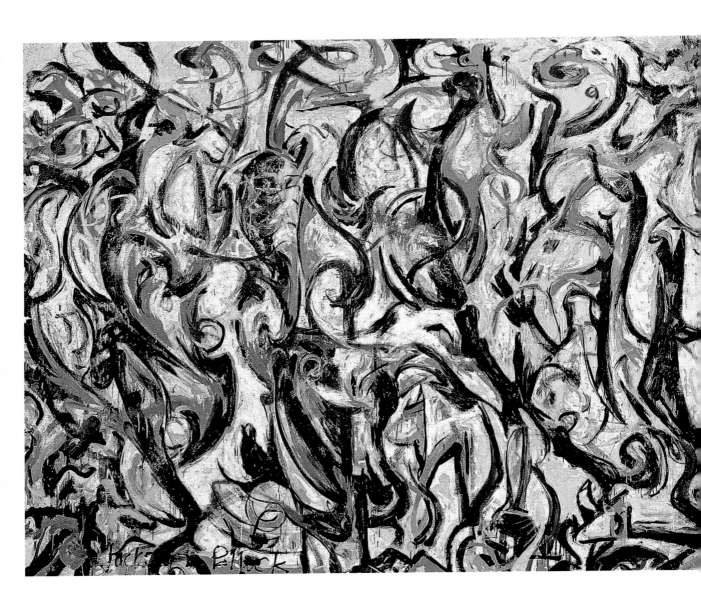

above——**JACKSON POLLOCK, MURAL** | 1943 | oil on canvas
247 × 605 cm | University of Iowa Museum of Art | Iowa City.

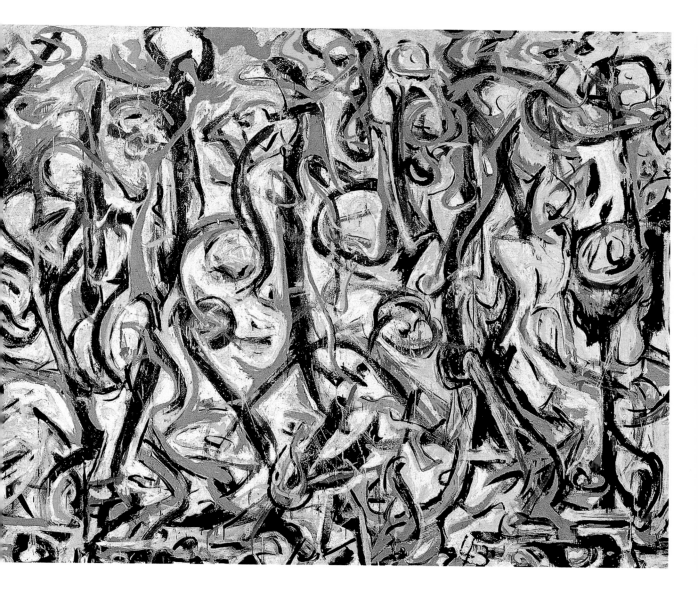

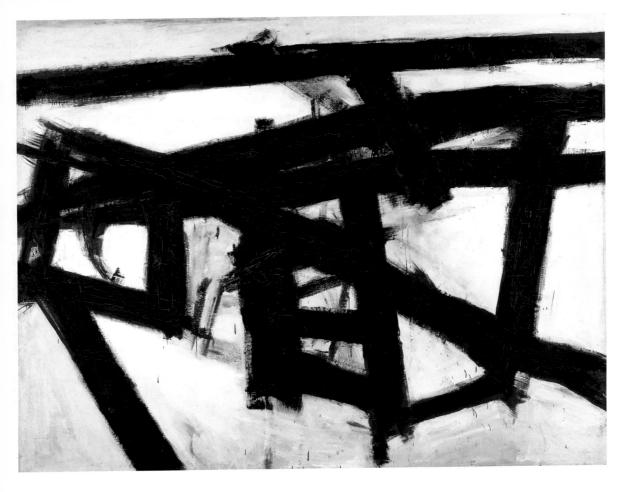

highly individual techniques that generally involved spontaneous action. Franz Kline's *Mahoning* (1956) displays the artist's characteristic style: black linear patterns against a white background (fig. above). A work of almost Japanese restraint, *Mahoning* nonetheless shares some of the psychic fervor of Pollock's art. Kline's fat black lines are created with quick brushstrokes, their fuzzy edges emanating a nervous vitality.

In 1950, the German-American photographer Hans Namuth dramatically changed the image of Pollock and the Abstract Expressionists. His famous black-and-white photographs—as well as his color film—brilliantly captured Pollock's drip technique in action. The artist was shown as a rugged antihero from the American West, his athletic frame stretching and dancing around the canvas surface. Namuth's imagery brought a romantic aspect to the process of making art. And Pollock's fame only intensified after his fatal auto accident in 1956—the same tragedy that had already befallen America's other

media rebel, James Dean. Abstract Expressionists had come to embody the nation's spirit of individualism, and it continued to dominate the U.S. art world until the rise of Pop Art in the 1960s.

But Pollock's influence extended beyond the sixties. Younger artists were inspired by the notion of art as rebellious gesture. In 1971, Paul McCarthy's (b. 1945) film *Painting Face Down—White Line* showed the performance artist dipping his face in white paint and then suggestively sliding face down on the ground to produce a white line (fig. right). Pollock's action art had lost its heroic edge, but it had remained relevant for America's new avant-garde.

above——**FRANZ KLINE, MAHONING** | 1956 | oil and paper collage on canvas | 203.2 × 254 cm | Whitney Museum | New York.

right——**PAUL McCARTHY, STILL FROM FACE PAINTING—FLOOR, WHITE LINE** | 1972 | performance, video, photographic series | videograph by Mike Cram | Courtesy the artist and Hauser & Wirth.

········1889: Completion of the Eiffel Tower············ 1900: Sigmund Freud publishes *The Interpretation of Dreams* ········ 142/143
··········1896: First modern Olympic Games ··········
···············1906: San Francisco earthquake············

1908 – 1997: Victor Vasarely

BRIDGET RILEY: OP ART

Western art has long relied on the power of optical tricks. The "rediscovery" of linear perspective enabled Renaissance painters to simulate three-dimensional space on a two-dimensional surface. Centuries later, when photography made these traditional illusions increasingly passé, artists began to look for other ways of making art out of optical science. French chemist Michel Eugène Chevreul described how, when seen from a distance, the juxtaposition of certain colors could make the eye perceive a different color. His research inspired the "scientific" Pointillism of Georges Seurat (1859–91) and Paul Signac (1863–1935), where entire pastoral scenes were conjured up from individual colored dots. Early twentieth-century illusionists, inspired by the quickening pace of urban life, tended to focus on movement. The Italian Futurist painter Gino Severini (1883–1966) splintered his figures into whirling patterns of shape and color, producing fantastical worlds of geometric motion and tempo. Hungarian artist Victor Vasarely (1908–97) made distorted zebras out of spiraling black and white stripes, giving the animals a contradictory

visual effect—that of sinking into the canvas while at the same time bulging outward toward the viewer. After World War II, the rise of Abstract Expressionism helped make the artistic process a central concern of modern art. The highly personal drip painting method of Jackson Pollock (1912–56) inspired other artists to find their own voice through the development of individualized techniques. In the malaise of post-war London, a young English painter achieved this goal and, at the same time, promoted optical illusion itself to an art form. Bridget Riley (b. 1931) had studied art at Goldsmiths College and the Royal College of Art, becoming adept at the classical illusion of representing human figures in pencil. But her subsequent career had suffered from a lack of direction, as well as a mental breakdown. Then in 1959, a collaboration with modernist art educator Maurice de Sausmarez helped her to focus her efforts toward a style that could be carefully, diligently constructed out of basic form and color. Riley started, as she said, "to dismember, to dissect, the visual experience ... to analyze the color of the situation, the form, the linear axis and the tone ... in quite consciously separate statements." This artistic journey began by creating an exact reproduction of Seurat's *Le pont de Courbevoie* (The Courbevoie Bridge). It also involved travel to Italy, where she studied the illusory motion of Italian Futurism and where she painted a Seurat-style

left——**BRIDGET RILEY, MOVEMENT IN SQUARES** | 1961 | tempera on board 122 × 122 cm | Walker Art Gallery/Arts Council Collection | Liverpool.

impression of a landscape near the Tuscan hill town of Radicofani. In this work, which she titled *Pink Landscape*, Riley enlarged her Pointillist blotches so that the landscape dissolved into pulsating expanses of color (fig. right). She later recalled this effort when she said, "The heat off that plain was quite incredible. It shattered any possibility of a topographical rendering of it. Because of the heat and the color reverberations, to be faithful to that experience it was only possible to 'fire it off' again in color relationships of optically vibrant units of color. It wouldn't in fact have mattered if those had been black and black ... The important thing was to get an equivalent sensation on the canvas."

When Riley returned to London, she experimented with other ways of constructing optical and emotional "sensations." She began to explore the possibilities of working with a single shape and, as she said, finding a way to "put it through its paces, ... push it to the fullest extent where it loses, or almost loses, its ... characteristics." For Riley, this process would involve hours of careful preparatory studies, making full use of her training as a draftsman. Then, in 1961, she produced her first breakthrough, *Movement in Squares* (fig. p. 142). In it we see Riley's "push and pull" investigations. Alternating black and white squares become gradually compressed as they "travel" from the left and right edges of the canvas board, eventually "meeting" at the right center. The effects of this compression and expansion are multilayered. Similar to the earlier work of Vasarely, the overall image seems to bulge outward toward the edges of the board and sink downwards where the squares are at their most compressed. Yet Riley's image achieves these effects without resorting to the depiction of zebras or other natural figures. Her picture fabricates undulating movement in completely abstract form. And as de Sausmaurez later wrote, the work achieves a "vibrationary climax at the point of contact," an

emotional and sensual stimulation, especially if viewed from a distance.

Movement in Squares was one of many such images that Riley produced in the early sixties, when she put a myriad of circular, angular, and linear forms through their "paces." Popular fascination with her work was evident almost immediately. Her exhibitions in London and New York attracted large crowds. A 1965 exhibition at New York's Museum of Modern Art, *The Responsive Eye*, placed Riley's art alongside the works of Vasarely and the American artist Richard Anuszkievicz (b. 1930). These three painters would initiate the "Op Art" movement, but it was Riley's work that became the movement's most iconic imagery. Op Art quickly succumbed to commercialization during the psychedelic sixties, as a generation of hippies viewed Riley's imagery as a means of achieving hallucinatory bliss. The decorative potential of Op Art patterns also inspired fashion trends. One clothing firm produced a dress decorated with Riley's artwork—but without the artist's permission. All of these developments exasperated Riley, as she felt they minimized the aesthetic complexity of her work. She even shied away from the Op Art label, which assembled the work of diverse artists into an easily digestible "niche" movement—ignoring the individuality of her working method. It would be up to artist-showmen like Andy Warhol (1928–87) and Takashi Murakami (b. 1962) to confront and exploit the relationship between art and modern commercialism.

But despite the setbacks in Riley's career, she remains one of the few women to have taken such a prominent role in the development of a modernist movement.

right——**BRIDGET RILEY, PINK LANDSCAPE** | 1960 | oil on canvas 101.5 × 101.5 cm | Private collection.

1939-1945: Second World War ················· **1959:** Completion of the Solomon R. Guggenheim Museum in New York ·············· RILEY **144/145**

1946: First computer ··········

1949: Founding of the Federal Republic of Germany ·············

b. 1938: Georg Baselitz b. 1957: Ai Weiwei b. 1960: Walton Ford

right——**Bridget Riley, Nataraja**
1993 | oil on canvas | 165.1 × 227.7 cm |
Tate | London

1968: Assassination of Martin Luther King ·· **1975:** Death of General Francisco Franco ··················
··········· **1969:** Neil Armstrong lands on the moon ··
·· **1980:** John Lennon shot ··················

b. 1962: Takashi Murakami b. 1967: Tal R b. 1970: Anselm Reyle

She would also show her versatility in later life, incorporating colors and patterns in more subtle ways. In *Nataraja* (1994), she built up a "plastic fabric" of slanting rectangular shapes, a shimmering combination of muted colors (fig. pp. 146/147). As with her early works, many of these later paintings were inspired by travel—especially her journeys to the Middle East and her exposure to Islamic handicrafts.

By the end of the twentieth century, the growth of computer-based digital art helped revive interest in Riley's work. Young artists again began to discover the aesthetic potential of optical illusion. German sculptor and painter Anselm Reyle (b. 1970) has created several good-natured Op Art parodies. In his sculpture *Philosophy* (2009), a wall of warped aluminum shapes humorously magnifies Riley's visual effects through the shininess of the reflective material (fig. above) . Other postmodernists, including the Israeli artist Tal R (b. 1967), treat Riley's ideas in a more joyful, celebratory manner. Tal R's *Lords*

of Kolbojnik (2002) (fig. right) features a giant Op art-style collage in the form of a star burst, which is surrounded by old magazine clippings that represent objects and ideas from the past. Tal has rescued these "throwaway" figures from the *kolbojnik*—a Yiddish word for garbage can—and has given them new life and meaning. The art of Bridget Riley, once considered a kitschy relic of the past, is being rescued from the aesthetic waste bin.

above——**ANSELM REYLE,** exhibition view from the *Monochrome Age* exhibition; works: *Eternity*, 2009 (front right), *Philosophy*, 2009 (front left), *Untitled*, 2009 (in the background) | 2009 | Aluminum, chrome optics 330 × 660 × 66 cm | Gagosian Gallery | New York.

right——**TAL R, LORDS OF KOLBOJNIK** | 2002 | mixed media on canvas| 244 × 244 cm | Courtesy of Contemporary Fine Arts | Berlin.

next double page spread——**BRIDGET RILEY, ARCADIA 1 (WALL PAINTING 1)** | 2007 | graphite and acrylic on wall | 266.5 × 498.5 cm courtesy Karsten Schubert | London.

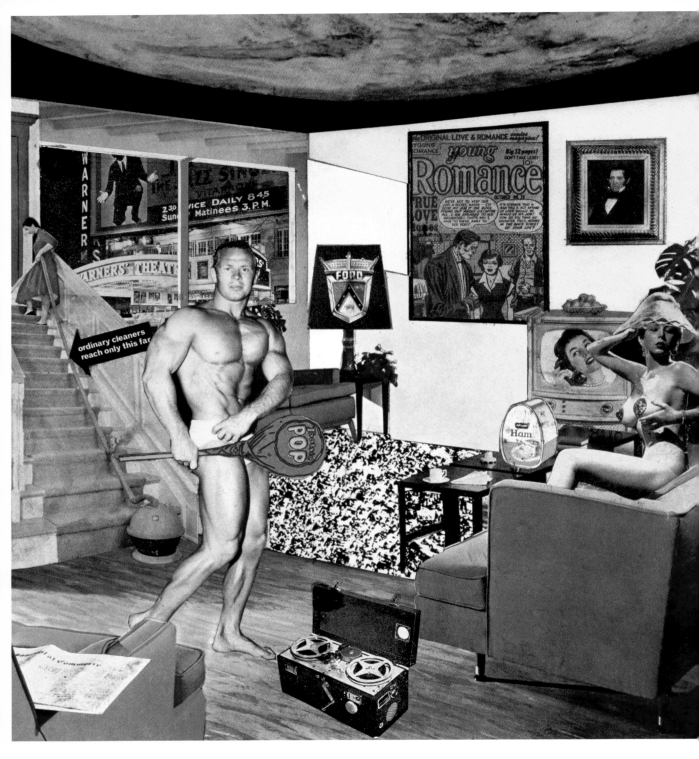

1922: Discovery of Tutankhamun's Tomb
1925: Invention of television
1939-1945: Second World War
1931: Completion of the Empire State Building

152/153

1922 – 2011: Richard Hamilton 1928 – 1987: Andy Warhol b. 1929: Claes Oldenburg

RICHARD HAMILTON: POP ART AND COMMERCIAL SOCIETY

In a 1966 interview for the English magazine *Art and Artists*, Marcel Duchamp (1887–1968) referred to the state of British art before World War II: "The English woke up to modern art very late. Forty years ago the idea of art did not interest them very much. 'Art' with a capital A couldn't even have been in the dictionary! It could only be conceived of in terms of the portrait, or the eighteenth-century Englishman. Doubtless, this was because of the monarchy. In a monarchy, painters paint portraits, and exhibit at *salons*."

Duchamp's witty stereotyping reflected a general impression of the British art establishment, as well as the country's inability to produce a true avant-garde. Yet the postwar era would see Britain relinquish most of its empire. English culture, too, would turn away from its aristocratic roots and look increasingly toward the United States for inspiration. During the 1950s, a group of young artists began responding to the glitzy commercial world they saw across the Atlantic. Their work stimulated a radical change in direction for modern art worldwide.

One of these artists was Richard Hamilton (1922–2011). He received his training in the traditional British system, spending time at the Royal Academy and at several schools of design. By the time he completed his studies in 1951, London was still emerging from years of postwar rationing and cultural stagnation. He soon joined a collection of artists, architects, photographers, and writers called the Independent Group. In their exhibitions, IG members sought to expand British conceptions of art. Many of them, including Hamilton and the critic Lawrence Alloway, were influenced by the work of Marcel Duchamp, and his pioneering way of using found objects as potent artistic symbols. The most famous exhibition associated with the IG, although conducted a year after the group formally disbanded, was called *This is Tomorrow* (1956). It was held at the Whitechapel Gallery in what was then a poor, bohemian district in London's East End. The exhibition consisted of several rooms, each of which created a multifaceted artistic "environment" of sculpture, architectural forms, and paintings or other two-dimensional art. One of the rooms, partly designed by Hamilton, incorporated objects of American commercialism as "art"—Hollywood posters and billboards, food advertisements, snippets of films, and a playing jukebox. For Hamilton, this artistic "fun house" represented the way modern life

left——RICHARD HAMILTON, JUST WHAT IS IT THAT MAKES TODAY'S HOMES SO DIFFERENT, SO APPEALING? | 1956 | collage | 26 × 24.8 cm Kunsthalle Tübingen.

1946: First computer

1948: Founding of the State of Israel

1959: Completion of the Solomon R. Guggenheim Museum in New York

1961: Construction of the Berlin Wall

b. 1957: Ai Weiwei

b. 1960: Neo Rauch

b. 1962: Takashi Murakami

»By the early 1960s, the center of Pop Art had shifted to the heart of world commerce, the United States.«

had extended—and would continue to extend—the range of ordinary people's "visual experience." Such new visual stimulation should, in his words, develop "our perceptive potentialities," making people able to recognize the artistic value in objects of "low culture" (posters and advertisements) as well as objects of high culture (paintings and sculptures). Hamilton wrote the catalogue for the exhibition, and in it he included a black-and-white reproduction of a collage he had made. Titled *Just what is it that makes today's homes so different, so appealing?*, the picture featured a spatially-warped suburban living room composed of various newspaper clippings (fig. p. 152). At the center of the room is the commercially "idyllic" suburban couple, made of trimmed reproductions of a posing bodybuilder and a lounging erotic film actress. The "lady of the house" is placed on a 1955 sofa from *Ladies Home Journal* and given a lampshade for a hat. At the left, a spatially disproportionate stairway—from a Hoover appliance vacuum cleaner ad—extends upward towards the front door. This detail also includes the Hoover, its hose extending suggestively up the entire length of the stairway, and a nattily dressed woman vacuuming the top step. All around the room are images of mass entertainment: a movie theater is shown out the window, a television set displays a smiling actress with a telephone, and a page of a comic book is used as a painting. Commercial food products also abound, including the work's central image—a giant lollipop held by the man so as to conceal his genitalia, with the word "Pop" displayed in bold lettering.

Hamilton later referred to the collage as an "allegory rather than a representation of a room. My 'home' would have been incomplete without its token life-force, so Adam and Eve struck a pose along with the rest of the gadgetry." *Just what is it* wittily expressed the transformative power of commercialism; how its inherently banal imagery could be made to represent the economic and social aspirations of modern society—just as religion and "fine art" had done in earlier eras. And the work's prominent use of the word "Pop" would help name an entire movement —Pop Art. The following year, in a letter to a friend, Hamilton would offer the first significant description of the new style:

"Pop art is:
Popular (designed for a mass audience)
Transient (short-term solution)
Expendable (easily-forgotten)
Low cost
Mass produced
Young (aimed at youth)
Witty
Gimmicky
Glamorous
Big business"

right——ROY LICHTENSTEIN, M-MAYBE | 1965 | oil and synthetic resin on canvas | 152 × 152 cm | Museum Ludwig | Cologne.

1967: Six-Day War........................ 1969: Neil Armstrong lands on the moon..................... 1975: Death of General Francisco Franco............ HAMILTON 154/155

1968: Assassination of Martin Luther King..............

1986: Chernobyl disaster

b. 1967: Matthew Barney b. 1970: Jonathan Meese b. 1974: Anri Sala

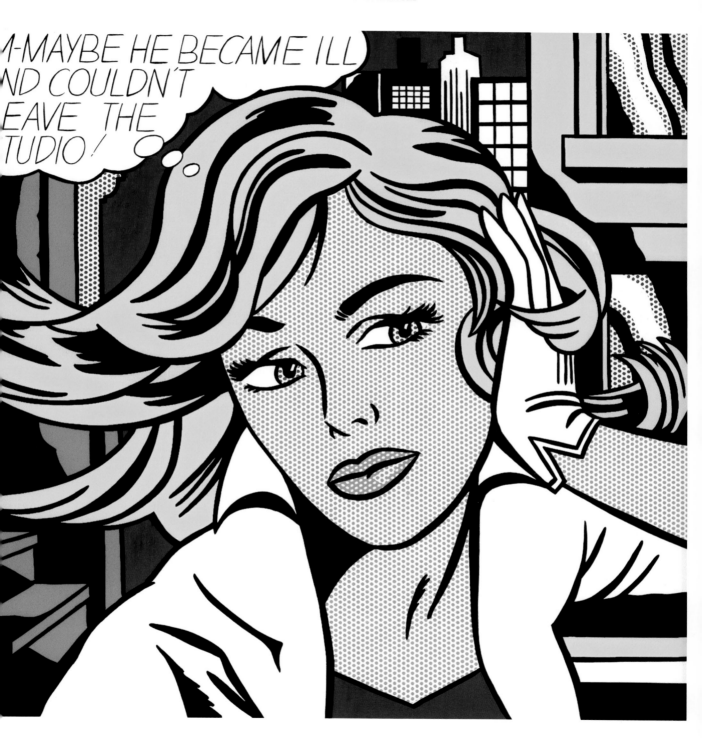

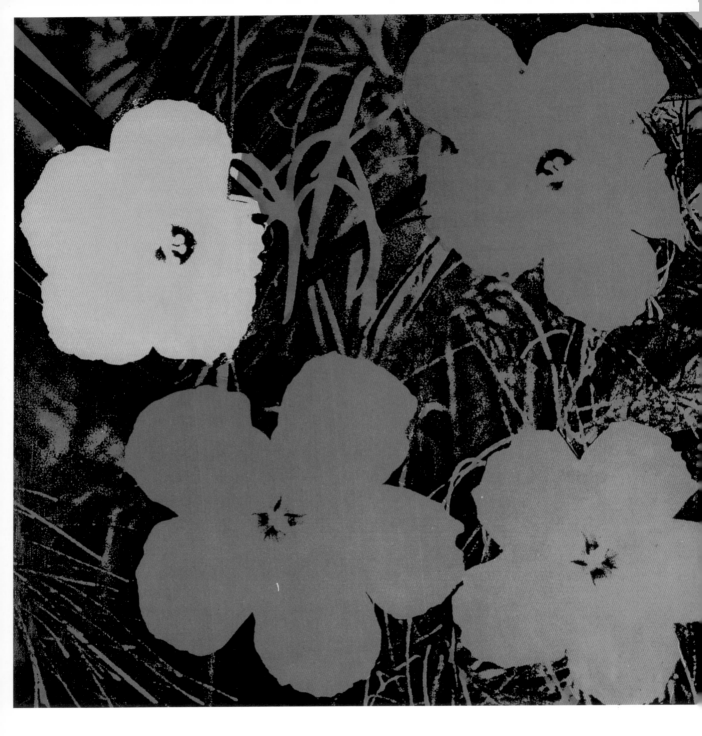

1990: Reunification of Germany 2001: Terrorist attacks on World Trade Center (9/11) HAMILTON 156/157

1999: Hugo Chávez seizes power

2010: Haiti earthquake

»*Warhol's art featured subtly repeated images which reflected the power of mass production in American life.*«

By the early 1960s, the center of Pop Art had shifted to the heart of world commerce, the United States. Artists such as Andy Warhol (1928–1987), Claes Oldenburg (b. 1929), and Roy Lichtenstein (1923–97) (fig. p. 155) would use the new style as a way of rebelling against the Abstract Expressionists, then the dominant artists in New York. For Warhol and others, Abstract Expressionism seemed overly serious and insular. Moreover, its rejection of figural art seemed passé, an offshoot of prewar ideas and theories. Pop artists chose to confront the wider world more directly, commenting on the dramatic cultural changes of the sixties; changes in music, film, dress, and general behavior. Warhol became completely immersed in this new world. His art not only used mechanized processes, such as silkscreen printing; but it also featured subtly repeated images which reflected the power of mass production in American life. In a series of prints entitled *Flowers* (1964) (fig. left), Warhol based each work on a photograph of four hibiscus blossoms. He abstracted the photo's flowers and leaves, flattening their shapes and using a variety of stark, industrial-looking colors. The artist designed these works as individual "units," so that multiple copies could be be displayed together on a single wall—giving them the look of commercial wallpaper. Warhol would later use his own "image" to blur the distinctions between art and pop culture, immersing himself in the celebrity world of New York and becoming a pop culture hero as instantly recognizable as a movie star.

Recent generations of Pop artists have made art and commerce nearly indistinguishable. Beginning in the 1990s, the Japanese artist Takashi Murakami (b. 1962) has created an art obsessed with his country's popular entertainment culture—the world of *anime* and *manga*. His wide-eyed, "superflat" characters are an expression of the insular, cult-like fantasy world to which many young Japanese have become addicted. But Murakami has taken his art beyond mere social commentary. With the help of Louis Vuitton and other manufacturers, the artist has created his own lines of licensed shoes, bags, and telephones. While Pop Art may have begun in a Britain removed from America's mass media frenzy, the culture of commerce has now engulfed much of the globe. Twenty-first century artists now have the luxury—and the challenge—of working from "inside the system."

left——ANDY WARHOL, FLOWERS | 1964 | oil and acrylic on canvas 61 × 61 cm | Collection José Mugrabi.

1922: Discovery of Tutankhamun's Tomb ·· **1931:** Completion of the Empire State Building ·······························

1925: Invention of television ···

1933: Adolf Hitler seizes power ···

158/159

1921 – 1986: Joseph Beuys 1925 – 2008: Robert Rauschenberg 1928 – 1962: Yves Klein

YVES KLEIN: THE IMMATERIAL

Yves Klein (1928–62) was a true second-generation modernist. His father, Fred Klein (1898–1990), had begun his painting career in 1920s Paris, when the city was still at the center of progressive art. Like Marc Chagall (1887–1985) and Franz Marc (1880–1916) before him, the elder Klein developed a highly lyrical style that explored the visceral power of color and animal form. His work often featured delicately simplified horses. Yves' mother, Marie Raymond (1908–89), gained fame in the late 1940s as a leading abstract painter. Her works too were expressively colorful, and they incorporate the shapes and splintered objects of Cubism. Young Yves was surrounded from an early age by his parents' circle of artists, writers, and critics. He also enjoyed an unusual level of creative freedom and independence, which enabled him to rebel comfortably against his parent's way of making art.

"The fact that my mother and father were painters annoyed me," he later wrote, "and put me off from painting. But because of that, I kept abreast of the most extreme ideas of avant-garde painting thanks to them. And therefore I was always striving unconsciously to go a little further."

Instead of attending traditional art school, Yves Klein spent much of his youth travelling and absorbing different cultures. Tirelessly energetic, he spent nearly two years learning the art of judo in Japan, earning the rank of fourth dan, one of the highest levels of mastery attained by a French citizen at that time. Klein absorbed ideas of Oriental philosophy, including the Chinese notion of immaterial space—the space in a vessel—as an active and useful entity. He also learned of the esoteric Christian sect, Rosicrucianism, through the writings of Max Heindel. Heindel argued for an evolutionary process in which humans would become transformed into spiritual beings. All of these studies promoted in Klein an obsession with immateriality, and when he began his artistic career in 1954, he pursued radical new techniques and media for expressing that idea.

Klein's first major works were his monochrome canvases, the most famous of which were done for a 1957 exhibit at the Iris Clert Gallery in Paris. Eleven identical canvases were covered in a type of blue paint that Klein had invented, *international Kline blue* (IKB). IKB was made with a newly developed chemical resin, and its rich, lapis lazuli shade had an unusual, ethereal luster. Klein wanted to show

left——**Yves Klein, Blue sponge relief** | 1960 | sponge, stone and pigments on wood and canvas | 145 × 116 cm | Städelsches Kunstinstitut und Städtische Galerie | Frankfurt.

»Klein was attempting to give space itself an active, aesthetic potency similar to that of ›material‹ art.«

how such a blue could express a sense of expanding space. In traditional art, he argued, the "line pierces space, it is always in transit, it inscribes itself; it is a tourist. Color finds itself permeated with space, it dwells in it. ... colors bathe in the whole like anything that partakes of an indefinable, formless and boundless sensibility." In 1958, Klein took the concept of aesthetic space further, eschewing traditional canvas paintings altogether. His installation *Le Vide* (The Void) featured an empty room in the Clert gallery, with walls that Klein had meticulously painted white (fig. left). Visitors to the installation were expected to go through a kind of ritual procession, travelling to the white room through a corridor decorated with a massive blue canopy and a door concealed by blue curtains. Klein's "decoration" of the room was, in the words of his collaborator Pierre Restany, meant to make the room "his picture, his work, in such as way as to 'stabilize' the surrounding space." Thus Klein was attempting to give space itself an active, aesthetic potency similar to that of "material" art. The extensive publicity attracted thousands of visitors to *The Void*, including many puzzled critics and curious young artists and art students. During

the show, a curator facetiously asked Klein what the value of his immaterial art might be. The ensuing argument inspired Klein to develop a new kind of ritual performance. It involved a "commercial" transaction, where Klein "exchanged" a piece of immaterial space—what he called a "zone of immaterial pictorial sensibility"—for a predetermined amount of pure gold. When the "payment" was made, Klein gave the buyer a signed receipt from a specially-produced receipt book. The artist would then ask the buyer if he wanted to become the owner of the space in "an absolute, intrinsic manner." If so, the owner would burn the receipt and Klein would throw half of the gold payment into a river or "some natural spot from which it would be impossible to retrieve it." Several of these transactions took place from 1959 to 1961, and they were conducted in the presence of "witnesses"—usually a museum curator and photographers. Images of patrons burning receipts, and of Klein throwing gold ingots into the River Seine, helped inspire the development of postmodern performance art (fig. p. 162 left). Klein's "immaterial zones" had redefined the role of the artist from a seller of material creations to someone who changed people's perceptions of—or "sensitivity" to—immaterial aesthetic concepts.

Yves Klein's brief, tumultuous career ended with his untimely death in 1962, but his innovations long

right——**YVES KLEIN, THE VOID,** photo from the 1958 exhibition.

survived him. In 1965, Joseph Beuys began to explore other means of expressing the "immaterial" through artistic action. In his 1966 work, *Filz TV* (Felt TV) (fig. above right), he placed a piece of felt over a working TV screen and then physically assaulted himself with boxing gloves before finally pushing the TV away and exiting the room. For many observers, the obstructed television set and the artist's overt physicality represented the manipulative "violence" of mass media communication.

The pioneering work of Klein and Beuys has led to a worldwide proliferation of performance art. Such work continues to explore cultural themes, while often pressing the boundaries of official taste. In the 1990s, Chinese artist Zhang Huan (b. 1965) compiled a body of performances that both pushed the physical limits of his own body and exposed the often painful costs of political indifference. In his 1994 work, *12 Square Meters*, Zhang sat naked for an hour in a public toilet in Beijing, his body covered in honey and fish oil and attracting flies. Here the artist seemed to represent Chinese society at large, a people accus-

tomed to painful endurance in the face of neglect by government leaders. In another work, *Foam* (1998), Zhang is shown with his face covered in soapy foam and holding a family portrait in his mouth (fig. right). The portraits seem to emerge out of the "ocean" of Zhang's face, symbolizing the eternal importance of ancestors in Chinese life. Despite official reprimands by his country's government, Zhang's work reached a worldwide audience, expressing the cross-cultural power of the "immaterial," transitory act in art.

above left——**YVES KLEIN,** Photo of transaction from Klein's Zone de Sensibilité Picturale Immatérielle.

above right——**JOSEPH BEUYS, FILZ TV** (Felt TV) | 1966 | still photo from performance.

right——**ZHANG HUAN, FOAM** | 1998 | performance | Beijing.

1986: Chernobyl disaster · **1997:** Death of Princess Diana · **KLEIN** **162/163**

1989: Fall of the Berlin Wall ·

1992: Founding of the European Union ·

1873: Jules Verne publishes *Around the World in Eighty Days* ... 1889: Completion of the Eiffel Tower

1876: Invention of the telephone ...

1884: Mark Twain publishes the *Adventures of Huckleberry Finn*

164/165

1879 – 1940: Paul Klee 1881 – 1973: Pablo Picasso 1886 – 1966: Jean Arp

JEAN DUBUFFET: *ART BRUT* AND THE OUTSIDER ARTIST

For many modern artists, the revolt against academic traditions was linked with their discovery of "primitive" art. Stylized African masks and pre-Classical European sculpture inspired some of Picasso's (1881–1973) most important work—including his seminal *Les Demoiselles d'Avignon* (1907). For other artists, this fascination with elemental forms led to the exploration of folk art and the art of children. Paul Klee's (1849–1940) paintings combine many childlike elements: the undefined, dreamlike space and the expressive stick figure. In *Dance of the Mourning Child* (1922), Klee displays his ability to achieve movement and passion in the simplest abstract scribbles (fig. p. 166).

Before World War II, mainstream attitudes toward Klee, Picasso, and other primitivists were generally negative. The infamous 1937 Nazi exhibition *Entartete Kunst* ("Degenerate Art") (fig. p. 167), which featured some of Klee's works, was designed to exploit these attitudes and promote the notion of Jewish and non-Western culture as subversive. But when Nazi atrocities were revealed after the war, the insidious nature of Hitler's cultural policies was fully revealed. Like the Dadaists after World War I, many artists of the 1940s would see "orderly" Western culture as dangerously flawed, capable of destroying millions of innocent lives. For them, the very art that had been labeled "degenerate" could now affect a "civilizing" influence on the postwar West.

Jean Dubuffet (1901–85) had never much cared for the elite art world. Though he began his training at the Académie Julien in Paris in 1918, his revulsion against the city's cultural pretensions made him indifferent to a career in art. For many years, he gave up art completely to run a wine business. But the growing chaos of World War II helped give Dubuffet a powerful motivation for re-igniting his art career, a career he would establish for good in 1942. From the outset, he focused on figures of Klee-like simplicity, while at the same time developing a rough, thick style of brushwork, and an almost aggressive aesthetic intensity that seemed to probe the deepest regions of the human psyche. In *l'Accouchement (Childbirth)* (1944), for example, Dubuffet creates an image resembling something between an icon from the Dark Ages and a modern graffiti mural (fig. left). The features and genitalia of a Madonna-like birthing mother are brutally abstracted, her flat, curving body serving as a field of thick orange-red paint with scratches and smudges of blue. Beside her

left——**JEAN DUBUFFET, L'ACCOUCHEMENT** (Childbirth) | 1944
oil on canvas | 99.8 × 80.8 cm | Museum of Modern Art | New York.

1895: Discovery of X-rays .. **1909:** Opening of Queensboro Bridge in New York ..

1903: First powered flight by the Wright brothers **1914-1918:** First World War

1895 – 1965: Dorothea Lange 1901 – 1985: Jean Dubuffet 1910 – 1962: Franz Kline

1919: Formation of the Bauhaus school ... **1931:** Completion of the Empire State Building **DUBUFFET** **166/167**

1925: Invention of television ..

1939-1945: Second World War...................

1922 – 2011: Richard Hamilton　　　　　　　**b. 1929: Claes Oldenburg**　　　　　　　**1932 – 2006: Nam June Paik**

stand two bourgeois figures in 1940s attire, both of whom are given similar pictorial treatment. The image's extremely flattened space, as well as the female figure's bared teeth and bright green eyes, speak of the primitive, animalistic nature of childbirth. As his painting career began to blossom, Dubuffet also became an influential writer, collector, and exhibitor of art. Beginning in 1945, he amassed a collection that was inspired by the writings of German psychiatrist Hans Prinzhorn. During the 1920s, Prinzhorn decided to study and publish art produced by mentally ill patients. Dubuffet's collection, which he would call *Art Brut* (or "Rough Art"), included works amassed from mental institutions throughout France and Switzerland. Over the following years, these pieces were displayed at various galleries, and an art society called the *Compagnie de l'art brut* was formed—a gesture that, in part, mocked the exclusive, establishment art societies of Paris. In 1949, the *Compagnie* would present a more extensive exhibition of 200 works—drawings, paintings and sculpture—with Dubuffet writing the essay for its

catalogue. The essay would describe Dubuffet's own conception of Art Brut:
"Anyone setting out, as we do, to look at the works of *irregulars* will ultimately acquire a totally different notion from the one commonly held of approved art, the art of museums, galleries, salons—let us call it *cultural art*. The latter will no longer appear as truly representative of artistic culture at large but merely as the activity of a very private clan: the clan of professional intellectuals. What we mean (by art brut) is anything produced by people unsmirched by artistic culture, works in which mimicry, contrary to what occurs with intellectuals, has no part. So that the makers (in regards to subjects, choice of materials, means of transportation, rhythms, kinds of handwriting, etc.) draw entirely on their own resources rather than the stereotypes of classical or fashionable art. Many (nearly half) of the objects in our exhibition are by the inmates of psychiatric wards. We see no reason whatsoever for putting them in a special department, as some people do ...
It is our viewpoint that the function of art is the same in all cases and that there is no such thing as art by the insane any more than there is such a thing as art by dyspeptics or by people with bad knees."
The development of Dubuffet's own art would be informed by the qualities he saw in Art Brut—the use of creative technique and free, emotionally raw

left——**PAUL KLEE, DANCE OF THE MOURNING CHILD II** | 1922 | tempera on canvas | 31.3 × 22.9 cm | Pinakothek der Moderne | Munich.
above——Photo of 1937 Nazi Degenerate Art exhibition, Room 3.

1946: First computer·· **1959:** Completion of the Solomon R. Guggenheim Museum in New York ··········
······························· **1949:** Founding of the Federal Republic of Germany ···
··· **1961:** Construction of the Berlin Wall ······

b. 1945: Paul McCarthy | **b. 1958: Julian Opie** | **1960 – 1988: Jean-Michel Basquiat**

brushwork. Beginning in the late 1940s, he would pioneer the use of "rough" materials, including sand, tar, and pebbles, onto his canvases. He would also begin to explore the aesthetic potential of the "Art Brut" landscape, a theme inspired by a trip to North Africa, where Dubuffet had absorbed the vast desert topography and folk arts of the Sahara. In several 1952 landscapes, Dubuffet transforms the North African desert into a pulsating web of cellular forms (fig. above). These forms suggest the cerebral "landscape" of neurons and transmitters, an almost literal painterly embodiment of extreme psychic states. Dubuffet himself wrote that the North African images "certainly showed a distinctive character which might be called psychic or metaphysical, or suggest mental derangement." The works also display their maker's sure, semi-automatic brushwork, often using "plastic paints put on in a thick paste that was more like putty than paint."

Such imagery would prove to be important in Dubuffet's artistic development. His most famous works, done in the sixties and seventies, incorporated similar psychic, semi-automatic forms—a process he would call *hourloupe*. The *hourloupe* method was used to produce paintings and canvas-like sculptures, many of which now grace museums and urban parks worldwide. But Dubuffet's career would also have ramifications beyond his own work. By the 1970s, the idea of Art Brut would inspire a broader interest in "outsider art"—the product of artists who, for reasons of race, class, education, disability, or inclination, had remained outside the official art establishment. Some of this art would attain considerable prominence. James Hampton (1909–1964), an African-American janitor from the rural South, spent the last 14 years of his life working on an integrated group of religious objects called *The Throne of the Third Heaven of the Nations' Millennium General Assembly* (fig. right). This glittering work includes an altar, throne, pulpits, and offertory tables, all of which are made of discarded materials—light bulbs, glass, and wood planks—and covered with metallic foil. Traditional Christian symbols, including wings and stars, project out of the objects, giving the piece an almost baroque decorative complexity. Yet the objects are also designed so that the entire arrangement creates a sophisticated, symmetrical unity; a unity that inspires deep spiritual reflection. Hampton's "Throne" is now displayed at the Smithsonian American Art Museum, and it celebrates the change in attitude toward "non-official" art that was first championed by Jean Dubuffet.

1967: Six-Day War ..

1969: Neil Armstrong lands on the moon 1977: Jimmy Carter sworn in as president of the U.S.

1986: Chernobyl disaster

DUBUFFET **168/169**

b. 1967: Tal R b. 1970: Anselm Reyle b. 1974: Anri Sala

left—— **JEAN DUBUFFET, LANDSCAPE** | 1952 | ink on paper | 45.3 × 60.2 cm
Museum of Modern Art | New York.
above—— **JAMES HAMPTON, THE THRONE OF THE THIRD HEAVEN
OF THE NATIONS' MILLENNIUM GENERAL ASSEMBLY** | 1950–64 | gold and
silver aluminum foil, Kraft paper, and plastic over wood furniture,
paperboard, and glass | 180 pieces in overall configuration, 3.2 × 8.2 × 4.4 m
Smithsonian American Art Museum | Washington, D.C.

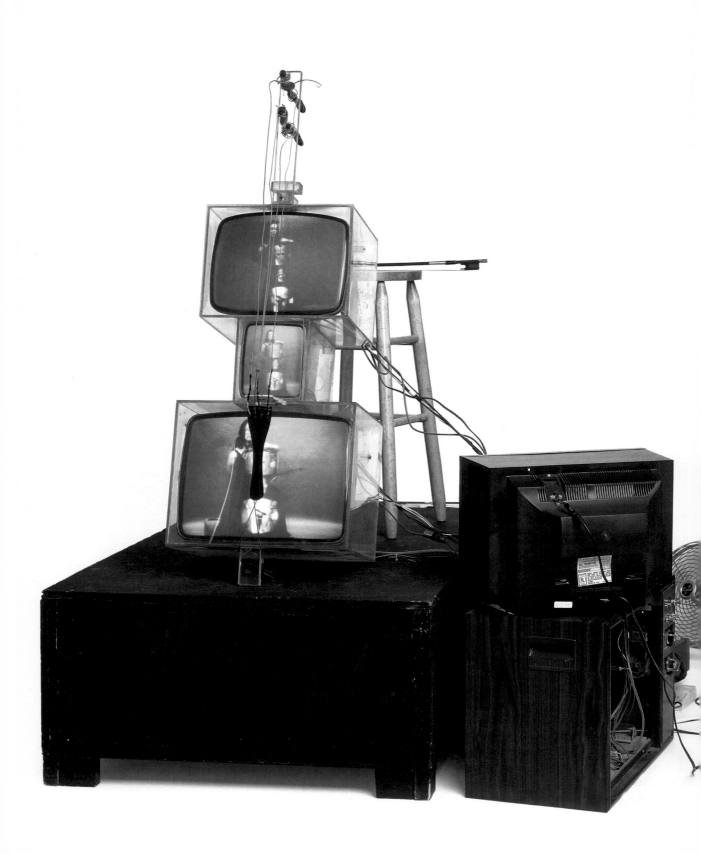

1883: First petrol-engined automobile

1887: First Sherlock Holmes novel is published

1896: First modern Olympic Games

1909: Opening of Queensboro Bridge in New York

170/171

1881 – 1955: Fernand Léger 1887 – 1968: Marcel Duchamp 1898 – 1976: Alexander Calder

NAM JUNE PAIK: *TV CELLO* AND THE MULTI-MEDIA REVOLUTION

When the age of mass media took off during the Roaring Twenties, it offered artists completely new ways of creating and transmitting their work. Fernand Léger (1881–1955) and Marcel Duchamp (1887–1968) began making art films in the 1920s, while famed La Scala conductor Arturo Toscanini brought classical music to millions through his NBC Symphony Orchestra radio broadcasts. Radio was the earliest form of mass media to invade the home and reshape middle-class family life. But after World War II, the potential of television as a cultural tool—or an attention-absorbing beast—far outstripped that of radio. Fittingly, the era of television began at the same time as the Cold War, the first global conflict waged largely through propaganda. Cold War tensions escalated quickly in Korea, a land divided between the Soviet-controlled North and the American-controlled South. The conquest of neighboring China by Communist forces made the maintenance of a Western-influenced Korean state imperative for the American government. Even before the outbreak of the Korean War in 1950, many South Koreans were forced to flee their homeland for safer harbors. Nam June Paik (1932–2006) and his family were among these émigrés.

Paik had an innate musical talent, fostered by years of piano studies and a music degree from the University of Tokyo in 1956. But he was also a born showman who sought to integrate music and the visual arts. Paik's supportive family enabled him to travel to the West, where he spent several years in Germany making contacts with composers John Cage and Karlheinz Stockhausen, both of whom were exploring the aesthetic possibilities of electronic music. Paik also met Joseph Beuys (1888–1958) and became absorbed in the newly developing field of conceptual and performance art. Many of these artists were part of the larger neo-Dada movement, which was inspired by Marcel Duchamp's notion of art as an individual gesture. Paik began performing works that combined both aural and visual gestures, symbolically rebelling against traditional artistic culture. In one piece, *Klavier Integral* (1958–63), the artist radically transformed a piano; altering its insides and "decorating" its exterior with barbed wire, smashed eggs, and other objects. This piece, which included Paik playing the unfamiliar sounds that the new instrument now generated, immersed the audience in a process of transformation. At about this time, Paik's search for new ways of generating sound and

left——**Nam June Paik, TV Cello** | 1971 | video tubes, TV chassis, plexiglass boxes, electronics, wiring, wood base, fan, stool, photograph Walker Art Center | Minneapolis.

» *Paik's innovative use of video, performance, sculpture, and postmodern energy inspired much of what is now called* ›multimedia art.‹ «

image—and his facility with electronics—led him to incorporate television into his work.

In the early 1960s, the artistic and educational potential of television was often discussed, but few artists were willing to translate these discussions into tangible artworks. Paik's penchant for deconstructing objects led him to examine ways of altering the physical television set for aesthetic ends. These explorations led to a landmark exhibition in Wuppertal, Germany called *Exposition of Music—Electronic Television* (1963), in which he exhibited several TVs that were transformed on multiple levels: they were displayed on their back and sides and their reception had been altered in ways that produced intentionally warped images. Some of these TVs could be adjusted by the viewers themselves, including one set that produced an electronic "fireworks" display when the viewer spoke into a microphone. Paik referred to this work when he said that "all 13 sets actually changed their inner circuits. No two sets had the same kind of technical operation. Not one is a simple blur, which occurs when you turn the vertical and horizontal control-button at home." Paik had begun to explore the complex, interactive nature of television and mass media—the ways people can manipulate, and become manipulated by, such media.

A year after this exhibition, Paik's restless nature and his desire to reach a broader audience led him to New York City. There he continued his radical deconstruction of the television in the heart of the commercial TV industry. He also made contacts with a diverse group of New York artists, musicians, and performers, including the cellist-actress Charlotte Moorman. Paik and Moorman would enjoy a long-term partnership and create some of the most lasting images of Paik's electronic art. One of their famous collaborations was *Concert for TV Cello and Video Tape* (1971) (fig. p. 170), which involved Moorman performing with two of Paik's creations: *TV Cello* and *TV Glasses*. When building *TV Cello*, Paik separated three TVs from their heavy casings and placed them in clear plastic containers. He then stacked them one on top of the other and attached the ensemble to a stringed plastic neck—creating an almost Cubist version of the cello. The instrument was wired to a jungle of electronic gadgets, which enabled the player of the cello to make mechanical sounds and to adjust the images on the TVs. Photographs from the original performance show Moorman's body merging into the instrument, while taped images of Janis Joplin

right——**Nam June Paik, Fin de Siècle** | 1989 | 201 television sets with 4 laserdiscs | 1219.2 × 426.72 × 152.4 cm | Whitney Museum of American Art New York.

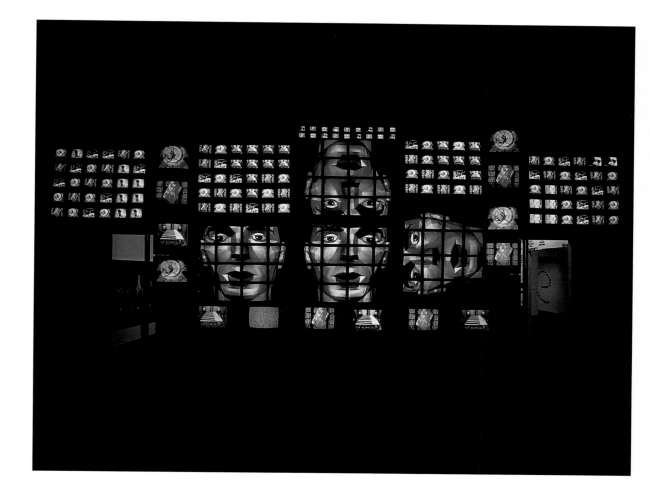

seem to emit directly from her chest, crotch, and legs through the TV screens. Moorman also wears the futuristic TV Glasses, which project images through tiny televisions attached to the glasses' temple arms. *TV Cello* was clearly an odd mix of science fiction campness and restrained eroticism. But it also reveals Paik's talent for playing with time and space, juxtaposing the movement of a live performance with an ever-changing loop of recorded imagery. The artist also wittily explores the sculptural possibilities of the TV object.

The success of *TV Cello* led Paik towards gradually more elaborate installation works. His *Fin de Siècle* (1989) (fig. above) used more than 200 television sets arranged in complex patterns along a wall in the Whitney Museum of American Art. The work's shifting video imagery created a luminous electronic mosaic of almost sculptural depth.

Paik's innovative use of video, performance, sculpture, and postmodern energy inspired much of what is now called "multimedia art." Its practitioners are many, including the American artist Matthew Barney (b. 1967). In Barney's massive *Cremaster* series (1994–2002) (fig. p. 173), the full-length feature film is at the center of an installation environment that includes photographs, drawings, performances, and sculptures. Each of the films is centered around the theme of embryonic development and biological cycles—and they use complicated plots and surreal costumes and sets. The project's title refers to the male cremaster muscle, which controls the temperature of the testicles, influencing the sex of the fetus.

As with Paik's *TV Cello*, Barney's *Cremaster* series uses electronic media to explore sensual, organic themes.

Another multimedia artist, Doug Aitken (b. 1968), carves out entire spaces for his presentations. In his *Frontier* (2009) installation (fig. above), a modernist pavilion was built in the heart of ancient Rome, on an island in the Tiber river. On the pavilion's walls, Aitken projected videos of the artist Ed Ruscha (b. 1937) travelling through various landscapes —contrasting the restless nature of human lives with the more slowly evolving river and ancient city. Such works highlight the dramatic evolution of mutimedia art. The humble, almost kitschy TV screens of Nam June Paik's early work have metamorphosed into an international phenomenon, just as the television medium itself has spawned the ubiquitous electronic chatter of the Twitter era.

right——**MATTHEW BARNEY, CREMASTER 5** | 1997 | production still
Gladstone Gallery | New York.
above——**DOUG AITKEN, FRONTIER** | 2009 | installation view, Tiber Island,
Rome | 303 Gallery | New York.

·····**1914-1918:** First World War ·· **1931:** Completion of the Empire State Building ······················ **176/177**
··· **1925:** Invention of television ··
··· **1933:** Adolf Hitler seizes power ····························

1917 – 2009: Andrew Wyeth **1923 – 1997: Roy Lichtenstein** **1928 – 1987: Andy Warhol**

CHUCK CLOSE: PHOTOREALISM

When photography first spread across the Western world in the 1840s, it seemed to presage the end of traditional art. Almost immediately, painted portraits and miniatures were replaced by framed daguerreotypes, putting many artists out of work. The new commercial photographers reproduced their sitter's features with startling fidelity, and at a far lower cost than was incurred at the painter's studio. The daguerreotype also had a lustrous aesthetic quality that suited middle-class Victorian taste. Over the succeeding years and decades, artists from J.M.W. Turner (1775–1851) to Jackson Pollock (1912–56) re-imagined the purpose of art, abandoning the "bourgeois" techniques of classical realism in favor of expressive abstraction. Many early critics considered modern art to be photography's "stepchild." Yet as photographic images became ubiquitous in contemporary life, artists began to experiment with the photo itself as an aesthetic tool; a tool that could produce a new kind of postmodern realism.

During the 1950s and early 1960s, many American artists began to fetishize the mass-produced image, bringing realistic figural elements and iconography

into their art. They often exploited the processes and products of media image-making. Roy Lichtenstein (1923–1997) developed his ironic cartoon art using the printing industry's Ben-Day dots (fig. 179). Andy Warhol (1928–87) produced silkscreen prints that subtly manipulated the celebrity photograph. And Jasper Johns's (b. 1930) mythic American flags incorporated both paint and layers of collage material—discarded newspaper clippings and other commercial waste. The manufactured "realism" of these artworks was used to highlight the complex relationships between viewer and image; between the iconic symbol and the culture that produced it. Then in the late 1960s, a group of young art school graduates created their own, extreme form of "mechanical" realism. Chuck Close (b. 1940) was to become the most famous among them. A gifted draftsman and technician, Close overcame childhood dyslexia to study at the University of Washington and the prestigious Yale University School of Art and Architecture. There he created masterful student works that combined fluid, expressionist brushstrokes and postmodern imagery—including a Johns-like American flag painting. But after his graduation in 1965, Close decided to abandon his efforts with traditional painting technique. He admitted that, despite his admiration for "painters like Rothko, Pollock, and Kline," these artists "nailed it down so well

left——**CHUCK CLOSE, BOB** | 1970 | synthetic polymer paint on canvas 275.0 × 213.5 cm | National Gallery of Australia | Parkes.

178/179 CLOSE 1939-1945: Second World War ... 1961: Construction of the Berlin Wall
1959: Completion of the Solomon R. Guggenheim Museum in New York ········
1946: First computer ················

b. 1940: Chuck Close b. 1945: Paul McCarthy b. 1959: Peter Doig

> »Roy Lichtenstein developed his ironic cartoon art using the printing industry's Ben-Day dots.«

that I couldn't do anything but weak impersonations of their work." So by 1967, in a concerted effort to develop his own style, Close developed a meticulous technique of "reproducing" a photographic image on canvas. He later referred to this decision as the "imposition of rigorous, self-imposed limitations that seemed to open doors, that seemed to make it possible to go someplace where a lot of other people weren't flocking at the same moment. But it was also just a way to keep from banging your head against a wall." Close chose for his new art that quintessential photographic image, the portrait. His process began by inviting a friend into his studio and taking a snap-shot, making certain that the sitter adopt an expressionless countenance. Afterwards, he would enlarge these photos and score them with grid lines. Close would then painstakingly reproduce each "square" on the grid—piece by piece—on a huge, nine-foot-high (3 meter) canvas. The artist used a remarkable variety of tools to apply and work his acrylic paint: spray guns, rags, erasers, razor blades, brushes, sponges, and even a modified commercial air-brush technique. Close chose the large-size canvas format so that he would be forced to create the painting in stages, making the work's details just as important as its overall composition.

During the process of making his first series of portrait heads, Close decided to record his process on film. The short documentary called *Slow Pan for Bob* focused on his portrait of Robert Israel, who became an important opera set designer in New York. As Close described, "I did a thing where I panned the rectangle that Bob's head was in. There was a flash as the lens opened and it was white, and then you saw the little fuzzy things go by and it was white again, and it flashed and it was white, and then you saw some fuzzy hair and then some sharp hair, and fuzzy hair, until you had slowly gone all the way over his face. You knew everything in the world about his face, but you didn't know who you'd seen, because you couldn't put all the pieces together."

Bob would be among several black-and-white por-traits that Close exhibited at the Bykert Gallery in New York in 1970. Because *Slow Pan for Bob* was also shown at these exhibits, the viewers were given "instructions" as to how they should view the works—scanning the carefully made details before viewing a piece in its entirety. *Bob* is typical of these images. Close has abandoned the traditional methods of portrait composition, refusing to highlight any particular aspect of the face or express the inner

right——ROY LICHTENSTEIN, DROWNING GIRL | 1963 | oil and synthetic polymer paint on canvas | 171.6 × 169.5 cm | Museum of Modern Art New York.

1967: Six-Day War ... **1977:** Jimmy Carter sworn in as president of the U.S.

1969: Neil Armstrong lands on the moon ... **1980:** John Lennon shot

b. 1965: Damien Hirst **b. 1968: Wolfgang Tillmans** **b. 1974: Anri Sala**

»In the Concrete Cabin *series, Peter Doig engulfs Le Corbusier's Unité d'Habitation building in a sensual, glistening forest.«*

personality of the sitter. Instead, the viewer is made to see the image—both in its close-up detailing and in its overall appearance—as a vast surface of carefully made form and textures. In short, the viewer's attention is focused on the artistic process.

Close would soon be categorized as a "Photorealist," a term he has always rejected. For him, the "only way I can accomplish what I want is to understand not the reality of what I am dealing with, but the artificiality of what it is." In other words, though the artist works from an image that reflects reality, his process of "re-creating" that image is a consciously artificial one. Yet this artificiality is enlivened by the elegance of Close's handwork. And the intelligence of his decision making creates images that are inevitably more expressive and captivating than the mechanical photographs on which they are based.

The art of Chuck Close gradually gained acceptance among critics and the public, and it helped inspire younger artists to explore other ways of using photography as an artistic tool. The Scottish-born Canadian painter Peter Doig (b. 1959) uses photographic sources to create misty, evocative landscapes. Some of these images examine the nature of hidden realities. In one well-known series, Doig features the Swiss architect Le Corbusier's (1887–1965) Unité d'Habitation building in Briey-en-Forêt, France (fig. left). His images engulf the modernist icon in a sensual, glistening forest. Doig's own writings explain the working process for these images: "The building took me by surprise as a work of architecture, but it was not until I saw the photographs I had taken of the building through the trees that it became interesting. That made me go back and look at it again. I was surprised by the way the building transformed itself from a piece of architecture into a feeling. It was all emotion suddenly." For Peter Doig, Chuck Close, and many twenty-first-century artists, the photograph never lived up to its original billing as a destroyer of art. Instead, it has become a cherished tool for heightening aesthetic sensibilities and channeling artistic journeys.

left——**PETER DOIG, CONCRETE CABIN II** | 1992 | oil on canvas
200 × 240 cm | Victoria Miro Gallery | London.

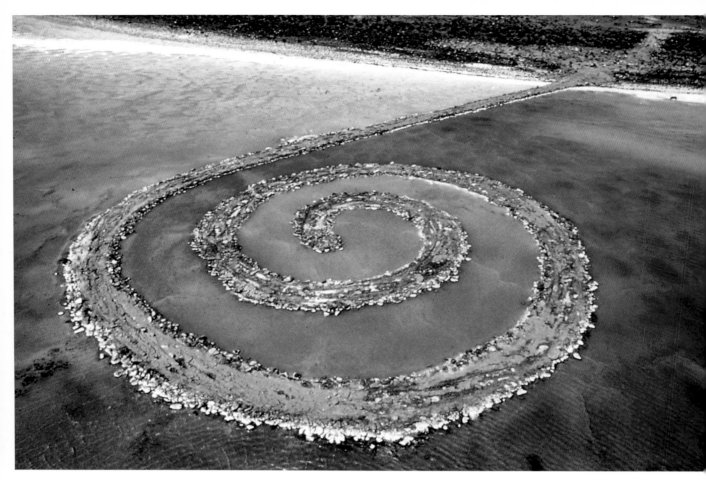

1933: Adolf Hitler seizes power

1946: First computer

1939-1945: Second World War

1948: Founding of the State of Israel

182/183

b. 1935: Christo

1938 – 1973: Robert Smithson

b. 1945: Paul McCarthy

ROBERT SMITHSON: *SPIRAL JETTY* AND THE ART OF ENTROPY

Human beings have long modified the land for ritual and aesthetic purposes—creating everything from giant burial mounds to rigidly patterned Baroque gardens. During the nineteenth century, expanding urbanization led many artists and writers to extol the virtues of nature. In response to this movement, developers began carving out places where people could enjoy the benefits of both city life and the natural world. Leafy suburbs sprang up around major urban centers, their winding streets and generous lots offering a welcome contrast to the city's grid pattern. Such communities gave well-to-do urban citizens a "healthy" alternative to their metropolitan lifestyle. Within the cities themselves, landscape architects were hired to create parks that provided green spaces for a broader segment of the working class. Central Park in New York City, designed in the late 1850s by Frederick Law Olmsted and Calvert Vaux, was the grandest example of this socially responsible "nature art" (fig. p. 184). Yet Olmsted's creation, like the city itself, was largely a product of massive engineering. Olmsted crafted an entire landscape of artificial lakes and mounds, planting hundreds of trees, moving tons of earth, and designing elaborate walking paths that wound through the park's manufactured vistas. The natural world and the industrial world were becoming inextricably linked.

By the 1960s, attitudes towards urban life were shifting. Pop Artists were beginning to revel in the commercial culture that industrialism had spawned. Such attitudes grew, in part, from a sense that persistent change had come to define life in the West, especially in the United States. Many monuments of America's first industrial era had become obsolete. Rail lines that originally connected the nation's cities had been replaced with superhighways. Urban areas that had been built up during the Victorian age were decaying and, in some cases, becoming depopulated. America was now, in many ways, a culture based on disposability.

This fascination with disposability was also shared by another group of 1960s artists. They began to consider how persistent cultural change might be reflected in America's landscapes, both rural and urban. One of these artists, Robert Smithson (1938–73), gave up a career as a painter to explore the forgotten by-products of industrial America. He toured the abandoned quarries and the decaying urban and suburban worlds of New Jersey and Pennsylvania. During his travels, he began to see connections between

left——**ROBERT SMITHSON, SPIRAL JETTY** | Mud, precipitated salt crystals, rocks, and water | 457.2 m long and 4.57 m wide.

1959: Completion of the Solomon R. Guggenheim Museum in New York··· **1969:** Neil Armstrong lands on the moon···········

1961: Construction of the Berlin Wall ··

1968: Assassination of Martin Luther King ·············

b. 1959: Peter Doig **b. 1965: Damien Hirst** **b. 1968: Doug Aitken**

evolving human culture and the geological concept of entropy—or the inevitable process of change from one state to another. In his famous essay, The *Crystal Land* (1966), Smithson writes of the sprawling New Jersey suburbs:

"The highways criss-cross through the towns and become man-made geological networks of concrete. In fact, the entire landscape has a mineral presence. From the shiny chrome diners to glass windows of shopping centers, a sense of the crystalline prevails." Smithson's mental linkage of human landscapes and mineral formations suggested similar ties between inevitable urban decay and geological upheaval. The artist also began producing minimalist sculptures, such as *Gyrostasis* (1968) (fig. right), that visualized this idea. Industrially-produced metal shapes are placed together in ways that suggest a collapsing motion.

During his tours of abandoned quarries, Smithson developed another key idea of his art, the dual concept of "Site" and "Nonsite." The Site represented the original, constantly evolving place of "indeterminate certainty" and "scattered information." The Nonsite, on the other hand, was a defined "array of matter" that could "represent" the Site in a museum setting. In Smithson's first visual embodiments of the Nonsite, he collected pieces of slate and other materials from abandoned mines and displayed them in "crystalline" metal containers. These jagged remnants evoked the crumbling, eroding nature of the

above——**PHOTO OF NEW YORK'S CENTRAL PARK** | 1860.
right——**ROBERT SMITHSON, GYROSTASIS** | 1968 | Painted steel 187.0 × 137.5 × 99.7 cm | Hirshhorn Gallery | Washington, DC.

1974: Watergate scandal .. 1986: Chernobyl disaster ... SMITHSON 184/185

1975: Death of General Francisco Franco ...

1989: Fall of the Berlin Wall

b. 1974: Anri Sala

2002: Introduction of the Euro
2003: Beginning of the Iraq war
2008: Barack Obama sworn in as president of the U.S.
1997: Death of Princess Diana

original Site's geology and of the human industrial activity on that Site.

In 1970, Smithson created his most famous work of geological art. *Spiral Jetty* (fig. p. 182) was built on a site at the edge of Utah's Great Salt Lake; a setting near multiple remains of bygone human endeavor: abandoned oil mines and the Golden Spike monument where the now obsolete intercontinental railway had been completed in the 1860s. The area also represented natural evolution, with the lake's constantly changing water levels revealing and then submerging coastal rock formations. Smithson wrote that: "Irregular beds of limestone dip gently eastward, massive deposits of black basalt are broken over the peninsula, giving the region a shattered appearance. ... Under shallow pinkish water is a network of mud cracks supporting the jig-saw puzzle that composes the salt flats. As I looked at the site, it reverberated out to the horizons only to suggest an immobile cyclone, while flickering light made the entire landscape appear to quake. A dormant earthquake spread over the fluttering stillness, into a spinning sensation without movement. This site was a rotary that enclosed itself in an immense roundness. From that gyrating space emerged the possibility of the *Spiral Jetty*."

For Smithson, this spiral shape symbolized his attitudes about entropy. Just as nature could slowly "shatter" and dissolve its creations, the spiral itself travelled in gradually smaller circles until it "collapsed" in the middle. So Smithson created a huge spiral earthwork, enlisting an army of dump trucks to carry the black basalt, limestone, and soil. It would become his most impressive effort to create a multi-layered "Site," a place where both the shape of the work and its eventual submergence into the rising lake would speak to the dissolving power of nature. *Spiral Jetty* would also yield "Unsites." Smithson produced photographs and a film of the jetty before it was submerged by the lake. These documentary objects were shown and sold in museums, performing the same role that the collected rocks had played in his earlier Unsites: they became a tangible way for people to perceive and understand the "real" Site.

In his *Spiral Jetty* film, Smithson himself becomes a representation of entropy, as a helicopter camera captured him running around the spiral, only to arrive at the remote "point of collapse" in the center. Since its original submergence into the Great Salt Lake in 1972, *Spiral Jetty* has resurfaced on several occasions, most prominently after the droughts of 2006 and 2010. Yet despite its inaccessibility, *Jetty* has inspired many artists to use the landscape as a way of communicating social and cultural issues. *Running Fence* (1976), by the American artists Christo and Jeanne-Claude (b. 1935), featured an undulating wall of nylon that wound through the hills in Northern California. Christo and Jeanne-Claude conceived the work as an object of aesthetic beauty—a fluttering version of China's Great Wall—and as a symbol of the political and social struggles that were required to build the piece, including an extensive environmental impact report and the compliance of dozens of ranchers and property owners. In a later work from 1983, Christo and Jeanne-Claude surrounded islands in Miami's Biscayne Bay in Florida with floating fabric (fig. right). This voluptuous pink material both emphasized and abstracted the islands' natural shapes. Aerial shots of the work showed a vast "highway" of pink forms, reflecting both the slow, watery evolution of nature and the changing—and often dramatic—impact of human technology on the landscape.

right——CHRISTO AND JEANNE-CLAUDE, SURROUNDED ISLANDS, BISCAYNE BAY, GREATER MIAMI, FLORIDA | 1980-83 | Photo: Wolfgang Volz, Copyright Christo 1983.

LIST OF ARTISTS

John **CONSTABLE**: born June 11, 1776 in East Bergholt, England; died March 31, 1837 in London

Jean-François **MILLET**: born October 4, 1814 in Gruchy, France; died January 20, 1875 in Barbizon, France

Gustave **COURBET**: born June 10, 1819 in Ornans, France; died December 31, 1877 in La Tour-de-Peilz, Switzerland

Frederick Law **OLMSTED**: born April 26, 1822 in Hartford, Connecticut; died August 28, 1903 in Belmont, Massachusetts

Camille **PISSARRO**: born July 10, 1830 in Charlotte Amalie, St. Thomas (now part of the U.S. Virgin Islands); died November 13, 1903 in Paris

Édouard **MANET**: born January 23, 1832 in Paris; died April 30, 1883 in Paris

Edgar **DEGAS**: born July 19, 1834 in Paris; died September 27, 1917 in Paris

Paul **CÉZANNE**: born January 19, 1839 in Aix-en-Provence, France; died October 23, 1906 in Aix-en-Provence

Auguste **RODIN**: born November 12, 1840 in Paris; died November 17, 1917 in Meudon, France

Claude **MONET**: born November 14, 1840 in Paris; died December 5, 1926 in Giverny, France

Pierre-Auguste **RENOIR**: born February 25, 1841 in Limoges, France; died December 3, 1919 in Cagnes, France

Vincent **VAN GOGH**: born March 30, 1853 in Groot-Zundert (now Zundert), Netherlands; died July 29, 1890 in Auvers-sur-Oise, France

Georges **SEURAT**: born December 2, 1859 in Paris; died March 29, 1891 in Paris

Paul **SIGNAC**: born November 11, 1863 in Paris; died August 15, 1935 in Paris

Edvard **MUNCH**: born December 12, 1863 in Ådalsbruk in Løten, Norway; died January 23, 1944 in Oslo, Norway

Henri de **TOULOUSE-LAUTREC**: born November 24, 1864 in Albi, France; died September 9, 1901 in Château Malromé, Gironde, France

Wassily **KANDINSKY**: born December 16, 1866 in Moscow; died December 13, 1944 in Neuilly-sur-Seine, France

Emil **NOLDE**: born Hans Emil Hansen on August 7, 1867 in Nolde, Germany (now Nolde, Denmark); died April 13, 1956 in Seebüll, West Germany

Henri **MATISSE**: born December 31, 1869 in Le Cateau-Cambrésis, France; died November 3, 1954 in Nice, France

Piet **MONDRIAN**: born March 7, 1872 in Amersfoort, Netherlands; died February 1, 1944 in New York City

Constantin **BRÂNCUŞI**: born February 19, 1876 in Hobiţa, Romania; died March 16, 1957 in Paris

Jean **PUY**: born November 8, 1876 in Roanne, France; died March 6, 1960 in Roanne

Gabriele **MÜNTER**: born February 19, 1877 in Berlin; died May 19, 1962 in Murnau am Staffelsee, West Germany

Kazimir **MALEVICH**: born February 23, 1878 in Kiev, Russia (now Kiev, Ukraine); died May 15, 1935 in Leningrad (now Saint Petersburg), Russia

Paul **KLEE**: born December 18, 1879 in Münchenbuchsee bei Bern, Switzerland; died June 29, 1940 in Muralto, Switzerland

Ernst Ludwig **KIRCHNER**: born May 6, 1880 in Aschaffenburg, Germany; died June 15, 1938 in Frauenkirch-Wildboden, Switzerland

André **DERAIN**: born June 10, 1880 in Chatou, France; died September 8, 1954 in Garches, France

Fernand **LÉGER**: born February 4, 1881 in Argentan, France; died August 17, 1955 in Gif-sur-Yvette, France

Pablo **PICASSO**: born October 25, 1881 in Málaga, Spain; died April 8, 1973 in Mougins, France

Georges **BRAQUE**: born May 13, 1882 in Argenteuil-sur-Seine, France; died August 31, 1963 in Paris

Jean **ARP**: born September 16, 1886 in Strasbourg, Germany (now Strasbourg, France); died June 7, 1966 in Basel, Switzerland

Diego **RIVERA**: born December 8, 1886 in Guanajuato, Mexico; died November 24, 1957 in Mexico City

Marc **CHAGALL**: born July 7, 1887 in Liozna, Russia (now Liozna, Belarus); died March 28, 1985 in Saint-Paul-de-Vence, France

Marcel **DUCHAMP**: born July 28, 1887 in Blainville-Crevon, France; died October 2, 1968 in Neuilly-sur-Seine, France

Giorgio **DE CHIRICO**: born July 10, 1888 in Volos, Greece; died November 20, 1978 in Rome

Egon **SCHIELE**: born June 12, 1890 in Tulln an der Donau, Austria; died October 31, 1918 in Vienna

Max **ERNST**: born April 2, 1891 in Brühl, Germany; died April 1, 1976 in Paris, France

Joan **MIRÓ**: born April 20, 1893 in Barcelona, Spain; died December 25, 1983 in Palma, Mallorca, Spain

Dorothea **LANGE**: born May 26, 1895 in Hoboken, New Jersey; died October 11, 1965 in San Francisco, California

Alexander **CALDER**: born July 22, 1898 in Lawnton, Pennsylvania; died November 11, 1976 in New York City

Henry **MOORE**: born July 30, 1898 in Castleford, England; died August 31, 1986 in Much Hadham, England

Len **LYE**: born July 5, 1901 in Christchurch, New Zealand; died May 15, 1980 in Warwick, New York

Jean **DUBUFFET**: born July 31, 1901 in Le Havre, France; died May 12, 1985 in Paris

Mark **ROTHKO**: born September 25, 1903 in Dvinsk, Russia (now Daugavpils, Latvia); died February 25, 1970 in New York City

Willem **DE KOONING**: born April 24, 1904 in Rotterdam, Netherlands; died March 19, 1997 in East Hampton, New York

Salvador **DALÍ**: born May 11, 1904 in Figueres, Spain; died January 23, 1989 in Figueres

Barnett **NEWMAN**: born January 29, 1905 in New York City; died July 4, 1970 in New York City

Victor **VASARELY**: born April 6, 1908 in Pécs, Hungary; died March 15, 1997 in Paris

Lee **KRASNER**: born October 27, 1908 in Brooklyn, New York; died June 19, 1984 in New York City

James **HAMPTON**: born April 8, 1909 in Elloree, South Carolina; died November 4, 1964 in Washington, D.C.

Franz **KLINE**: born May 23, 1910 in Wilkes-Barre, Pennsylvania; died May 13, 1962 in New York City

Jackson **POLLOCK**: born January 28, 1912 in Cody, Wyoming; died August 11, 1956 near East Hampton, Long Island, New York

Milton **RESNICK**: born January 7, 1917 in Bratslav, Russia; died March 12, 2004 in New York City

Jacob **LAWRENCE**: born September 7, 1917 in Atlantic City, New Jersey; died June 9, 2000 in Seattle, Washington

Joseph **BEUYS**: born May 12, 1921 in Krefeld, Germany; died January 23, 1986 in Düsseldorf, West Germany

Richard **HAMILTON**: born February 24, 1922 in London; died September 13, 2011 in London

Roy **LICHTENSTEIN**: born October 27, 1923 in New York City; died September 29, 1997 in New York City

Robert **RAUSCHENBERG**: born October 22, 1925 in Port Arthur, Texas; died May 12, 2008 in Captiva, Florida

Yves **KLEIN**: born April 28, 1928 in Nice, France; died June 6, 1962 in Paris

Andy **WARHOL**: born Andrew Varchola, Jr. on August 6, 1928 in Pittsburgh, Pennsylvania; died February 22, 1987 in New York City

Claes **OLDENBURG**: born January 28, 1929 in Stockholm, Sweden

Bridget **RILEY**: born April 24, 1931 in London

Nam June **PAIK**: born July 20, 1932 in Seoul, Korea; died January 29, 2006 in Miami, Florida

Dan **FLAVIN**: born April 1, 1933 in Jamaica, New York; died November 29, 1996 in Riverhead, New York

CHRISTO: born Christo Vladimiro Javacheff on June 13, 1935 in Gabrovo, Bulgaria

Robert **SMITHSON**: born January 2, 1938 in Passaic, New Jersey; died July 20, 1973 in Amarillo, Texas

Richard **SERRA**: born November 2, 1939 in San Francisco, California

Chuck **CLOSE**: born July 5, 1940 in Monroe, Washington

Paul **MCCARTHY**: born August 4, 1945 in Salt Lake City, Utah

Peter **DOIG**: born April 12, 1959 in Edinburgh, Scotland

Neo **RAUCH**: born April 18, 1960 in Leipzig, East Germany

Jean-Michel **BASQUIAT**: born December 22, 1960 in Brooklyn, New York; died August 12, 1988 in New York City

Takashi **MURAKAMI**: born February 1, 1962, in Tokyo

Zhang **HUAN**: born 1965 in Anyang, China

Damien **HIRST**: born June 7, 1965 in Bristol, England

TAL R: born Tal Rosenzweig Tekinoktay in 1967 in Tel-Aviv, Israel

Matthew **BARNEY**: born March 25, 1967 in San Francisco, California

Doug **AITKEN**: born 1968 in Redondo Beach, California

Wolfgang **TILLMANS**: born August 16, 1968 in Remscheid, West Germany

Anselm **REYLE**: born February 12, 1970 in Tübingen, West Germany

LITERATURE

FRIED, MICHAEL. *Manet's Modernism, or, The Face of Painting in the 1860s.*
 Chicago/London, 1996.

SPATE, VIRGINIA. *Claude Monet, The Color of Time.* London, 1992.

RISHEL, JOSEPH J. AND SACHS, KATHERINE (EDS.).
 Cézanne and Beyond. New Haven/London, 2009.

SUH, H. ANNA (ED.) VINCENT VAN GOGH, *A Self-Portrait in Art and Letters.*
 New York, 2006.

MASON, RAPHAEL AND MATTIUSSI, VÉRONIQUE. *Rodin.* Paris, 2004.

FLAM, JACK. *Matisse, The Man and His Art, 1869-1918.* Ithaca/London, 1986.

DAIX, PIERRE. *Picasso, The Cubist Years, 1907-1916.* Boston, 1979.

BARNETT, VIVIAN ENDICOTT AND FRIEDEL, HELMUT. *Vasily Kandinsky,*
 A Colorful Life. Munich, 1995.

HULTEN, PONTUS. *Marcel Duchamp, Work and Life.* Cambridge,
 Massachusetts, 1993.

HERBERT, BARRY. *German Expressionism, Die Brücke and Der Blaue Reiter.*
 London, 1983.

DOUGLAS, CHARLOTTE. *Malevich.* New York, 1994.

CAMFIELD, WILLIAM A. *Max Ernst, Dada and the Dawn of Surrealism.*
 Prestel- Verlag. Munich, 1993.

ROCHFORT, DESMOND. *Mexican Muralists, Orozco Rivera Siqueiros.*
 San Francisco, 1993.

PRATHER, MARLA. *Alexander Calder, 1898-1976.* NEW Haven/London, 1998.

ROSE, BARBARA (ED.). *Pollock Painting.* New York, 1978.

MADOFF, STEVEN HENRY. *Pop Art, A Critical History.* Berkeley/London, 1997.

CHARLET, NICOLAS. *Yves Klein.* Paris, 2000.

SAUSMAREZ, MAURICE DE. *Bridget Riley.* Greenwich, Connecticut, 1970.

GLIMCHER, MILDRED AND DUBUFFET, JEAN. *Jean Dubuffet, Towards an*
 Alternative Reality. New York, 1987.

HANHARDT, JOHN G. *The Worlds of Nam June Paik.* New York, 2000.

BEARDSLEY, JOHN. *Earthworks and Beyond, Contemporary Art in the Landscape.*
 Third Edition, New York/London/Paris, 1998.

STORR, ROBERT. *Chuck Close.* New York, 1998.

INDEX

Numbers in *italics* refer to images.

Front cover: Roy Lichtenstein, *M-Maybe*, 1965, see p. 155
Back cover (from the left to the right): Claude Monet, *Impression, soleil levant*, 1872, see p. 20/21; Christo and Jeanne-Claude, *Surrounded Islands*, 1980-83, see p. 187; Bridget Riley, *Movement in squares*, 1961, see p. 142;
Frontispiece: Kasimir Malevitch, *Suprematism (Red Cross on Black Circle)*, 1926–28, oil on canvas, 72,5 × 51 cm, Stedelijk Museum, Amsterdam

Prestel Verlag, Munich
A member of Verlagsgruppe Random House GmbH

Prestel Verlag
Neumarkter Strasse 28
81673 Munich
Tel. +49 (0)89 4136-0
Fax +49 (0)89 4136-2335
www.prestel.de

Prestel Publishing Ltd.
4 Bloomsbury Place
London WC1A 2QA
Tel. +44 (0)20 7323-5004
Fax +44 (0)20 7636-8004
www.prestel.com

Prestel Publishing
900 Broadway, Suite 603
New York, NY 10003
Tel. +1 (212) 995-2720
Fax +1 (212) 995-2733
www.prestel.com

Library of Congress Control Numberr is available; British Library Cataloguing-in-Publication Data: a catalogue record for this book is available from the British Library; Deutsche Nationalbibliothek holds a record of this publication in the Deutsche Nationalbibliografie; detailed bibliographical data can be found under: http://dnb.d-nb.de

Prestel books are available worldwide. Please contact your nearest bookseller or one of the above addresses for information concerning your local distributor.

Editorial direction: Claudia Stäuble, assisted by Franziska Stegmann
Copyedited by: Jane Michael, Munich
Picture editor: Franziska Stegmann
Timelines: Andrea Jaroni
Index: Katharina Knüppel
Cover design: Joana Niemeyer, April
Cover design: LIQUID Agentur für Gestaltung, Augsburg
Design: LIQUID Agentur für Gestaltung, Augsburg
Layout: Benjamin Wolbergs, Berlin
Production: Nele Krüger
Art direction: Cilly Klotz
Origination: ReproLine Mediateam, Munich
Printing and binding: Druckerei Uhl GmbH & Co. KG, Radolfzell

Printed in Germany

Verlagsgruppe Random House FSC®-DEU-0100
The FSC®-certified paper *Hello Fat Matt* has been produced by mill Condat, Le Lardin Saint-Lazare, France.

ISBN 978-3-7913-4721-9
(German edition: ISBN 978-3-7913-4722-6)